A HISTORY OF
GIRL GUIDES
AND
GIRL SCOUTS

A HISTORY OF
GIRL GUIDES
AND
GIRL SCOUTS
BROWNIES, RAINBOWS AND WAGGGS

JULIE COOK

PEN & SWORD
HISTORY

AN IMPRINT OF PEN & SWORD BOOKS LTD.
YORKSHIRE – PHILADELPHIA

First published in Great Britain in 2022 by
PEN AND SWORD HISTORY
An imprint of
Pen & Sword Books Ltd
Yorkshire – Philadelphia

ISBN 978 1 39900 341 4

Typeset in Times New Roman 11.5/14 by
SJmagic DESIGN SERVICES, India.
Printed and bound in the UK by CPI Group (UK) Ltd.

Pen & Sword Books Limited incorporates the imprints of Atlas, Archaeology,
Aviation, Discovery, Family History, Fiction, History, Maritime, Military, Military
Classics, Politics, Select, Transport, True Crime, Air World, Frontline Publishing,
Leo Cooper, Remember When, Seaforth Publishing, The Praetorian Press,
Wharncliffe Local History, Wharncliffe Transport, Wharncliffe True Crime and
White Owl.

For a complete list of Pen & Sword titles please contact
PEN & SWORD BOOKS LIMITED
47 Church Street, Barnsley, South Yorkshire, S70 2AS, England
E-mail: enquiries@pen-and-sword.co.uk
Website: www.pen-and-sword.co.uk

Or

PEN AND SWORD BOOKS
1950 Lawrence Rd, Havertown, PA 19083, USA
E-mail: Uspen-and-sword@casematepublishers.com
Website: www.penandswordbooks.com

Contents

Acknowledgements

This book was written entirely during the coronavirus lockdown of 2020/2021. I had envisaged myself sitting in archives, studying primary sources and photographs and going to meet Girl Guide and Girl Scout alumni interviewees face to face – as is normal for anyone at the research stage of writing a book.

Suddenly that was impossible.

The world was locked down.

Archives that had previously welcomed authors and researchers were forced to close. Libraries were shut. Book stores' signs were flipped around to read, 'Sorry, we're closed'. Writing a book suddenly seemed impossible.

For a short while, I despaired. How would I write a book on the history of such a wonderful organization as the Girl Guides and Girl Scouts without resources such as archives and libraries? How could I research without real, in-person archives? How could I write a history book without, well, history?

The answer? With the help of the very people who had lived that history. Thanks to the good old-fashioned telephone, email and internet, I was able to access online archives, photographs and newspapers. But more importantly, with online meeting technology such as Zoom, I was able to 'meet' women from all over the world who kindly gave up their time to talk online, sometimes, for those in different countries. fitting me in at 7.00 am in the morning their time to accommodate the time differences between us. Because of this, I was able to source hours and hours of social history from the women who had been Girl Guides and Girl Scouts themselves over the decades – more precious, arguably, than any written text in a dusty archive.

I think this just goes to show how resilient, practical and enterprising women who have been or are still Girl Guides or Scouts are. Without these women giving up their time to be interviewed, sharing their stories and memories, this book really could not have been written.

Acknowledgements

It is therefore with enormous, heartfelt gratitude that I wish to thank: Ardi Butler, Susan Heyes, Karen Chobot, Jenny Jones, Gillian Goldsmith, Vanette Christensen, Jina M. Costa, Alexa Brown, Talitha Burris, Elaine Taylor, Maria at Girl Guides Branding Matters, Breanne Hewitt, Akiko Koda, Judith Mitchell, Liz Bebington, Chris Daniels, Sam Eccles, Tonia Crouch, Jean Jennings, Jenny Beacham, Mary Care, Mary Hornsby, Mary Derby-Pitt, Alice Wood (who sadly passed away in August 2021, some months after telling me her stories), Barbara Dow, Joanna Griffin, Kat Nash, Judith MacLellan, Sherley Penrose, Lebby Eyres, Alison King, Heather Burbridge, Christine Daniels, Denise Ingenito, Marilyn Jones, Hannah Lilley, Evie Mussett, Lori Mobley and her daughters Katelyn and Emily Mobley, the press office at Girl Guiding UK, and, of course, to my own Brown Owl, Tawny Owl and Snowy Owl who gave me such happy memories in the 1980s when I was a Brownie myself.

I would like to extend my sincere thanks to fashion designer Jeff Banks CBE, who redesigned the entire Brownie and Guide uniform in 1990, for giving up his time to tell me about the design process and share some incredible anecdotes – including a royal visit! Also, to Alison Lloyd at Ally Capellino who designed more pieces of the Brownie and Guide uniform in 2002.

I wish to thank Jonathan Wright, commissioning editor, and Pen and Sword Books for commissioning this work and copy editor Carol Trow, Girlguiding UK for their assistance, the Girl Scouts of the United States of America and everyone who has helped find me names of people they knew who might want to share their stories with me.

I thank the Society of Authors and the K. Blundell Trust who supported me during this work and the coronavirus crisis.

Thank you to the British Newspaper Archive for their incredible, extensive collection of newspapers which was paramount to my research, and the same thanks to Newspaper Archive via which I was able to research American newspaper databases.

I must thank my husband and two children for their support and belief in this book.

Finally, I want to thank the Girl Guiding and Girl Scouting movement the world over for supporting, teaching, nurturing and believing in girls and young women for over one hundred years.

It was an honour to write about this movement and I hope it continues into perpetuity.

Introduction

I stood in the centre of the circle, a red and white plastic toadstool to one side and a sea of little faces watching me. The lights had been dimmed. Brown Owl held my hand and led me to a round mirror lying flat on the floor.

'Look inside,' she said.

I stood over the mirror and stared down into it.

'What do you see?' she asked.

I took in my reflection; my seven-year-old face, flushed from the excitement, my brown bobble hat, my neat, yellow crossed tie with a shiny silver badge. I looked up at Brown Owl to check. 'A Brownie?' I ventured.

She smiled and nodded. 'Yes, a Brownie,' she replied.

Everyone erupted into applause.

It was a simple, humble ceremony. Nothing special, perhaps. But to me, it was of huge enormity. I'd been waiting for my ceremony for weeks now, watching other Brownies become enrolled and initiated into our pack. I'd worn the 1980s uniform – a brown knee-length dress, brown belt and yellow tie – but my tie had been plain at the point where it crossed at the centre. Now I sported a shiny new pin trefoil badge on my tie which meant I was truly one of them – a real Brownie.

I had no idea what being a Brownie meant when I first joined. At first, it had seemed a fun thing to do on a Thursday evening after school. We'd meet in a chilly church hall with an ancient heating system that came and went, noisy wooden floorboards that creaked when we ran across them and a decaying stage at one end. When we ran behind the stage curtains, plumes of dust would gush from them like clouds of smoke.

The hall smelt of decay and the past. But the laughter, energy and vibrancy coming from all the little girls inside the hall was anything but staid. Their laughter brought the old hall back to life again.

This was Brownies. It was a chance to make friends outside of school, to learn new things, to be active. It would come to mean so much more than that, though. As I settled in, I learnt that Brownies was not just another social club for children. There were challenges to be met, badges to achieve, camps to prepare for. But the resounding feeling – and memory – I have of from all those years ago is one of simple kindness. The kindness of the group leaders. The kindness of the other Brownies. The kindness we were taught to extend to others.

In the 1980s, Brownies wasn't the same as it is now. Being a Brownie and Guide or Girl Scout has evolved so much even in my lifetime. Now, Brownies have badges to achieve such as archaeology, bushcraft and even blogging. Back then, we did agility, childcare and 'hostessing'. Things have truly moved on. But I learnt skills that have stayed with me for life. We were taught British Sign Language Finger Spelling – something I can still do to this day. We were taught to tie knots and be prepared for all eventualities. That rubbed off on me and even now I feel I am more organized and prepared as a result of my time at Brownies. The camps in my troop back then were not done outdoors; we stayed in church halls. But they are some of my life's fondest memories: unfolding your camp bed, rolling out your sleeping bag, giggling through the night with your friends. We visited incredibly kind local people during our camps – often with huge houses and swathes of land – who welcomed us into their home, letting us girls run amok. That kindness of others who love the Brownies; of elderly local people, or landowners or homeowners who too have their own fond memories of the Guiding movement, is something that came up again and again in my research for this book. People love the Brownies, Guides and Girl Scouts. It has changed immeasurably but there is still something so very wholesome and positive about the movement at heart. That has not changed.

My research for this book took me back to the earliest part of the twentieth century, to a decorated war hero returning from the Siege of Mafeking who wrote a guidebook on scouting. That book and Sir Robert Baden-Powell's fame led to enormous changes at a time of great upheaval for women. While suffragettes were arrested and force-fed while imprisoned to gain women the vote, young girls too were pushing boundaries in their desire to do more than sit at home waiting to become mothers. Those few girls who turned up uninvited to the first ever Boy Scout rally at Crystal Palace in 1907 and pressed Baden-Powell to let

them be Guides, who vocalised their need to do more than sit idly and wait to marry were, I'd argue, as important to the feminist and suffrage movement as those first suffragettes themselves. These girls wanted more than to be restricted, to not exercise in case they dared break into a sweat. They longed to scout, to be challenged, to be prepared and to enjoy nature and the outdoors as much as any boy. Those first girls and the women who became their leaders paved the way for future generations to enjoy the freedom they too deserved.

This book aims not to re-tell a potted history of the Guiding movement. Rather, this book will record people's memories of their own experience of Guiding through the decades. The aim is also to frame their comments within the socio-economic events of the time at which they were involved in the Guiding movement. From its origins in the early part of the twentieth century, through the tragedies and hardships of the two world wars, to the feminist liberation of the 1960s and '70s, right through to the present day, the Guiding movement has evolved alongside women's and girls' rights, giving them a voice, a purpose, new challenges and friendship. It seems impossible to talk about the evolution of the Girl Guides without the feminism movement evolving alongside it.

This book will focus on the history of the Guiding and Girl Scouting movements in Britain and America – the two countries where it all began. But that is not to ignore the fact that Girl Guides exist in 150 countries around the world, with 10 million members worldwide. It truly is a global movement.

I look back now at my Brownie days with sweet fondness. They are some of the happiest times of my life. That phrase 'the happiest times' is something that came up again and again with the interviewees who kindly shared their memories for this book. And, like them, I hope that Guiding will continue to give girls and young women the happiest of times for years to come.

Julie Cook
2020/21

Chapter One

No Place for a Girl?

'Better that a girl should become a "tomboy" than an idle doll with poor morals.'

Letter to the editor, *Spectator*,
11 December 1909

If looking from above, the scene below might have resembled bees buzzing around the central hub of a hive. Thousands of young boys dressed in similar uniforms – flat, wide-brimmed hats, a handkerchief tied around the neck, flannel shirts, knee-length shorts and long socks – were congregating at a venue in the centre of London. Some boys were in larger groups, talking and gesticulating gregariously. Others were more quietly walking two by two. Many carried flags with a patrol of other boys behind them. All shared the same tangible sense of excitement. Each of them was craning his head to see a single man – the man who had started everything. The king bee at the centre of this thrumming hive.

The venue was London's Crystal Palace – a magnificent building created for Britain's Great Exhibition of 1851. Designed by architect Joseph Paxton, it had housed around 15,000 exhibitors from all over the world showing the very best of technology for the new Industrial Revolution. With more areas of glass in its architecture than any other building ever built, the name Crystal Palace soon stuck. But now, exactly sixty years on from its inaugural exhibition displaying the world's wonders in the Victorian era, the great building was hosting a new, modern *human* revolution – a revolution for boys.

The movement had been started by Robert Stephenson Smyth Baden-Powell – later to be known as Lord Baden-Powell. Born the son of Reverend Professor Baden-Powell and Henrietta Grace Smyth, Robert Baden-Powell was born in Paddington, London, on 22 February 1857. His mother, Henrietta, was Reverend Baden Powell's third wife and, as such, Robert would have four half-brothers and sisters. After being sent

to Charterhouse, a public school which had also educated names such as Thackeray and Vaughan Williams, the young Baden Powell had to decide what to do with his life. Robert hadn't been an academic boy, but he had thrived at anything which involved physical prowess – climbing trees, hunting, building tents and shelter and, of course, cooking outdoors.

Instead of going to university when the time came as was expected of someone of his class, Baden-Powell joined the army in 1876. He was posted to Africa and India and became a colonel. But he became world-famous in 1899 when he successfully defended Mafeking in a 217-day battle (the Siege of Mafeking) and he would henceforth be known as the Hero of Mafeking. During his time in the forces, Baden-Powell honed his scouting skills and wrote his own training manual *Aids to Scouting*. When it was discovered his books were also lapped up by boys back home in Britain, he followed up with *Scouting for Boys*. It was in 1907, returning to Britain as a decorated army general and household name, that Baden-Powell held his first demonstration camp for boys at Brownsea Island, near Poole in Dorset. Three years later he would retire from the Army and form the Scout Association.

But now the date was 4 September 1909. Baden-Powell had returned from his final year in the army to hold a Scout rally at Crystal Palace. He had heard that thousands of young boys had been acting out his published advice and tips and had been meeting in parks in makeshift, improvised uniforms to 'go scouting'. Boys wanted to be Scouts. But what they needed was order and a national organization – a national uniform, national rules and regulations, a national name. And now 11,000 young men and boys had congregated to see their leader, to get a sense of coherence. What would the uniform proper be? What would the rules be? How would the various packs and groups across the land be organized? But, if you had looked harder amongst the masses and masses of young men and boys, you would also have seen something else. *Girls*. True, their number paled into insignificance when compared to the boys. There were, onlookers noted, perhaps a few hundred. But they too were dressed in self-mustered uniforms as per the instructions in the book *Scouting for Boys* – long socks, flat hats, ties, shirts and shorts or skirts. One group was led by their leader, Marguerite de Beaumont, who would later become close friends with Baden-Powell and write his biography. After contests, knot-tying and displays, each patrol did a march-by before the eyes of Baden-Powell. During the final march-by,

nine girls walked among the boys and stood in their makeshift uniforms waiting to be inspected. Legend has it that Baden-Powell approached and, perplexed at these females among their number, asked them who they were.

'We're the Girl Scouts,' came the reply.

A confused Baden-Powell was reported to reply: 'You can't be. There aren't any Girl Scouts.'

A 16-year-old girl called Nesta Maude would utter a reply that would be known forever in Girl Guide and Scout movements around the world: 'Oh yes there are – 'cos we're them!'

Two other groups of girls who were known as Pinkney's Green Scouts and the Girls' Emergency Corps also were present. And it became clear to Baden-Powell that although these girls only numbered in the hundreds in the jamboree of 11,000, there was a real desire for girls to do something similar to boys. They too wanted to join the movement and do the same tasks, challenges and activities. It is said that Baden-Powell had some idea that girls were interested in scouting but hadn't realised just how much until he met with girls at the Crystal Palace meeting.

But 1909 was a tinderbox of a year for women. The very axis of society was beginning to teeter. A year earlier in 1908, the WSPU – the Women's Social and Political Union – had held a demonstration which had been attended by 250,000 people. It was the largest political rally in British history to that date. Afterwards, suffragettes had taken to smashing windows in London, including the political hub of Downing Street, and tying themselves to railings in protest. The *London Daily News* of Tuesday, 23 June, reported on the huge rally:

> The Suffragettes admit that yesterday's demonstration far exceeded their most ardent expectations. I was present at the congratulatory reunion at the Queen's Hall today and was much struck by the enthusiasm displayed. The announcement of the new campaign was received with almost wild delight; and hands were clapped and handkerchiefs raised when Mrs Pankhurst declared that 'not a village nor hamlet shall be untouched by our organization'. The WSPU proposes to take a leaf out of the brewers' book of tactics by advising women to withdraw their subscriptions to hospitals and colleges and give them to the cause.

But the same newspaper seemed to change tone just a day later and reported readers' views of the Hyde Park demonstration:

> Mr G Fleming Simons (Bournemouth) turns with disgust from reading the report saying: 'The Suffragettes mad, silly and foolish, brainlessly oppose man and his noblest aims.' Mrs Margaret I Saunders protests against adult suffrage 'as the policy adopted to grant votes to women.'

In 1909, in July – two months before the Scout rally at Crystal Palace would take place – the struggle became even more dramatic. More and more women were making more dramatic protests such as breaking windows and destroying property. And then the suffragettes began another tactic. Marion Wallace Dunlop was the first jailed suffragette to go on hunger strike. The newspaper *Votes For Women* was enamoured with Wallace Dunlop's move and Christabel Pankhurst herself wrote in the newspaper:

> Miss Wallace Dunlop and thirteen other prisoners recently sought to enforce their claim to be treated as political prisoners by means of a 'hunger strike'. Rather than yield on this point, the Government set them at liberty. This, from the Government's point of view, was a colossal blunder, for it revealed to the members of this Union that they possessed a hitherto unsuspected power – the power, namely, to regain their liberty at the price of a period of starvation.

This power over their captors, however, would not last long. Prison guards and nurses began force-feeding the suffragette detainees with tubes and cups. The government played this down as being 'for the women's own good' but, as prisoners were released, they reported the truth of what it had been like. One prisoner, Miss Bryant, reported at a meeting that when she was force-fed a 'horrible feeling of indignity came over her.' Debate continued to rage in Britain about women's roles and women's rights. And this, in turn, led to debate about girls' rights too. If women wanted the right to vote, then surely girls – future women after all – had the right to camp, build fires and shelter, and 'help their country' as boy Scouts wanted to? The 'girl scouts' appearance at the Crystal Palace rally made the headlines in an already torrid, heated environment. For

those men against women's suffrage – and women who were also against it – the idea of Girl Guides was another threat and a step in the wrong direction for women's emancipation. If even the youngest girls and women wanted these freedoms hitherto denied them, what would happen next? If young girls would be gallivanting over the countryside, setting up camp, climbing trees and building fires, how could society contain them as adults and the mothers they were destined to become? The *Spectator* newspaper ran the story. A very vocal anti-suffrage speaker, Ms Violet Markham, wrote a letter to the *Spectator* in which she lamented the presence of girls at the Crystal Palace event and equally their desire to be scouts in the first place. Markham, then in her late thirties, was a very famous opponent of women's suffrage. An heiress and campaigner, Violet Markham had enough money to concentrate on politics and social reform – all reform, that is, apart from women's suffrage. Horrified at the idea of girls becoming scouts and cavorting with members of the opposite sex, she wrote to the *Sheffield Daily Telegraph* on Saturday, 4 December, saying that, should girls join the movement, they would be going off on 'glorified larking expeditions from which they have been known to return home as late as 10pm'. In letters to other newspapers, including the *Derbyshire Courier* of Saturday, 27 November, Miss Markham wrote:

> I am a warm supporter of Boy Scouts but so far as girls are concerned, scouting seems to me useless from the national point of view, and very undesirable as regards the whole tone and spirit it produces in children at a difficult and impressionable age.

Miss Markham's initial letter would form the basis for a debate that would run in newspapers for weeks. Her belief was that to encourage girls and young women to 'act like boys' would lead to their moral demise. But a 'warrant scoutmaster' wrote to the *Spectator* in December that, before utterly condemning the movement for girls, opposing voices should instead understand that the mixing of the sexes would not happen.

'The girls' organization is to be known as the "Girl Guides",' he wrote, the charming idea being that:

> ... if we want the manhood of the country to be men of character, it is essential that the future mothers and wives—

the 'guides' of these men—should also be women of character. Girls must be partners and comrades rather than dolls. As things are, one sees our streets crowded in the evenings with girls, overdressed and idling, learning to live aimless, unprofitable lives. Ladies have pressed me to start Girl Guides in this village to stop the girls 'frequenting' the lanes of an evening. What is the remedy? Surely it is worth while giving this scheme a trial. Better that a girl should become a 'tomboy' than an idle doll with poor morals. But this scheme is not in any respect designed to produce 'tomboys', but to encourage refinement and self-respect combined with utility.

If that did not sway public opinion enough, the letter continues to say – as if to soothe anti-suffrage public figures such as Ms Markham – that:

There are badges for cooking, to include washing up and waiting at table; nursing, to include care of children and elementary instruction; music; art, to include drawing, painting, carving, &c.; tailoring, for sewing, &c.; florist, for knowledge of gardening and wild flowers; masseuse, for anatomy and massage; and so on. The signalling which Miss Markham deprecates is an excellent form of physical drill, since it not only exercises the body without strain, but also the brain. I have the greatest admiration for girls' clubs such as Miss Markham's, but they are not possible everywhere. The 'Girl Guides' will attract every class of girl, from the most retiring to the most 'modern'; not only will it attract, but it will hold them, and possibly form a 'feeder' to the Territorial organization of voluntary aid, a desirable object, which the *Spectator* would be the last to oppose.

The tit-for-tat letter-writing in the press continued. Anti-suffrage voices worried that girls would be led astray, coming home at all hours, wet-through having been frolicking all over the countryside with members of the opposite sex. Pro-Girl Scout voices emphasised that the genders would never be mixed; that, yes, they might well go rambling over the forest and woodland but more to study nature than to be overly physically

zealous. News, of course, reached Baden-Powell himself. In order to concentrate on his burgeoning Scout movement, he would need someone else to take the reins of these excitable girls. He'd returned from a war zone. He didn't want to enter into another one. In time, a person closer to home than he realised became the perfect candidate to sort out these young women and girls who so longed to join his movement; his sister Agnes Baden-Powell.

Two years older than Robert, Agnes also loved camping, sailing and fishing. She had been presented at Court as a young woman but, by all accounts, was far more interested in the natural world than frocks and high society. She kept butterflies – letting them fly freely around the house as well as various birds. Agnes was also a keen flier and balloonist and became a member of the Women's Aerial League and could strip an engine down as deftly as any man. With this in mind, it was no surprise that, when faced with an onslaught of keen girls desperate to join the movement, Baden-Powell asked his sister to help out. And this was not only happening behind closed doors; soon after Agnes began to help out, things went public. In November 1909, Baden-Powell wrote of 'The Scheme for Girl Guides' which was published in the Scout movement's newsletter, the *Headquarters Gazette*. In it, Baden-Powell wrote:

> If we want the future manhood of the country to be men of character – which is the only guarantee for safety of the nation – it is essential in the first place that the mothers, and the future wives (the guides of those men), should also be women of character.

But the training, wrote Baden-Powell, had to be specific to the opposite sex:

> …you do not want to make tomboys of refined girls, yet you want to attract, and thus raise the slum-girl from the gutter. The main object is to give them all the ability to be better mothers and Guides to the next generation.

The name 'guide' was not only because women must now 'guide' their menfolk. It would replace the word Scout because of Baden-Powell's apparent admiration for the Corps of Guides, a regiment in the British

Indian Army who were respected for their survival and tracking skills. The corps had been made up of British and Indian soldiers to serve on the North West Frontier and was made up foot soldiers and cavalry. Some opponents of Girl Guiding were now apparently appeased by the name 'guide', because of its inference of women 'guiding' their menfolk and brothers in life. 'Guide' somehow sounded more womanly and less robust, arguably, than the word 'Scout.' And, for many parents of young girls, the notion that this movement might, arguably, be the way to keep them *out* of trouble rather than getting them into trouble was also a persuasive bonus. As the *Headquarters Gazette* wrote:

> As things are, one sees the streets crowded after business house, and the watering places crammed with girls over-dressed and idling, learning to live aimless, profitless loves; whereas, if an attractive way were shown, their enthusiasm would at once lead them to take up useful work with zeal. Loafing, trusting to luck, want of thrift, unstableness are increasing defects among our men. So they are among the women…homes are badly kept, children are badly brought up. There is a great waste of life among women of every class.

The scheme would go on to include detailed plans for the roles of Guides and how different the movement would be for girls, compared to the Boy Scouts. Baden-Powell wrote that all classes of girls would be instructed in cooking, home nursing, ambulance work and patriotism, Christianity and courage. Without, he wrote, 'making her a rough tomboy.'

And, at last, a proper, nationally recognised uniform would come about: a company colour jersey; a neckerchief (also of company colour); skirt; knickers; and stockings – all dark blue. The cap would be a red biretta for winter and in summer a straw hat. Their haversacks would also be uniform, and each Guide would also need a cooking billy (a lightweight cooking pot), lanyard and knife and a walking stick. The first badges for Girl Guides would be as follows:

1. First aid
2. Stalking
3. Nursing sister
4. Cook

5. Cyclist
6. Local Guide
7. Nurse
8. Musician
9. Gymnast
10. Electrician
11. Tailor
12. Clerk
13. Florist
14. Artist
15. Masseuse
16. Telegraphist (which would include Morse Code)
17. Swimming

Of course, this was not all. Other challenges for the girls would include sailing, signalling and life-saving which were extra-curricular to the basic badges and would mean the Guide who achieved them would then receive the Order of the Silver Fish – the highest accolade for Guides who had made an exceptional contribution. Other generalized attainments expected of Guides included a sense of the spiritual and a 'knowledge of God' as well as a duty to the country and one good deed to be done every day.

By 1910, there was an official Girl Guide Committee and the Girl Guide Association was formed, with Agnes Baden-Powell at the helm. She then began writing her book *How Girls Can Help Build up the Empire,* published in 1912, which was to become the handbook for Girl Guides and Girl Scouts all over the world. Her work would include much copy taken from Baden-Powell's original Scouting for Boys but with feminine additions such as cooking tips, presentation, dressing, sewing and the like. One introductory page reads:

Duties of Girl Guides: Be prepared to help your country – To be brave – To be womanly – To be strong – To live the frontier life if necessary. Why Guides? On the Indian frontier, the mountain tribes are continually fighting, and our troops there is the corps called 'The Guides'. These are a force trained to take up any duties that may be required of them, and to turn their hand to anything. They are the 'handy men'

of India. To be a Guide out there means you are one who can be relied upon for pluck, for being able to endure difficulty and danger, for being able cheerfully to take up any job that may be required and for readiness to sacrifice yourself.

The book would be a huge success and referred to as *the* handbook for girls around the world. The 'pluck' she wrote of and the readiness for self-sacrifice to help others would become key messages for the Guiding movement for years to come. There was also a heavy leaning on a sense of duty in her writing that might well have put off flightier girls. Guiding, it seemed, was not to be taken lightly. Far from a simple hobby of an evening, it would be about serving your country, your peers and comrades, facing difficult and dangerous times and being ready for anything - hardly a fun club for flighty girls. Agnes herself was one for outdoor pursuits, rolling her sleeves up and helping others and was indeed a key figure, if not the figure, in establishing the Girl Guides.

But that same year, 1912, was also a year of momentous upheaval for bachelor Baden-Powell. On a trip to Jamaica, Baden-Powell, now in his fifties, started a conversation with a young woman called Olave Soames. Despite their age gap, romance blossomed – much to the shocked interest of the national and international press, for example this piece in the *Illustrated London News* of 28 September:

> To adopt Sir Robert's own expression, Cupid has pierced the heart of the Chief of the Boy Scouts, Sir Robert Baden-Powell, hero of Mafeking. His fiancée, Miss Olave Soames, is a daughter of Mr and Mrs Harold Soames of Gray Rigg, Parkstone, Dorset. She is twenty-three, her birthday occurring by a curious coincidence, on the same date as that of Sir Robert. She was born on February 22, 1889 and he on February 22, 1957. Miss Soames is a skilful horsewoman and accomplished musician.

This was a big scoop. Baden-Powell had long been the bachelor soldier, the man who ran camps, fought in wars and defeated foes. Little boys and young men around the world admired and adored him and saw him as B-P the war hero – not B-P the husband, tamed and with pipe and slippers. But, although Boy Scouts themselves might have worried that

this newfound love and the domesticity that would surely come with it might steal their leader away from them, congratulations poured in for the Hero of Mafeking. On 19 September, the *Daily Mirror* wrote:

> Scores of congratulatory telegrams poured into the offices of the Boy Scouts Association in London yesterday from people who read the announcement of Sir Robert Baden-Powell's engagement, exclusively published in the Daily Mirror yesterday. The prospective bride is Miss Olave Soames, of Parkstone, Dorset, and the wedding will take place this year. 'The news took us completely by surprise,' said the secretary of the Boy Scouts Association. 'When we showed the Chief the Daily Mirror containing the announcement of his engagement he said: "Yes, that is absolutely correct."' 'I have heard of Miss Soames,' continued the secretary, 'but have not seen her. She lives at Parkstone, which overlooks Brownsea Island where the first boy scout troop was formed. The Chief, I believe, has known Miss Soames from the time he began the first scouts at Brownsea Island.'

The romance was a whirlwind one. Just ten months after their first meeting – and despite there being over thirty years age gap between them – Baden-Powell and Olave married in October 1912. Olave was thrust from her previously quiet life as an unknown into national and international fame. Baden-Powell was a national hero and an international name as Chief Scout. On his arm, Olave felt the limelight shine on her for the first time. But her youth and zest for life would prove a boon for the 'Chief' and she soon immersed herself into the Scout Movement as wife of the chief Scout himself. The year 1912 was not only the year Baden-Powell became a husband, but it was proving to be an important one for him and his movement. The same year he married, he also met with Juliette Gordon Low.

An American, Juliette Low lived between Britain and America after marrying William Mackay Low in 1886. The Gordon Lows spent their time between her native Georgia and the UK. But her husband had died in 1905 and Juliette had become increasingly frustrated at her lack of 'usefulness'. Upon hearing of the work Baden-Powell had done and the national and international interest from young people, Juliette found her

calling. She set up the first Girl Guide troop in Scotland. There, she taught young women and girls of all classes about cooking, knot-tying, signalling and more. It is said that she then returned home to Savannah, Georgia and excitedly telephoned her cousin. On this call, she uttered what would become her most famous words. 'I've got something for the girls of Savannah, and all of America, and all the world, and we're going to start it tonight!'

But Scout and Guide fever had already spread to America. Before this meeting of minds between Low and Baden-Powell, American newspapers ran reports of 'splinter groups' of Girl Scouts long before a nationalisation and organization took place. The *Sioux City Journal* was excited to share the news on 19 January 1912:

> The schoolgirls of Sioux City are not content to let the boy scouts do all the scouting. Under the direction of the YWCA they are planning a similar movement … During the winter meetings will be held every second Thursday at 4:30 o'clock. The girls will be taught to darn and sew and mend and will be instructed in other domestic pursuits … As soon as spring opens, the girls will go on hikes similar to those taken by the boys. Meals will be cooked over campfires and the scouters will adopt the 'back to nature' movement. The girl scout movement is an entirely new department in association work, only a few divisions having as yet been organized.

More of these splinter groups, started by the YWCA or other voluntary women's organizations, began to pop up all over America. If Juliette Low wanted to copy the blueprint of Baden-Powell's success, she would need to nationalise the movement in the same way as in Britain. So, in 1913, Juliette Low did just that. The book *How Girls Can Help Their Country* was published – written by Juliette Low. It was based on the book by Agnes Baden-Powell and featured the same rules, ideas, theories, beliefs and raison d'être as the first book but it was Americanized to suit the readership. In her foreword, she wrote:

> Some reference to the Boy Scouts book may be of service to the instructors but should not be followed too closely. Good

womanly common sense will be a sure guide as to how far to go with it. And in America, we have in some parts of our big country problems to meet that are unknown abroad. In some parts of the country too much actual scouting cannot be indulged in except under competent protection.

Much of the book retains the same rules and ethos as that of Agnes Baden-Powell's book but Juliette Low also wrote specifically of the sense of liberty as well as the duty that came with being a young American citizen:

> You belong to the great United States of America, one of the great world powers for enlightenment and liberty. It did not just grow as circumstances chanced to form it. It is the work of your forefathers who spent brains and blood to complete it … In all that you do think of your country first. We are all twigs in the same fagot, and every little girl even goes to make up some part or parcel of our great whole nation.

Juliette's Americanized book would do wonders to bring the nation's Girl Scouts together. Unlike in the UK where the official name was Girl Guides, the American movement would retain the word Scout – perhaps a nod to a more outdoorsy ethos in the Big Country? Her book advised young Girl Scouts on everything from cooking and sewing skills to first aid, from rescuing people from drowning to navigating and telling the time by the stars. The theme throughout, though, is a recurrent one of doing one's best and of self-improvement, just as Baden-Powell had written in his own work: 'The instructor's chance now is to encourage the young to look out for themselves. A great deal of poverty comes from trusting to luck and loafing with no knowledge of any other line but their own.'

As the months passed, Girl Scouting became more and more popular in the United States. It spread from state to state, from town to town. Just as they had done in Britain, American newspapers discussed the purpose and point of Girl Scouts and women's rights. But for those who had joined the movement, there were answers to every sneering comment. For those who thought the Guiding movement would lead women and girls astray, young American Girl Scouts would talk of how the movement would teach them

humility and modesty. For those who felt that this was merely a copycat of a strange, eccentric movement across the pond in Britain, Girl Scouts could retort that all of them were taught patriotism and the history of the American flag as well as the lyrics to the Star Spangled Banner. This, arguably, was not simply another of Baden-Powell's outposts. Patriotism, not nationalism, would be interwoven with the Girl Scout Movement.

Meanwhile, back in Britain, Olave Baden-Powell was garnering popularity as the young, fresh wife of Robert Baden-Powell. But as her star ascended, Agnes – the founder of the Girl Guides in Britain – was being pushed further and further to the side-lines. In 1913, Olave and Robert set up home at Ewhurst Place in Sussex. Two months later, they set up a troop of scouts there and Olave became Scoutmaster. Gradually, she became indispensable to Robert Baden-Powell, driving him around by car, typing up his letters. But, although she longed to become more involved with the Girl Guides, her requests were at first turned down. Finally, in 1915, three years after her marriage to Baden-Powell, Olave began organising Girl Guiding in Sussex and was given the title of County Commissioner. By this time, she had two children. Agnes, meanwhile, was becoming eclipsed by this younger, more vivacious face of the Girl Guides. Later, it was Olave who would be called 'Chief Guide' – despite Agnes having started the movement before Baden-Powell had even met his young wife. If Olave had become the face of the Girl Guides in Britain, America's national and local press took a keen interest in Juliette Low and her role as leader of the Girl Scouts. As time passed more and more troops appeared in even the most suburban and rural settings as well as in the cities, the *Evening Star* of Sunday, 14 May 1916 reported:.

> Girl Scout Notes. Last Saturday the Girl Scouts of Washington gave a demonstration of their activities at the Women's Training Camp at Chevy Chase. Mrs Juliette Gordon Low, national president, came on from New York to be present and to make an address on the scout movement for girls.

Indeed, the Girl Scout message was being spread far and wide. The American newspaper *The Atlanta Constitution* wrote on 12 November that preparations were underway for an Atlanta branch of the Girl Scouts and that:

Mrs Juliette Gordon Low, of Savannah, who arrives in the city Wednesday morning, and will speak at a public meeting ... Mrs Low will clearly outline the purposes of the organization which now has representation in active branches of the Girl Scouts in nearly every section of the country and which stands for the initiation of young women into the highest service to their country and to humanity.

It was around this time that uniforms began to be much more homogenous in America and began to have a national feel and identity. Early Girl Scout uniforms in the United States had been largely copied from British Girl Guide pictures – a blouse and a skirt and a neckerchief. Until this point, before nationalization, small groups had made their own makeshift uniforms. Now, thanks to Juliette Low's adaptation of Agnes and Robert Baden-Powell's book, uniforms were clear-cut. Although, as Low wrote in her book, 'Uniform for Girl Scouts is not compulsory. Scouts should, as far as possible, dress alike, especially in each patrol, as regards hat, necktie and colour of blouse.'

The hat, she wrote, should be dark blue with a flat, wide brim in scout's felt. The neckerchief should be forty inches of pale blue worn knotted at the throat. The blouse should be in company colours with two pockets. The skirt should have two flap pockets and also be of company colour and under which should be worn dark blue knickers. Finally, stockings should be blue or black woollen worn over the knee.

But there were still voices of disdain about the Girl Guide and Girl Scout movement, even in free-thinking America. The *Houston Post* made its position clear on 30 April:

The Girl Scouts movement will not amount to much unless the girls are uniformed in kitchen aprons and armed with frying pans, feather dusters and other things that will enable them to help mother.

But Juliette Low's book had responses for this disdainful attitude as well:

No one wants women to be soldiers. None of us like women who ape men ... Some girls like to do scouting but scouting for girls is not the same kind of scouting as for boys.

The chief difference is in the courses of instruction. For the boys, it teaches manliness, but for the girls it all tends to womanliness and enables girls the better to help in the great battle of life.

Indeed, if girls were still to be nothing more than mini-mothers in the making, even the Girl Guides and Girl Scouts were aware of the importance of mothering tuition and nurturing to also be at the heart of the movement (as well as fire-lighting, star-navigating and first aid). And mothers, of course, were indispensable in any society - suffrage movement threat or not.

After all, wrote Low in her book, almost every man you read of in history who has risen to a high position has been helped by his mother.

Chapter Two

Wartime

'In time of peace prepare for war.'

How Girls can Help their country, Juliette Gordon Low.

'The public had now come to see the value of a Movement which filled girls with so strong a desire to serve their country and trained them in ways of rendering quiet and efficient service.'

The Story of the Girl Guides, Rose Kerr

On 5 August 1914, a man stood in the House of Commons. He wore a dark suit with a high-necked, stiff-collared shirt. His demeanour appeared calm and collected but his face belied his true feelings; that Britain was on the verge of certain Armageddon.

'Our Ambassador at Berlin received his passports at seven o'clock last evening,' he announced, 'and since eleven o'clock last night a state of war has existed between Germany and ourselves.'

His name was Herbert Asquith and he was the British Prime Minister. He had just announced the start of the First World War. Since the assassination of Archduke Franz Ferdinand of Austria in Sarajevo just six weeks previously on 28 June 1914, Asquith and the majority of his Liberal government had done everything in their power to avoid war. When Russian troops mobilised on 30 July, however, it became apparent that there would be no other option. As war was declared, Asquith's popularity as a wartime Prime Minister soared immediately. The nation – which had so far been so split on everything from women's suffrage, to home rule in Ireland, from overcrowded houses to poverty – was galvanized now into facing this common foe, Germany. Poverty, ill health and the battle for women's suffrage would have to wait. Patriotism and nationalism took flight. The sense of serving one's country was already at the heart of the Guiding movement. But better yet, there seemed no other group of civilians better prepared for a war

situation than the Girl Guides and Boy Scouts. Long-trained in the art of camping, roughing it in all weathers, being prepared, and, of course, in the Scouts' groups 'scouting' in military style, these young people were arguably even better-placed to help the war effort than the average enlisting soldier with no experience. But their strength lay in more than just being prepared. Girl Guides had long been taught to be kind, to help out and to do practical acts to help others. This soon became apparent all over Britain. The *Bexhill-on-Sea Observer* on 17 October, reported:

> Bexhill Girl Guides are helping their country by making suitable gifts of comforts for our sailors and soldiers. All articles are knitted in grey or khaki wool ... A letter has been received from the Duchess of Somerset thanking the Bexhill Girl Guides for their kind gifts.

The article went on to say that the Secretary for The Ladies Emergency and Navy League said:

> The Committee wish me to thank the BP Girl Guides most sincerely for their generous gifts of socks, mufflers, mittens and belts for the sailors in the North Sea. We send from 50 to 60 parcels daily and have very many letters from officers and men expressing their thanks and satisfaction with the gifts. The Girl Guides' parcel is a most welcome addition.

But the Girl Guides' skills were not limited to providing parcels of mittens and mufflers. While the Boy Scouts were being extolled for their help in the war effort, working on farms while men were away fighting and, in the Sea Scouts' case (formed in 1910) watching the coast for enemy vessels, Girl Guides were quietly doing what they could to help without as much mention in the local and national press. But Girl Scouts were mobilising, arguably, to the same degree as their male counterparts. They were taking on jobs under Red Cross nurses in auxiliary positions in hospitals, helping scrub floors, fetching and carrying, sending messages, and washing up. Others were helping in kitchens to cook and serve, or using their sewing skills to mend territorial army members' uniforms and even darn their socks. These girls also helped mothers whose husbands

were away at the Front, minding their children, or helping in creches. In fact, wrote *The Common Cause* on 21 August:

> Anyone in charge of a branch of the Red Cross nurses and desiring the services of the Girl Guides should write to the Secretary at 116 Victoria Street, London.

While older girls in the Guiding Movement were now using their skills to help the war effort, younger girls were asking to get involved too. Olave Baden-Powell – now known as Lady Baden-Powell – had been married for two years and was becoming increasingly involved in the movement. It was in 1914 that Lady Baden-Powell wrote in the movement's *Gazette* that there was a growing number of younger members of the Guiding movement called 'Rosebuds':

> I am so glad that some to hear that some of you are taking up the work of training Rosebuds to follow in your footsteps. I heard the other day from a company at an Ealing school who had formed a company of little sisters.

These Rosebuds would, of course, later be called by a different name – the Brownies. A Brownie, in old folklore, was a small, hardworking fairy-goblin that cleaned up when no one was looking at night. But for now, the name Rosebuds stuck and represented their innocence, their freshness and the sense that they would surely bloom into something marvellous in time. It was, it could be argued, perfect timing. Just as their older 'sisters' were being called away from the campfire and the jamborees to assist with very real war work, these younger girls were stepping up to fill their places and learn their arts to become like them in due course. The press reflected this growing shift in attitude towards the Girl Guides. The voices that had so far sneered, either arguing Guiding was no place for girls or, conversely, that Guiding was fine so long as the girls focused on darning and cleaning, began to hush. Newspapers far and wide began to report the useful work these young women and girls were doing and the help they were providing in their communities. 'In their own sphere,' wrote the *Hampshire Telegraph* on 6 November, 'the Girl Guides are becoming as useful as are the Scouts.'

Guides were now being trained in stretcher work, carrying wounded soldiers, bandaging and preparing nourishing meals for invalids. The signalling semaphore they had learnt in the Guides was also proving useful and, for those girls who passed tests, Guides could now wear a badge showing they had achieved standards expected of either the Red Cross or the St John Society which they could wear without passing any further examination. This acceptance, although gradual, of young women and girls playing a valid part in the national war effort cannot be underestimated. From just a few years earlier when voices lamented the end of the delicate young female or the terror that these young girls might become boys or, worse, frolic with them, things were now shifting tangibly to one of acceptance. Yet, these girls and young women did so much so silently. There were news reports of Girl Guides – now 10,000 in number – scrubbing down a house in Leeds so it could be transformed into a military hospital. Other Girl Guides were reported to be doing mending for a branch of the Territorials in Hertfordshire and making puzzles for convalescent soldiers in Crawley. In London, Girl Guides became nurses for children at Belgian Refugee camps and in Harrow they grew vegetables for those too poor to buy any.

Touching stories arose again and again in the local and national press of how the Girl Guides were doing silent work that had a huge impact on those on the receiving end. In one troop, girls were reported sitting around a table cutting up flannel rags into tiny pieces. When asked by a newspaper journalist from the *Sheffield Daily Telegraph* who was visiting to see what they were doing on 9 December, one Guide replied: 'We are making quilts for the Belgian refugees. They are badly needed. We fill linen bags with the small pieces of wool and join the bags. Four of them sewn together make quite a nice eiderdown.' The article ended, 'What does all this show? That the Girl Guides are as willing and as able to help the country as their brothers.'

But by December 1914, the sense of proximity to the war changed. For the months beforehand, the war was 'over there', at the Front on the continent. But in December, Germany began Zeppelin raids on Britain which meant that, for many, a war that seemed somewhere else was now very much part of their everyday lives. The Boy Scouts soon were called upon to help out. Many were trained to help during air raids, to put out fires and to guard railway bridges while soldiers were being sent to the

Front. Likewise, the Guides' involvement began to grow in momentum both in plain sight and hidden from view. Documents would later reveal that MI5 recruited 90 Girl Guides – then only in their teens – to be messengers earning 10s a week. These 90 girls reported to Waterloo House in London as well as other secret locations and were given new patrol leaders. The characteristics required of a Guide chosen by the secret service were described: 'A messenger should be between the ages of 14 and 16, a Guide of good standing, quick, cheerful and willing.' Boy Scouts had been used at first but, it was soon discovered, they were not as trustworthy as girls not to talk. As Baden-Powell himself was reported saying later:

> One of the big government offices in London has taken on Girl Guides as confidential messengers and orderlies - avowedly because 'they can be trusted, better than boys, not to talk'. If the character of the girl is developed, she will discipline herself not to 'blab' and will 'play the game' not for herself and her own glorification - but in the interests of her side, that is of her country or her employer.

At last, after being described as a non-starter, or a terrible idea that would surely unravel all that was natural and good about women, the Girl Guides were being taken seriously - not just by opponents to women's rights and suffrage, but the whole country. More and more Guides joined the movement. They were visible on virtually every street corner in their blue skirts, which could be no more than eight inches off the ground, and their hats and belts and badges on their arms. They also kept the nation's spirits up. Returning soldiers, or those about to depart, were often entertained with songs and shows by the Guides. The war did not stop general Girl Guide meetings or inspections, either. In June 1915, Agnes Baden-Powell performed an inspection of the Girl Guides of Devon in Exeter. This involved parades as well as Agnes handing out badges. The Mayor was also in attendance and gave a speech thanking the Girl Guides for their efforts so far during the war and that 'when the landmarks of civilisation seemed in danger of being moved, it was satisfactory to know that the coming generation of boys and girls were determined, as Boy Scouts and Girl Guides, to prove themselves equal to their destiny...' as reported in the *Exeter and Plymouth Gazette*

that month. Interestingly, the Mayor went on to say that the Girl Guide movement actually signified a new 'womanly' movement:

> 'We expected great things from our Girl Guides. We looked to them to show that capacity was compatible with womanliness and that a girl might be ready to play her part in the hard work of the world without sacrificing one iota of her personal charm.'

The tone in the press had changed hugely since those first angry letters to the *Spectator* from Miss Markham and her opposition to girls joining the movement. Now, instead of so many articles lamenting the death of womanhood and womanliness, other characteristics of womanliness were emerging as desirable: strength, character, confidence, hard work and patriotism. Girl Guides were not to be tolerated or indulged now. They were needed.

As the war progressed, German raids hit Britain again and again. On 8 September 1915, a German Zeppelin attacked London causing damage to the value of £530,000. It was the Girl Guides who volunteered for the unenviable task of joining the 'after air raid' squads, walking through rubble, putting out fires, helping rescue people from collapsed buildings and giving first aid. They would have seen bodies, badly-injured people and destroyed homes. For teenage girls to see this so early in life must have been as disturbing as it was character-building. But for those who had lost a home, were injured or disoriented after an air raid, the sight of these girls in blue must have been of great comfort. In all the chaos of war and loss of city landmarks and buildings and homes, the Girl Guides remained a constant, in their neatly-pressed uniforms, always there, always helping out. In fact, they became respected members of the community, in cities and rural areas, there not just to do the larger things required of them, but even the seemingly minute or inane. The *Somerset Standard* of 31 December has this account:

> The most exciting incident that had reached us took place in Cheap Street where two men who had been drinking not wisely but too well commenced quarrelling and a troop of Girl Guides rushed to the rescue, separated the disturbers of the peace and marched them off in different directions.

Girl Guides were at last being recognised as a serious movement of young women to be respected and seen as figures, if not of authority, then of aid and support to those around them. These were no longer silly girls who wanted to rough and tumble like boys, or girls who wanted a chance to frolic outdoors. These were sensible future women who wanted to play a part in helping their countrymen and women during the war and beyond.

Across the Atlantic, change was afoot in the United States as well. When war began in Europe in 1914, President Woodrow Wilson promised America would not join. He pledged neutrality and the American people supported that. For three years, America sat on the side-lines of the war. But by spring 1917, this was no longer possible. Germany had so far tried to isolate Britain and had promised attacks on any ships that entered the waters around the United Kingdom. And now, Germany began attacking American merchant ships, despite America still agreeing to trade with Germany as in any other time. But in March 1916, after Germany sank the French boat *Sussex*, Woodrow Wilson had threatened to sever ties with Germany unless they could agree on a pact that crews of merchant and passenger ships could be allowed to escape before any attacks. Germany agreed and a pledge was forged, the Sussex Pledge. But Germany did not stick to the agreement. Hundreds of merchant and passenger ships were sunk – including the infamous sinking of the passenger liner *Lusitania* in which 1,200 people died, including 94 children. In April 1917, President Wilson requested a declaration of war on Germany from the American congress. The Sussex Pledge had been broken. However, Germany argued that America had already broken the pledge by supplying the Allies with ammunition. This, they argued, was not neutrality at all. But hundreds of merchant ships were being sunk by U boats, with innocent American lives lost. America could no longer do nothing. Finally, on April 4, 1917, America declared war on Germany. And not only a war. The president declared a 'war to end all wars that would make the world safe for democracy'.

And so, America joined the war effort. Juliette Gordon Low was a resident of Britain as well as the United States and had travelled to and from Belgium with her sister Daisy helping the Red Cross during the war. Almost as soon as President Wilson had announced the war, the American Girl Scouts sprang into action, digging victory gardens, learning to drive ambulances for the Red Cross and helping out in hospitals as auxiliary nurses. Their work was not un-noticed by the

powers at the top. Herbert Hoover, who would become the next President but who then was the Secretary of Food Administration, wrote directly to Juliette Gordon Low:

> 'My dear Mrs Low, may I take this opportunity to express the appreciation of the Food Administration for the work that the Girl Scouts in the District of Columbia have been doing under their leader Mrs Coleman, during the past few months, along the lines of conservation of food.'

Food, long seen by many females throughout history as a medium for showing love and care, would be a theme prevalent within the Guiding movement. In fact, so legend has it, 1917 was the very first year that Girl Scouts cookie bake sales were recorded.

In June 1918, Herbert Hoover wrote to Juliette Low again, writing that the future of the war, in part, depended on the good work of the Guides:

> The work accomplished by the Girl Scouts last year in the production of vegetables from home gardens, and in the picking, canning, preserving and drying of fruit and vegetables has been of material benefit in solving the problem of food distribution.
>
> If in doing this, all the Girl Scouts in the country could secure the cooperation of all the members of all their families, and of all the friends they can influence, there would be enough food saved to feed a large army.

In Britain, Girl Guides continued to support the war effort on the Home Front. But attitudes to the Great War were changing. At the beginning in 1914, the general public in Britain saw the war as one of defence, not attack. Germany had invaded Belgium, the result of which – the Belgian refugees – was there for all to see as Belgians began arriving on Britain's shores. This was a war of honour and doing the right thing. In general, the British public backed it. Likewise, men's decisions to enlist were positive due to reasons of honour, virility, chivalry and manliness. Lord Kitchener's famous campaign involving his renowned 'Your Country Needs You' poster had encouraged over one million men to enlist

voluntarily. This was of course aided by the White Feather Movement, which had begun in the summer of 1914 when Admiral Fitzgerald had given women the task of handing out white feathers to men not in uniform. The craze had then swept across Britain as women read of the men shamed in this way for not 'doing their duty' and more and more feathers were handed out. The women were known as the White Feather Brigade or Order of the White Feather. Men who received a feather in public were ridiculed, humiliated and encouraged to enlist and 'wear a uniform'.

But, as the war progressed, those soldiers who came home – often severely injured, maimed or with life-changing disabilities – knew that the war to end all wars had been nothing like the valiant battle they had expected. They had seen comrades as young as 16 die, blown to pieces before their eyes. Many had undiagnosed post-traumatic stress disorder, then called shellshock. As word reached back from these men to those younger men coming of age to enlist, the attitude to war began to change. It would not be 'over by Christmas' and there was certainly nothing glamorous or boys' own comic book about having one's legs blown off in a trench. Signing on diminished and in 1916, the Military Service Act was passed in Parliament. This law meant that all single men between 18 and 41 who passed a medical test were called up for compulsory active service. Exempt were the medically unfit, teachers, the clergy as well as most farm workers, miners and industrial workers. In May 1916, the conscription law went on to include married men. In April of that year, hundreds of thousands demonstrated against enforced conscription in Trafalgar Square.

But the war was coming ever closer to home. On 25 May 1917, a group of 80 Girl Guides had gathered at Kent College Gymnasium. It was a warm, late spring evening and was the Friday before a long bank holiday weekend. Those outside in the street suddenly heard a low drone of aircraft overhead. Most people thought it was a British plane coming in to land or perhaps out on manoeuvre. But then someone spotted the plane. Then another. It wasn't a British aircraft. It was a fleet of Gotha planes – heavy German bombers. They swept in as if from nowhere and began dropping huge explosive bombs. Sixty people were killed instantly. Many others were wounded. The Girl Guides, however, were inside the gymnasium when the bombing started. A clergyman who was leading a religious service entitled Be Prepared – the Guides and

Scouts' motto – with the Guides, recounted his experience in *The Times*, subsequently also reported in the *Hampshire Telegraph* of 1 June:

> I was trying to take the terror out of the exhortation 'Prepare to meet thy God' that a terrible explosion seemed to make the building rock an instant. Other shocks followed. I felt sure we were being bombarded from the sea. We went on with the arranged programme, singing as the last hymn 'God bless our native land, may His protecting hand still guard our shore' …

It was after the Benediction and the National Anthem – during which the Guides continued to stand and sing and salute, despite the enormity of the bombing – that the headmistress of Kent College entered and told the group there was an air raid.

The clergyman was told to stay put, along with the Guides. He went on to say:

> I want to say that as long as my life lasts I shall remember with admiration and pride the perfect self-control and cheerfulness of those 80 daughters of England, some of whose homes were far away. Their behaviour was superb.

Seventy-five miles away in London, Girl Guides were behaving in an equally cool, calm and collected manner under fire. Girl Guide troops had been put in charge of helping equip bomb shelters with food provisions, bedding, cots for babies and other supplies. During air raids, the Guides would help civilians find their way to air raid shelters. If people were injured, Girl Guides helped them to a hospital or to a nearby makeshift clinic.

The year 1917 marked an even greater turning point in the war. The Battle of Passchendaele began on 31 July 1917 and would last until November. Already, military morale was low and soldiers were exhausted. Those sent to Passchendaele would face not only horrific warfare but also the most impossible terrain on which to fight – liquid mud. Many soldiers drowned in the mud, along with their horses. In total, in the three-month conflict, 325,000 Allied troops died. The heaviest rain in three decades in the region meant that even those who were not shot

or killed at close-range drowned in liquid mud. Others died of mustard gas poisoning. The battle would become synonymous with the mud-drenched horror of trench warfare that we know today. And as news reached home of the casualties and undignified ways in which so many British soldiers had died, morale nose-dived in Britain. The civilian public was also war-weary by now, having endured threeyears of the conflict which had led to food shortages, air raids, losses of family members and friends and a sense of hopeless despair that the war that would be 'over by Christmas' might never end. The Girl Guides, therefore, with their positive spirit, sense of community and wholesomeness was needed more than ever. In August 1917, Sir Robert and Lady Baden-Powell addressed a meeting in Edinburgh where it was stated that there were just over 3,000 Guides in Scotland. Sir Robert Baden-Powell stressed the importance of the Girl Guides during this time of war and said that either 'evolution or revolution' awaited Britain. He said that the only thing that could save Britain was the training of the youth of both sexes to meet the responsibility that they would have to face. But however great this huge responsibility that loomed for young people after the war, Girl Guides were aware that the smallest jobs helped the bigger effort. In Alton, Hampshire, for example, one troop of Guides received a letter from the Prince of Wales congratulating them on their efforts for collecting wastepaper for the National Relief Fund. According to the prince's letter, the Guides had reduced the need for imported paper from abroad, thereby freeing up shipping for other necessities and, as such, wrote the local paper: 'they are helping to end the war'.

The newspaper publishing of minor activities such as saving wastepaper might have seemed unimportant. But the receiving of thanks from a public figure as prominent as the Prince of Wales must have been a great morale-boost for a country sick and tired of death, mud and despair.

In the United States, there were by now over 100,000 Girl Scouts registered. Juliette Low was now a prominent public figure during wartime and, as in Britain, the war had meant that Girl Scouts' skills and abilities were now being gratefully extolled and utilised. Since America had joined the Allies, American Girl Scouts had knitted and sewn soldiers' uniforms, helped make bandages for wounded soldiers, worked in canteens, trained in First Aid, become mothers' home helpers and auxiliary nurses as more and more trained nurses were deployed at the Front. The close partnership between the Girl Scouts and the

Department of Agriculture and Food Administration meant that Girl Scouts were now actually assisting trained government-appointed instructors in demonstrating how to make 'victory bread' (a bread made with 25 per cent substitutes for wheat such as corn, barley or rice flour) and how to use meat and sugar substitutes safely and effectively in food preparation. In agriculture, Girl Scouts were now raising chickens and smallholdings, growing vegetables, and had now formed canning 'clubs' to orchestrate the canning of vegetables that could be preserved.

That was not all. In the Bureau of Education, the Girl Scouts were now assisting alien immigrants to the United States, some who had been displaced by war. Girl Scouts were recorded helping the children of refugees or immigrants to learn some English words to be able to express themselves, and even worked within the Department of Labor to help these new American citizens find work. Girl Scouts were now also trained in military drill and army signalling, not to be encouraged to form some sort of military organization but to help them with team building, responsiveness to dangerous situations and general discipline. Even the Guides' little sisters, now called the Brownies, were noted for their work in the American war effort. They knitted afghan squares for invalid soldiers and made scrapbooks for them with hand-glued pictures and cuttings to keep those who were infirmed amused while they recovered.

Juliette Low told the *Nashville Banner* in May 1918:

> These girls are reaching out to help the country and are coming to be of the greatest assistance in its time of stress. Their whole previous training in scout work has rendered them alert and prepared for emergency war work here as they have been found in England.

She was quite right. In Britain, the Girl Guides were increasing in number but also in visibility. Brownie members were also increasing and in 1917, the tunic dress was introduced: a brown dress with patch pockets; a tie; and knitted cap in either brown or dark blue. Guides, who had started off with a dark blue blouse, long dark blue skirt and felt wide-brimmed hat and tie now were given a shorter, more practical skirt which finished just on the knee. The shirt was also made longer and was worn with a belt, while a blue tie now replaced the yellow one. A shorter skirt – although still modest and respectable and knee-length – represented a belief that a

uniform should be practical for girls who were now performing often very physically demanding acts and deeds during wartime. Rushing people to air raid shelters, helping nurses with first aid and helping grow wartime vegetables were not so easy in an ankle-length skirt. The uniform change represented a change in attitudes not just to the girls' abilities to engage in physical activities like the Scouts, but also to the genuinely useful war work they were now doing.

This reflected the wider politics of women's rights. So far, during the war, much of women's suffrage – both peaceful and militant – had been suspended. But the war had meant that women had had to take on the roles of men in transport, farming, the production of munitions and more. Finally, in February 1918, Parliament granted some women the right to vote in the Representation of the People Bill. It did not apply to all women but was, at first, solely for women over age 30 who had already voted in local elections or who were married to men who had. The act also applied to women who owned property which had to bring in a minimum £5 annual rent. This meant that 20 per cent of women over 30 didn't fulfil these criteria and were therefore still denied the right to vote. Ironically and frustratingly, the very women who had done the majority of the war work – younger women, poorer women – were still denied their right to vote. But it was a start.

And it was a start that would surely help lead to more changes. Just two months later, an organization was born that might have been unthinkable just ten years earlier: the Women's Royal Air Force (WRAF). In the WRAF, civilian women joined up and were divided into four job groups: household; clerks and store-women; technical; and non-technical. Clerk work involved typing and secretarial work, technical section women learnt to fit engines and to weld and household mostly comprised of cleaners and cooks. Dame Helen Gwynne-Vaughan would be Commandant of the WRAF. Agnes Baden-Powell, the first Girl Guide, was also a keen airwoman and had reluctantly resigned from being President of the Girl Guides Association a year earlier in 1917, being replaced by Princess Mary. Agnes had worked with the Red Cross and had won a war medal for her services during wartime. With these women becoming ever more prominent and with their link to the Girl Guides (Commandant Dame Helen Gwynne-Vaughan would later join the Girl Guides Association) the general public was rightly seeing Girl Guides – and women in general – with completely different eyes

than they had the beginning of the war. Soft, 'delicate' girls were being replaced with useful, robust young women. Things were changing. The Guides, it seemed, simply reflected what was going on in wider society and the changing role of women.

Or, were they leading that change?

As 1918 dragged on and war continued, the Guiding movement did not diminish but only grew in number. By this year there were said to be over 300,000 Girl Guides in the movement, many doing important war work. But another enemy was attacking the world at the same time; the Spanish Flu. In America, Girl Scouts who had already been helping the war effort now also turned their hand to helping those suffering as a result of the pandemic. American Girl Scouts distributed soup and hot meals to those in poorer areas and would ensure children were fed if their mothers were ill with influenza. There was even a Girl Scouts' badge called 'Invalid Cook'. This taught the Girl Scout to make gruel, barley water, milk toast, oyster or clam soup, beef tea, chicken jelly and kumyss (a fermented form of milk) The Girl Scouts' contribution during a time of war and pandemic was not to be underestimated. By the autumn of 1918, it was apparent the Great War might soon reach an end. The Allies were gaining ground and peace seemed the natural end to things. But still the pandemic went on, ravaging old and young. The Spanish Flu was so deadly that ten to twenty percent of those infected died. It was also more prevalent in young people. As in other times, Girl Scouts didn't baulk at their task. They risked their own health by coming into contact with people in the poorest communities, serving them warm meals and drinks. At a time of great loss due to the war and fear due to a deadly virus, Girl Scouts became synonymous with comfort, warmth and kindness as well as their stoical attitudes in the face of adversity.

On 11 November 1918 at 11 o'clock, the Armistice was signed which would end the fighting on land sea and air. 'Armistice signed, end of the war! Berlin seized by revolutionists: new chancellor begs for order, ousted Kaiser flees to Holland,' wrote the *New York Times*:

> The State Department announced at 2:45 o'clock this morning that Germany had signed. The Department's announcement simply said: 'The Armistice has been signed'. The World War will end this morning at 6 o'clock, Washington time, 11 o'clock Paris time.'

Jubilation rocked America and Britain. Four years of horror, of loss, death and unthinkable sacrifice was now over. But life had changed forever. Most families had lost someone or, in many cases, more than one person. Men returned maimed, injured, near death or suffering unimaginable stress and trauma. They also returned to find that their jobs had been done – in agriculture, technology, munitions, factory work and transport – by the very women they had gone to war to protect. Some women now had the vote in Britain. Women were now prominent in the Red Cross and the WRAF. Girl Guides and Girl Scouts had now changed forever as well. From a fledgling group of young girls who wanted to be like Scouts just nine years earlier, they had come a long way. From girls who simply wanted to be outdoors, to camp, to cook, to learn about nature as the boys had done, they had evolved into a very real, reliable, important 'force' in the war effort. As one girl's poster read, 'Guiding IS national service'. And it really was. In Britain, Girl Guides had rushed people to underground air raid shelters, risking their own lives. They'd worked in roles they might not have dreamed of inhabiting in the forces, in the WRAF, even within MI5. In America, Girl Scouts had nursed returning soldiers, knitted and sewn and mended uniforms, had worked alongside the Department of Agriculture and Food Administration to ensure Americans did not go hungry or malnourished during the war. They'd risked their own lives caring for those near death during the Spanish Flu epidemic. War brought many tragedies to many people. No one was left unchanged. But if the war brought one positive result to the Girl Guides and the Girl Scouts it was this; due respect at last.

Chapter Three

A Royal Endorsement

'As President of the Girl Guides, I am watching with the fullest interest the progress of the movement in India. I am particularly glad that sisters in that great country are entering upon guide activities with that keenness and success which distinguish their sister guides every part of the Empire.'

Princess Mary, 1921

'Before her marriage, the Duchess of York was a Guider...The Duchess's interest and work in the Guide movement probably accounts for the fact that her tastes in dress are quiet. She always turns to quiet models and never wears anything extreme or outre.'

Belfast Newsletter, Wednesday, 16 July 1924

An imposing, red brick building in the centre of a 14-acre site in the north of Oxford, England, St Hugh's College had been founded as a women's college by Elizabeth Wordsworth. She was the great-niece of the poet William Wordsworth and this college had been founded by her, after inheriting some money, to provide an education for poor female students. Now, thirty-four years after it had been founded, it was opening its doors once again to women and girls – but in a different way. Two by two, representatives of the Guiding movement from all over the world entered through St Hugh's imposing doors and stepped inside. This was an event of great importance for the Girl Guides; it was the first World Conference ever to be held. And what better venue than an institution that championed female education? By now, the Guiding Movement was spreading across the world at such a rate that it could no longer be a selection of splinter groups but needed a centralised sense of order and cohesion. Just three years later, in 1924, the third International Conference saw 1,100 girls and women meet together from over 40 countries. Guiding was now officially worldwide and in 1928, at a convention in Hungary, it was given a new name. The movement now

became known as the WAGGGS – the World Association of Girl Guides and Girl Scouts.

But with any major organization, it needed stiff rules and order that could be understood internationally. Lord and Lady Baden-Powell would be at the helm along with an elected Director. Now there were founding members of WAGGGS from all over the globe including Britain, America, Canada, France, Hungary, Japan, Australia and even Iceland. It was decided that, because there were now so many worldwide members, the conferences would take place every three years. It was in 1926, at the annual convention held in America, that Baden-Powell launched World Thinking Day. It was decided that this would be held each year on the birthday he shared with his wife – 22 February. It would be a day for Guides, Brownies and Girl Scouts to think about what being a Guide meant, to think about raising funds for organizations or for those less fortunate. Years later, Olave Baden-Powell wrote to all the Guides and Girl Scouts asking them to donate a penny each on World Thinking Day. This day would evolve to become one of the most important dates for Girl Scouts and Girl Guides, giving them a common day of celebration around the world.

In Britain, Girl Guides were at last getting the recognition they deserved as a respected organization for young girls and women. All over the country their numbers were expanding. On 4 October 1930, *the Aberdeen Press and Journal* wrote:

> Viscountess Arbuthnott declared that the gloomy prophecies made when the movement was started had now been refuted by the Guides themselves. Over 2500 Guides – a noteworthy increase of 200 last year in the number of Girl Guides in Aberdeen, bringing the total membership up to over 2500, has led to new buildings being acquired at 22 Union Street ... Her speech struck the right note for the occasion, for it contained a gentle reminder to those critics who, seventeen years ago, saw in the Girl Guide movement subtle way of taking girls away from home and home duties...None of their gloomy forebodings had come to pass. The Girl Guide to-day was of real value.

Arguably one of the most important driving forces behind the growth and popularity of the Guiding movement was the involvement of the British

Royal Family. Girl Guides had now seen people through the Great War, a global pandemic, they had delivered food to those in need, helped terrified people to shelters during bombing raids and offered home help to mothers while their husbands were fighting at The Front. Guiding uniforms on Britain's streets had become as recognisable as those of a solider, policeman or shelter warden. It had become impossible to ignore the contribution Girl Guides were making to society and, as such, the Princess Royal, Princess Mary had become the President of the Girl Guiding Association in 1920. She became more than a president, but an ambassador of the establishment's acceptance of this organization that just ten years earlier had caused furore among the more conservative voices in the press. She attended rallies, salutes and events all over the country, and even worked to increase membership of the Guides around the world:

> Princess Mary has sent telegram to Lady Baden-Powell, in which her Royal Highness wrote: 'As President of the Girl Guides, I am watching with the fullest interest the progress of the movement in India. I am particularly glad that sisters in that great country are entering upon guide activities with that keenness and success which distinguish their sister guides every part of the Empire.'

Princess Mary became ever more visible, in uniform, as a symbol of the Guiding movement and in doing so, gave royal endorsement. She travelled all over the country in her capacity as President, announcing that the Guides were growing greater and greater in number. *The Scotsman* reported in April 1931:

> Princess Mary, dressed in the uniform of the Girl Guides in her capacity as President, attended the annual meeting of the Council of the Association at Imperial Headquarters, London, yesterday … Commenting on the wonderful increase in numbers during the past year, Princess Mary announced that the total number of guides in the British Isles was now 660,654, an increase of over 40,000 during the year. In the overseas Dominions and colonies the total was 116,000, thus making the figure for the Empire over 676,000. In foreign countries Guides numbered nearly

270,000 showing how the movement had spread through the world, with its world total of 946,000.

That incredible worldwide figure of almost one million Guides was a milestone. The movement had come so far since its early days and coming under fire from those who felt the movement would lead girls astray. Instead of 'taking girls from their rightful place', Guiding was uniting girls all over the world, from vastly different cultures and backgrounds. Princess Mary was ambassador for this change and for this growing sense of female solidarity. In newspapers of the time, Princess Mary's tireless work with the Guides came up again and again. She even got 'completely drenched' in the rain at a salute in Leicester along with 3000 other Girl Guides.

Before and after her marriage, Princess Mary's dedication to the Guides did not waver. The *Daily Mirror* told its readers in 1930:

> Tomorrow, on the eve of Empire Day, Princess Mary will lay the foundation stone of the new Girl Guide headquarters in Buckingham Palace Road. It is just ten years ago since Princess Mary consented to become President of the Girl Guides and it was her generous gift on the occasion of her wedding which largely financed their training centre in the New Forest. Founded in 1910, the Girl Guide Movement is now 500,000 strong and is represented practically all over the world.

Foxlease was the name of the new training centre, an imposing house set in an estate of 65 acres. The estate had been owned by the Saunderson family but in 1921 had been put up for sale. The lady of the house, Anne Saunderson, was fleeing to America with her children after a divorce and offered the house and grounds to the Guides after giving them permission to camp there. Without the means to keep such a grand house and grounds, though, the Guides – at first – had to refuse. But fortune had it that that same year, 1922, Princess Mary was to marry and, after much discussion, it was decided that the princess would donate some of her wedding fund to the Girl Guides to buy a training centre, Foxlease. The house would be renamed Princess Mary House in the princess's honour. Over the time that followed, Princess Mary donated a further £10,000 to keep the house and grounds running.

It wasn't just Princess Mary, though, who was prominent in the Guiding Movement. The Duchess of York – born Elizabeth Bowes-Lyon, who would later become Queen Consort after her brother-in-law's scandalous abdication – was also active in the movement and had been Commander of the 1st Glamis Troop at her family home in Scotland. She was born Lady Elizabeth Bowes-Lyon, daughter of the Earl of Strathmore and Kinghorne and his wife. The young Elizabeth grew up at Glamis Castle, an imposing building in Strathmore, Angus, in Scotland. During the Great War, when she was just a teenager, the castle became a military hospital and she fetched and carried for the injured servicemen, running errands, bringing them cigarettes and generally raising their spirits. In 1918, Elizabeth's mother took ill and the young Elizabeth had to run the household while it was still a military hospital. It was in 1920 that her life would change when she met the then Duke of York at a dinner party. After three proposals of marriage from the Duke, Elizabeth accepted and in 1923 they married. As a wedding present, the 1st Glamis Troop of Girl Guides gave the new Duchess a silver ink stand and pens as a wedding present.

After her wedding day, the now Duchess of York continued a keen interest in the Guides that extended around the world. On a royal tour with her husband, she received an enthusiastic reception when she inspected a troop of Girl Guides at Palmerston North, New Zealand.

The Duchess also attended inspections all over Britain in the 1920s, inspecting troops of Girl Guides and being presented with bouquets where Guides would form a Guard of Honour for her. The *Belfast Newsletter* of 16 July 1924 even commented that the Duchess's demure, quiet style of dress was most likely down to her having been a Guider in her youth:

> Before her marriage, the Duchess of York was a Guider and took a real and active interest in the movement. She held the important office of District Commissioner for Glamis and was at one time captain of a company.
>
> On her marriage, the Guides of the district made her a handsome presentation …The Duchess's interest and work in the Guide movement probably accounts for the fact that her tastes in dress are quiet. She always turns to quiet models and never wears anything extreme or outre.

Perhaps it was the Duchess's experience as a Guider in the wilds of Scotland that led her to choose modest, unfussy styles of clothing. Perhaps that and running a castle in her teens when it was a military hospital made her opt for practical garments rather than elaborate ones. But outfits aside, the Duchess continued to attend numerous Girl Guide events and inspections throughout her time as wife of the Duke of York. Then, in 1926, a baby girl was born into the Royal household to the Duke and Duchess and named Elizabeth. A year after her birth, in 1927, the Duke and Duchess visited Ballarat in Australia and, as fitting for a Royal who was once a Girl Guide herself, the local Girl Guides there welcomed them with a Guiding Arch of Victory. It was then that one of the younger girls, a Brownie, stepped forwards to the Duchess and held out a tiny doll dressed in a Guide's uniform. The Duchess thanked her and gracefully accepted it as the little girl said: 'For the baby Elizabeth,' before curtseying. It would be the start of something for the baby Elizabeth who would one day become Queen.

But that was all a long way off. Princess Mary continued to be the royal face of the Girl Guides and was tireless in promoting its virtues for girls and young women. At the annual meeting of the Girl Guides' Association in London in 1928, a letter was read out from Princess Mary in which she wrote:

> It gives great pleasure to hear of the growing numbers Guides throughout the Empire and the world. An increase in 1527 of over 30,000 in the British Isles and of over 40,000 in the Overseas Dominions and Colonies and in foreign countries, is a splendid record, showing how strongly the Guide ideals and training are appealing to the girls of our time. During the past year I have seen many Guides in various parts of the country and was impressed their general efficiency. I should like once again to emphasise the fact that for this high standard of Guiding great credit is due to the unfailing energy of the Commissioners and Guiders.

The wind would change, though. In 1936, public opinion of the royals would alter forever. Following the death of his father, George V, Edward VIII took the throne in January 1936. But he had a secret that would later become known the world over – a divorcee named Wallis Simpson.

It was said that he had planned to discuss his plans to marry Simpson with his father before he had died but hadn't raised the subject in time. Now he was king but torn between his duty to his country and the love he had for Wallis Simpson. Marrying her would be impossible. She was a divorcee who was in the process of divorcing her second husband. The Church of England did not allow divorced people to marry if their ex-husband or wife were still alive. And so, Edward VIII had a choice: keep the throne and lose the woman he loved; or marry Mrs Simpson once her second divorce was finalised, and abdicate. Less than a year after Edward had taken to the throne, his choice was made. In December 1936, he announced his abdication, saying:

> 'A few hours ago, I discharged my last duty as King and Emperor, and now that I have been succeeded by my brother, the Duke of York, my first words must be to declare my allegiance to him. This I do with all my heart. But you must believe me when I tell you that I have found it impossible to carry the heavy burden of responsibility and to discharge my duties as King as I would wish to do without the help and support of the woman I love.'

The nation was stunned. Edward VIII had not even ruled one year.

But this constitutional crisis led to many other people's lives being changed forever, especially that of Edward VIII's brother, the Duke of York, now next in line to the throne. Edward's brother Albert – or Bertie, named after his great-grandfather Prince Albert – would be known as George in honour of his father George V and to give the British people a sense of continuity. But George was not a natural king. Suffering from a stammer, he had lived in his elder brother's shadow, never expecting to take the throne. But many were relieved that George was now king – he was living the right way, for starters – married and with two daughters. A more wholesome family image was what Britain needed now. But life would also change for those around him, especially his eldest daughter, Elizabeth. Overnight, her life's path had altered. She was now no longer the daughter of a duke and duchess but the daughter of a king and queen; a princess.

It was, by all accounts, Princess Elizabeth's governess who suggested that both Princess Elizabeth and Princess Margaret be treated as

normally as possible in their childhood. Princess Elizabeth had gone from the relatively unknown daughter of a duke and duchess to the Heir Apparent. For a girl at age just 11, that must have been an overwhelming piece of news to digest. Perhaps Guiding was the answer to providing some normality for the Princess? And so, that year, Princess Elizabeth and her sister Princess Margaret, aged six, joined the Guiding movement. Elizabeth was enrolled as a Guide and Margaret as a Brownie. But of course, she wouldn't simply join a local group. A troop had to be created. That year, the 1st Buckingham Palace Guide Company was born. It would need a very special leader. Someone with vast experience of Guiding, the ability to teach a monarch in the making to camp and cook outdoors, as well as signalling and knot-tying. One woman's name was put forward; Violet Montresor Synge. Many Guide leaders might have baulked at the idea of setting up a new company from scratch but the idea of setting up a new company from scratch at Buckingham Palace was something else. But Violet Synge was, by all accounts, the best woman for the job. She had driven ambulances during the First World War and, it was said, believed the Guides should be for girls from poorer members of society – not little princesses. But she took the job and the 1st Buckingham Palace troop began.

The press revelled in the story that the country's future monarch would not be wearing dainty dresses and furs but would be joining a movement that encouraged girls to go camping, get dirty, light fires, tie knots and learn signalling. The *Sunday Mirror* of 27 June 1937 carried the story:

> Princess Elizabeth and Princess Margaret Rose are to join the Girl Guide movement – Princess Elizabeth as a Guide and her sister as a Brownie. They will be members of a new company to be formed in the Westminster from among their friends and the daughters of regular visitors to Buckingham Palace. 'They will join just as ordinary children,' the Hon. Mrs C. Tufton, Secretary of the Association, said yesterday.

The task for Violet Synge was no easy one. She was no stranger to setting up Guiding packs, but this was arguably the most unusual pack anyone would ever have to start. Although Princess Elizabeth and Princess Margaret seemed naturally outdoorsy and more than ready to get mucky

and dirty outdoors, the other little girls who joined their troop arrived in neatly pressed party frocks with their hair curled and wearing white gloves. In her book *Royal Guides: The Story of the 1st Buckingham Palace Company*, published in 1948, Violet Synge recalls:

> From the outset I was faced with a problem never met in my previous fifteen years of Guiding; namely, to incite those children to let themselves go, to run, to climb and do all those things that the eleven-to-fourteen-year-old is usually all too willing to do.

With patience, though, the other little palace girls loosened up and, once in uniform, were more freely able to run amok in the grounds of the palace. The group decided to split into patrols – Robins and Kingfishers. Princess Elizabeth became leader of the Kingfishers. Young Princess Margaret asked to also join but at age only six she was five years too young to be a Guide. So, a Brownie attachment was created for Princess Margaret and another little girl of the same age and they became Leprechauns. But, just as promised, Violet Synge ensured she did not treat the royal Guides any differently than she would any other little girls. When badge test days arrived, Synge invited specialists in that area of expertise down to test the girls so there would be no question of the princesses getting special treatment to achieve their badges. There were no special 'soft' games either. The princesses and their friends played cricket and did drill outdoors as well as Scottish dancing lessons. They even played in the dark, going on torch-lit treasure hunts at night around the palace grounds as well as make-believe games of cowboys, nurses, and even detectives 'helping' Scotland Yard. Lord Baden-Powell was unable to ever visit the 1st Buckingham Palace troop but he did write them a letter, quoted in her book by Violet Synge:

> I am so glad to hear that you are enjoying Guiding and that your company has already made itself so smart. Wishing you 'good camping', I am yours v. sincerely, Baden Powell.

His wife also wrote to the young future queen, saying, 'I am so awfully glad that you are all so really keen about Guiding.'

And keen they were. On 'indoor days' when the weather was inclement, the Royal Guides would meet indoors in the palace, running amok and dancing past priceless art works and pieces of fine china as the queen would simply laugh and wave them along. Whilst all this went on in the safety of the palace grounds, the press of the day seemed to follow the princess's enrolment into the Guiding Movement as closely as they'd followed her father's route to coronation. Most newspapers covered the occasion, including this piece in the *Dundee Courier*:

> Princess Elizabeth and Princess Margaret, who became members of the Girl Guide movement at the end of last year, held the first meeting this year of the Buckingham Palace Troop of Girl Guides at the Palace yesterday. Princess Elizabeth is a Girl Guide and her sister a Brownie. Their little friends, who are fellow members of the Kingfisher Patrol and the Leprechaun Brownies, came to the Palace during the afternoon, and with the two Princesses planned their future activities for the year and carried out work connected with the troop.

The troop continued meeting in the garden summerhouses and the young princesses soon began learning the art of pitching a tent, cooking al fresco on campfires, first aid, knot-tying and signalling. Photographs from the time show a young Princess Elizabeth practising bandage-tying on her younger sister Margaret. The world's press was fascinated with the young future queen's induction to the Girl Guides and she was photographed and filmed during her time as a Guide. She was first filmed with Princess Margaret at Windsor Castle when the Guides paraded through the quadrangle. Footage shows Princess Elizabeth in her uniform – with her red and blue shoulder ribbons signifying she was part of the Kingfisher Company – along with her hat and tie. She became entangled with something on her back at some point and Princess Margaret – dressed in her Brownie uniform – stepped behind to help her which made the new king and Mary, the Queen Mother, giggle. Princess Margaret was filmed fidgeting and moving around but, as the Movietone voiceover rightly said: 'That's what you'd expect of a Brownie of the Leprechaun Six of the 1st Buckingham Palace Pack.' The piece of film is fascinating because it shows a future queen and her sister, not standing

still in stuffy dresses, but rearranging their uniforms, fidgeting and behaving as any other children of their age might. Clearly, being part of a Guiding and Brownie pack, being outdoors in all weathers and mixing with other children was indeed giving them the 'normal upbringing' their governess had wanted. In fact, Princess Elizabeth was even allowed to join camps and the king and queen gave her permission to join an open air Guides' summer camp which would be held at Windsor Great Park in the summer of 1938.

> The Princess will take her full share of duties with the other Guides, living under canvas and helping to prepare the meals. She will mate her third official public appearance with the Buckingham Palace troop of Guides when she leads them past her parents the service which 1000 Guides will attend at St George's Chapel on June 19. The Princess Royal, who is Commandant-in-Chief of the Guide movement, has been coaching her niece in the responsible duties which she will have to undertake that occasion.

As the months passed, it appeared the Princess Royal was coaching Princess Elizabeth well. The princess and her sister attended weekly drills with the other 1st Buckingham Palace Troop of Guides and, apparently, were so keen they even practiced their own drills while at Sandringham with the king and queen.

> Nearly every day the two Princesses 'parade', sometimes in their uniforms, and practise marching and turns on the level concrete outside the back of the big house near the Royal garages, which they have turned for the time being into their 'barrack-ground'.

Princess Elizabeth also seriously studied her Guide rules, by all accounts, and was always preparing to take her proficiency badges at the next meeting with her fellow Guides who were daughters of high officials at the palace. They met every Wednesday afternoon at Buckingham Palace and paraded on the main lawn in the gardens. On bad weather days, the troop would meet in a room on the second floor of the palace which had been used for schooling of the king and his

brothers and sister. Guiding had become a regular part of palace life, with girls in uniform meeting every Wednesday, running about in the grounds or meeting indoors when it rained. At Christmas, the queen gave the 1st Buckingham Palace pack two flags – a Union Jack and a troop flag. But despite the Princess's status as Heir Apparent, she was not treated any differently from the other Guides in her troop.

> It is a hard-and-fast rule of the Guides that the two Princesses shall receive no preferential treatment because of their rank.

And this rubbed off on the young Princess Elizabeth who, by all accounts, really was like any other young Guide. Troop members reported that she was humble, never arrogant, and completely unselfish. She was also full of energy and enjoyed hiking. The troop asked the Boy Scouts to make them a trekking cart so the young Brownies could also go with them on hikes and be dragged when they got tired. They also enjoyed cooking outdoors over a campfire, spearing raw sausages and holding them over the flame and even making al fresco chocolate spread, as told by Violet Synge in her book.

Camping, too, became a favourite of the Princess and in 1939, the 1st Buckingham Palace Troop camped in Great Windsor Park. The king was so pleased his daughters were enjoying Guiding so much that he had a new summer house built in the grounds of Buckingham Palace for the Guides to meet in. Described as 'imposing' for an outdoor house, it had heating, electricity, wide windows that 'let down completely', it was built a little further away from the original summer house (which had been demolished) and out of view of the Palace. The old summer house had been used by George V who would sit there in the afternoon and read and sign state papers.

> Following the custom of his father, the King will use the new building for work in the afternoons and it is probable that the family tea parties at which the princesses meet their mother and father to talk over the events of the day may take place in it when the weather is fine.

A central room in the summer house would be used for the weekly meetings of the Guides – although, perhaps not when George VI would

be signing important state papers. Guiding also was seemingly teaching the princesses about housework and cleaning. When at Windsor, in her Little Welsh Cottage, which had been given to Princess Elizabeth by the people of Wales, Princess Elizabeth and Princess Margaret were allowed to play there – but only if they did the housework. Princess Margaret polished furniture and did the washing while Princess Elizabeth did the ironing. Apparently, this was at the orders of their mother, but one can't help but think that the princesses' teachings from their Guide Troop also played a part in encouraging their sense of duty to keeping things orderly, neat and tidy. Princess Elizabeth would also go down to the Buckingham Palace kitchens once a week to learn how to cook. Life carried on in a happy idyllic, Guiding bubble for the young Princesses. Violet Synge also reported that once Princess Elizabeth had to go for a dress fitting and was put out about it, but that she remembered she was a Guide and it cheered her up. But idylls never last. And in September 1939, Adolf Hitler invaded Poland and life would never be the same again.

When war was declared two days after Hitler's Polish invasion, life suddenly changed for the people of Britain. At first, the Buckingham Palace Guiding meetings continued. Princess Elizabeth was even featured in a full-page photograph in *The Tatler* in her Guide uniform. 'A portrait of Princess Elizabeth as a Girl Guide,' wrote the periodical, 'there is no question that that sort of training for our boys and girls that is needed in these strenuous times and will bear fruit in due season.' For the public, seeing their teenage future queen in uniform as the country went to war gave a much-needed boost to morale. Many might have remembered the work the Girl Guides did and services given during the Great War and now that the future queen was a member of the movement, the movement gained an even greater respect. Indeed, that same year the Guides were asked to always appear in uniform now that the nation was at war and the princesses followed suit. One *Birmingham Mail* noted that the princesses had been seen in Scotland in their Guide uniform, marking that they usually wore tartan kilts and simple jumpers or blouses.

> In this country, the Guides are doing much valuable national service when their school duties are over, or when they have finished work for the day, and it was on this account that they were asked to appear always in uniform.

In fact, Princess Elizabeth telephoned the queen to ask if there was anything they could do whilst staying in Scotland to aid the war effort. The queen, apparently, replied that she would look into it but added that they should do a 'good deed every day' as was the motto of the Girl Guides.

All over the country, Guides were in uniform and offering help. As the first wave of child evacuations began from city to countryside, Guides stepped in to help carry luggage and help show evacuees to their new homes, helping the billeting officers. The most famous Girl Guide of all, Princess Elizabeth, would later address the nation and the Commonwealth children on the radio programme *Children's Hour* on 13 October 1940. It was her first ever public speech. Many of these children listening had been evacuated to other homes due to war.

> Thousands of you in this country have had to leave your homes and be separated from your fathers and mothers. My sister Margaret Rose and I feel so much for you as we know from experience what it means to be away from those we love most of all.
>
> To you, living in new surroundings, we send a message of true sympathy and at the same time we would like to thank the kind people who have welcomed you to their homes in the country...
>
> Before I finish I can truthfully say to you all that we children at home are full of cheerfulness and courage. We are trying to do all we can to help our gallant sailors, soldiers and airmen, and we are trying, too, to bear our own share of the danger and sadness of war.
>
> We know, everyone of us, that in the end all will be well; for God will care for us and give us victory and peace. And when peace comes, remember it will be for us, the children of today, to make the world of tomorrow a better and happier place.
>
> My sister is by my side and we are both going to say goodnight to you.

But before that peace would come, even the young Princess Elizabeth would be evacuated. The Guides could no longer risk living at

Buckingham Palace in London, let alone continue their Guide meetings there. The princesses were evacuated to Windsor Castle in 1942 after a bomb threat to London. But Guiding would not stop simply because of war. Violet Synge, head of the 1st Buckingham Palace Troop was busy working in the capital with the Mechanised Transport Corps but she still left London once a week to visit Windsor and her Girl Guides. In her book, Synge recalled:

> No one who did not experience the horror of those days
> in London and the loneliness of a city where one never
> saw a child and from which even dogs had been evacuated,
> can imagine what it was like to escape into the country for
> two short hours a week and have the joy of working with
> children once again.

By now Princess Elizabeth was 16 and Margaret was 11 which meant she could now leave Brownies and join the Guides. For a while, the Guides settled in to their new surroundings and – despite the war – engaged in fun games and activities once again. A few months later, Princess Elizabeth went up to Sea Rangers. But although the girls were safer in the countryside than in London, they were not completely out of danger. Although Windsor Castle was never bombed, enemy aircraft regularly flew in flight paths overhead and the Guides had to occasionally dive for cover while out playing or on patrol. A more war-like feel came to the 1st Buckingham Palace troop and Grenadier Guards were even enlisted for physical training sessions. Violet Synge recalled with relish in her book that the Guides had to 'crawl under tarpaulins and then jump onto a "horse", and from there swing on a rope attached to a tree across a chasm.' Other training exercises involved dodging trip wires to which 'mild explosives' were attached and climbing across seven-feet high tree trunks with no footholds.

By now Princess Elizabeth, enrolled as a Sea Ranger, also wanted to do her bit for the war effort and had joined the Auxiliary Territorial Service. Here she learnt to change a wheel, diagnose engine problems as well as stripping them down and rebuilding them and driving ambulances and other vehicles. Within just five months of joining, Princess Elizabeth achieved the rank of Junior Commander. Her time in Guides was at an end, a time of outdoor play, make-believe, camping, treasure hunts,

physical training and good, old-fashioned exercise. But it had been more than that. The future queen had learnt discipline, camaraderie, friendship, skills such as First Aid, and so much more. One cannot help but believe that it was her Guiding experience that stood her in such good stead to rise so quickly through the ranks of the ATS when her country needed her. It had changed her from more than a princess or figurehead. It had made her a true asset to the war effort at ground level – something truly inspirational for a future monarch.

Chapter Four

The Nation Calls

'You will be called upon, as time goes on, to make sacrifices, and I know that you will do so bravely and uncomplainingly in the true Guide spirit.'
Princess Royal, President of the Girl Guides,
October 1939

'It is no use fighting Hitlerism if we allow the new generation to grow up without religion, good principles or discipline. These ideals are the very foundation of our Guide movement...'
Princess Alice, Duchess of Gloucester,
October 1939

In 1939 when war was declared against Hitler there was none of the patriotic flag-waving that there had been in 1914 at the start of the Great War. Too many families had lost someone. Too many sons, daughters and wives had seen a loved one return shell-shocked, injured, in post-traumatic shock. Boys had seen their fathers return from the Front who could not even speak of the unimaginable horrors they had endured in the trenches. Jingoism now belonged to another time; young men and their mothers now knew how horrific war in Europe could be. But there was still that unstoppable British spirit for which the country was known. Britain may have gone to war with less of a patriotic, nationalist spirit than in the First World War but the general belief that Hitler must be stopped and freedom retained kept people together. While the 1930s had been a peaceful time of the Guides gaining momentum and popularity amongst young girls – and respect among their elders – now, as hostilities began again, Guides were often seen in uniform at all times. Girl Guides helped in all manner of ways as war broke out. They assisted in helping evacuees find their billets, carried letters to and fro, helped deliver parcels of food and were generally present on the British streets – in uniform – to lend a hand. Many older Guides and Guiders were called

up to join women's services such as the Auxiliary Territorial Service and the Wrens. As the Princess Royal herself said:

> No nation rises above the level of its womanhood, and it is to be the women and girls of Britain, so many of them Guides, that the country looks for calm, reliable service in this time of anxious strain. So many of our Guiders have been called to the women's services and I am proud to think that their Guide training has proved a ready passport into any field of work. To each of you, called to the service of your country, I send my good wishes.

The Princess Royal later explained that because so many Guiders and Rangers had been called to active service, many patrol leaders had the extra burden of running troops without them. She appealed to the general female public to come forward, to join the Guides and help the movement, particularly 'in the reception areas for evacuated children, from which already come countless letters asking for the immediate formation of companies.'

It wasn't just Girl Guides in Britain who were called upon to serve the war effort. Princess Alice, Duchess of Gloucester, who was now President of the Overseas Branch of the Girl Guides Association, also appealed to Guides to do what they could to help but not at the cost of abandoning their Guiding work:

> 'The chance to help in the fight for freedom and justice has come first to the Guides in Great Britain because they are the nearest to the scene of action and they have been splendidly helpful and reliable ... but don't desert your Guiding for war work unless your help is especially needed. Remember the young will need your care ever so much more now when possibly both their parents may be engaged in war work of some sort. It is no use fighting Hitlerism if we allow the new generation to grow up without religion, good principles, or discipline. These ideals are the very foundation of our Guide movement ...

Good principles shone through during the war, arguably, more so than at any other time. Guiding transcended borders – one example

was when the founder of Girl Guides in Poland, Olga Malkowska, went missing after Hitler had invaded her country. Guides in the UK immediately began writing letters to try and locate her, many believing she would stay with her troop no matter what. But more bad news came confirming that twelve Guides in Poland had been killed in a bomb attack. The Girl Guides Association tried their best to trace the missing pen pal of one of their number, offering to grant her asylum in Britain if she could be found.

This sense that Guiding was one nation, devoid of borders, nationality or creed – even during times of war – was one that resounded through the conflict. Guides were in constant communication with their peers around the world, checking they were safe, finding missing persons, offering help, sending parcels of food and letters of goodwill and support.

Of Olga Malkowska, news eventually came of what had happened. She was in charge of a school when war broke out. Fearing for their safety, she sent the children home but remained there with twelve Rangers and two orphaned children. On September 1, 1939, her school was bombed and she, her Rangers and the orphans escaped onto an evacuation train. But they had not reached safety. The train was bombed from the air as well as coming under machine-gun fire. The Rangers scattered from the train and lay flat before giving First Aid to casualties from the bombing. Malkowska recalled how she then managed to get her Rangers and orphans to the safety of an children's home where the adults in charge had disappeared – killed or taken prisoner, she didn't know. Her Rangers offered to take charge of taking care of them. But of the Guides left behind in Warsaw, Olga Malkowska had no idea what had happened to them.

> They fearlessly exposed themselves to danger in doing their duty. One patrol at the main railway station, who were giving out hot drinks to refugees, were killed outright together by a single bomb.

Olga Malkowska eventually arrived in Britain where she promised that, after resting and recovering from her ordeal, she would work with British Guides to help the war effort in the UK. She reported that camping skills she had learnt and taught in Poland had been incredibly useful

for refugees and that villagers had been camping with Guides in safer havens outside the cities.

At home in Britain, Guides were doing all manner of things to help the war effort. They knitted blankets, collected wastepaper and sold it to buy wool to knit clothing for troops, they donated parcels of food to people who were housebound, and aided children who had become evacuees. One troop in Woking staffed two empty houses to host 50 evacuated children but were surprised when instead of children, 90 mothers and babies arrived. As evening fell and the blackout came, the Guides had run out of clean terry nappies for the babies. The Guider ran out into the street and found a policeman. She asked him if he could procure her some nappies. An hour later he returned with hundreds and so the Guides equipped the mothers and babies with enough to last a couple more days. In Yorkshire, a company of Rangers spent two days doing the washing and ironing for 60 evacuees. All over the country, in fact, these small, intimate, everyday acts of help and kindness were being done by Guides, Brownies and Rangers. On their own, they might not have changed the outcome of war, but collectively they helped morale, kept people warm, dry, safe and clothed. Their acts of kindness changed many lives.

Since the start of the war, America had announced its neutrality. Still reeling from its losses in the First World War, the United States had even run a poll at the start of the Second World War as to whether the nation felt they should go to war backing the British. In a Gallup Poll in May 1940, 93 per cent of people polled said they did not believe the US army and navy should be sent to Europe to fight.

And President Roosevelt listened. America would remain neutral – unless directly attacked. Just before 8 o'clock on Sunday, 7 December 1941, people in Pearl Harbor, Honolulu, Hawaii, heard a low drone. That drone grew louder. People looked up and were met with the most horrifying of scenes; over 350 Japanese fighter planes and dive bombers were darkening the skyline. The eight US Navy battleships in the harbour were all damaged, and four were sunk. Along with that, 188 US aircraft were obliterated. The human cost was far higher with 2403 people killed and over 1,100 wounded. The attack was not only devastating, it seemingly came from nowhere. No formal proclamation of war had been made on the United States. There had been no warning. Newspapers' front pages in the United States and around the world

reported the atrocity, such as this piece from the *Boston Daily Globe* of the following day:

> Japan assaulted every main United States and British possession in the central and western Pacific and invaded Thailand today (Monday) in a hasty but evidently shrewdly-planned prosecution of a war she began Sunday without warning. This formal declaration of war against both the United States and Britain came two hours and 55 minutes after Japanese planes spread death and terrific destruction in Honolulu and Pearl Harbor at 7.35 am Hawaiian time.

As newspapers around the world ran with the headline that Japan had declared war, President Roosevelt addressed the US Senate and the House of Representatives, saying:

> Yesterday, December 7th, 1941 – a date that will live in infamy – the United States of America was suddenly and deliberately attacked by naval and air forces of the Empire of Japan…It will be recorded that the distance of Hawaii from Japan makes it obvious that the attack was planned many days or even weeks ago … I regret to tell you that very many American lives have been lost. In addition, American ships have been reported torpedoed on the high seas between San Francisco and Honolulu…As Commander in Chief of the Army and Navy, I have directed that all measures be taken for our defense. But always will our whole nation remember the character of the onslaught against us.
>
> No matter how long it may take us to overcome this premeditated invasion, the American people in their righteous might will win through to absolute victory.
>
> I believe that I interpret the will of the Congress and of the people when I assert that we will not only defend ourselves to the uttermost, but will make it very certain that this form of treachery shall never again endanger us.
>
> Hostilities exist. There is no blinking at the fact that our people, our territory, and our interests are in grave danger.

With confidence in our armed forces, with the unbounding determination of our people, we will gain the inevitable triumph – so help us God.

I ask that the Congress declare that since the unprovoked and dastardly attack by Japan on Sunday, December 7th, 1941, a state of war has existed between the United States and the Japanese empire.

For the American people, this terrible attack had come from nowhere. Newspapers had, until this day, been reporting ongoing diplomatic talks between the United States and Japan. There had been no hint of an attack. Yet, just twenty-two years after the First World War, from which America was still reeling, they had been attacked in the most horrific of ways. Not only was it tragic that so many lives had been lost. It was an embarrassment. A great and mighty empire with great and mighty battleships had been attacked in full view of the world. Its ships had been sunk on its own territory. Overnight, a nation of Americans who had been so anti-war were fuelled by bitter anger and fury. This could never happen again. But the United States Army was not big enough to fight another world war. As a result, Congress passed an act that all able-bodied men aged 18 to 64 had to register with the draft board for military service. And, after Pearl Harbor, public opinion about the war in Europe changed dramatically. In another Gallup poll run in December 1941, they asked 'Should President Roosevelt have declared war on Germany as well as on Japan?' The answer was a resounding 91 per cent 'yes'. Suddenly the war 'over in Europe' was an American war too.

Once again, the nation was at war. Men were drafted to fight. Factories were enlisted to make ammunition. Steel and metal scrap was requested from anyone who could find any. Gardens that grew flowers would need to be turned over for vegetables to be grown. And, once again, America's Girl Scouts rose up to help out their countrymen and women in their time of need. Just as they had done during the First World War, Girl Scouts began digging Victory Gardens, cultivating their own produce, tinning and canning it and dishing out the proceeds to those in need. A huge government drive for the masses to collect and save scrap metal began. Girl Scoutstook part in the collection of scrap metal but also of scrap paper, rags and other material to help the war effort.

By 1942, there were around 600,000 Girl Scouts in America and they were – as in the last world war – as busy as the adults in helping win the war. Many newspapers were vocal in recalling that it was the present day Guides' mothers who were Guides in the First World War who had done the same thing – planting fruit and vegetables, tending Victory Gardens, collecting scrap. Now their daughters were leading the home front war effort just as they had done. The *Bronxville Review Press* spoke for everyone in February 1942:

> The work of the Girl Scouts in the years of 1917-1918 will be remembered by those of the generation of World War 1. Then, as now, the Girl Scouts entered into every form of Red Cross work for which they were eligible. They campaigned in the Liberty Loan Drive and helped in the Food Conservation Plan. Today, as twenty-five years ago, the Girl Scouts, true to their motto, stand prepared.

They were indeed prepared. In fact, following the attack on Pearl Harbor, the Girl Scout Council immediately sent a telegram to President Roosevelt offering support in civilian defence work. A national Girl Scout liaison representative was elected to work closely with the Office of Civilian Defence and other government agencies. First Aid courses were rolled out nationally, with Girl Scouts giving advice and demonstrations, as well as cooking classes including 'one-pot meal cooking' should families be forced to evacuate and leave their belongings behind. Older Girl Scouts, over the age of 16, were used as runners and messengers for the Defence Council.

At this stage in the war, sugar rationing had not come into force, so Girl Scouts were still able to do what they did best – and what they were best known for; baking cookies. But by the spring of 1942, sugar became the first food to be rationed in the United States. This meant Girl Scouts' cookies had to be scaled down. But Girl Scouts became central in helping sugar rationing as well, volunteering their services at County Sugar Rationing Boards. President Roosevelt himself said:

> We know that many Girl Scouts and former Girl Scouts are prepared through their scouting experience to render valuable service to their communities and to their fellow citizens. I know each will find her job and do it.

Another area Girl Scouts helped with was toy lending for children. They would collect unwanted toy donations, clean them and mend them and then hold lending days when local children could come and choose a toy to borrow for the duration of two weeks. Girl Scouts were also deployed to teach people how to light a fire, cook outdoors and to pack an emergency overnight bag in a limited amount of time. Even the Brownies, who were aged seven to eleven, were encouraged to be prepared in the home front war effort, learning what to do in case of injury, who to call for fire dousing during air raids, collecting paper, tinfoil, metal and other scrap items, even looking after people's pets. More senior girls were trained in hospital work, helping busy nurses by performing auxiliary tasks like feeding patients, collecting supplies, bed-making and cleaning. The Girl Scouts did not just collect scrap metal and grow vegetables, though. They collected over one million clothing items for refugees. They were also a key part of the government drive for the public to buy war bonds. Posters were put up around cities and towns of a pretty blonde Girl Scout smiling and holding war bonds, which said, 'Girl Scouts, today's minute maids, do their part … Do yours! Buy war bonds and stamps now!' In fact, as rationing of sugar, flour and butter set in, it became far more common to see Girl Scouts on street corners selling war bonds than it did to see them selling freshly-baked cookies.

Wrote the *Pampa Herald* in December 1942:

> Our children can as possibly be victims of war turmoil and instability as they can be and are – Boy Scouts and Girl Scouts – effective community workers in fighting the home front war. The desire to help is one of the most beautiful and most universal traits of young people and of children. When this can be turned to a purpose so vital to their community and at the same time so inspiring and so protecting to them, the Girl Scouts are seen to be essential for the war.

Talk of Girl Scouts not only being useful or helpful, but 'essential' marked an enormous shift in society's attitude towards them. In their beginnings, thirty years earlier, Girl Scouts had been ridiculed, asked what their purpose was and met, by some, with outright anger that a girl might deem herself able to behave 'like a boy'. Not anymore. Girl Scouts were collecting tons of scrap metal, which was then used to make

ammunitions and machinery for war, they had trained and helped train others in important First Aid, they had raised millions in the sales of Government War Bonds. Their very presence on American streets, in uniform, helped encourage a sense of patriotism and belief that this war was the 'right' fight, even if it was thousands of miles away in Europe. So, in reality, Girl Scouts really were essential to the war. This would have had an effect on girls in general who, up until now, had been largely trained to become future mothers and homemakers. Now, even non-Girl Scouts could see that women and girls did have a purpose and were useful, not only ornamental. Girl Scouts encouraged the belief that girls and women could make as much a contribution to society as their male counterparts. Girls were now active, not passive, taking part, not observing, fighting, not waiting to be saved. As Juliet Low had written herself in the early part of the twentieth century in what might, now, looking back, be seen as strangely prescient. 'Do your duty first, and then you will earn your rights afterwards.'

These girls and young women had been doing their duty long before the Second World War. Since their beginnings at the start of the twentieth century, through the First World War, through the Depression in the 1930s up until the Second World War, Girl Scouts had been quietly, sometimes thanklessly, doing their duty for years. But although the war brought emancipation and respect to members of the Girl Scout movement, it also brought disturbing and unpalatable events to the American home front. In February 1942, three months after the bombing of Pearl Harbor, President Roosevelt announced his Executive Order that people of Japanese descent would now be interred in camps for the duration of the war. This would include children. Although in some cases the parents might have been non-American citizens, two thirds of them were and most of the children were American citizens. However, this, his administration argued, would be with the aim of preventing espionage on the home front now that America was at war with Japan. Around 120,000 people of Japanese descent or ancestry were relocated from their homes to internment camps. The camps were dour places with high walls and fences, armed guards and often poor hygiene. The camps were akin to Army barracks but were often well below the standard of living provided to those in Army camps. In summers they were sweltering, in winter they were freezing. There was no privacy – most sleeping areas were only given a partition of a thin piece of wood

or a curtain. All facilities including eating, sleeping and washing areas were communal. Outside, there were high barbed wire fences, armed guards and towers for surveillance like a prison. When the Girl Scouts heard of this, and that many of the children interred had been Girl Scouts in their normal lives, the Juliette Low Memorial Fund donated sums of money to the military zones to provide these girls with activities while interred. At the Crystal City Internment Camp, near Crystal City, Texas, a troop of Girl Scouts was formed. They even put on a performance of Hinamatsuri – Dolls' Festival – on Japanese Girls' Day. By 1943, there were around 750 Girl Scouts in internment camps in Wyoming and Arizona. These imprisoned groups provided a sense of normality for the children who no doubt had little understanding of what they had done to be incarcerated. Likewise, the Boy Scouts also organized troops and eventually formed groups in all ten of the incarceration camps. Each day, the Boy Scouts and Girl Scouts would raise the American flag in the internment camps to show allegiance to their country – despite being incarcerated by the country they loved.

Girl Scouting (and Boy Scouting), it seemed, transcended different attitudes and culture, xenophobia and mistrust in times of war. Many Girl Scouts who had created or joined troops inside the internment camps went on to continue scouting when they were later released when the war ended. Working towards badges, a sense of community and kindness would help give them some decent memories of a brutal time in their lives.

Outside the camps, meanwhile, the free Girl Scouts, although doing all they could for the war effort, often had to stop doing the more fun things they had always enjoyed. Not only did the baking of cookies have to stop due to rationing and a shortage of supplies of sugar and flour, but for the nautical branch of the Girl Scouts, the Mariners, there were big changes too. After the bombing of Pearl Harbor, the sea became a dangerous territory – even around America's previously 'safe' coasts. The Mariner Girl Scouts were told to stay out of open water and stop sailing. This group had over 5,000 members and instead were utilised elsewhere, learning to operate switchboards, learn First Aid and then teach it, serve food in canteens and other tasks. In 1944, three Girl Scouts posed for a photograph with President Roosevelt. He handed them a 'check' with an invoice attached. That invoice was for 15,430,000 hours of Girl Scouts' service since the Pearl Harbor attack. The three Girl Scouts pictured were

there to represent the 850,000 members of the organization. For the most powerful man in the world to pose handing a cheque to three Girl Scouts was a moment of prodigious importance. He was recognizing – in a single still image – the work that young women and girls had done to keep their country fed, safe and buoyant during its most difficult era of history.

In Britain, the Second World War became a time of great upheaval for children. In the first three days of the first wave of British evacuation, 1.5 million people were moved. Of that, 827,000 were children. These children were allowed to take a small case, the clothes they stood up in, a name tag and their gas mask. They had no idea where they would be taken, and their parents had no idea when they might see them again. Here, Margaret Phillipson (from the 1st Kendall Guides) recalls her experience of Guiding during the Second World War:

'It was a very emotional experience for us and much more so for the evacuees'

> I was a 1st Kendal Guide from 1937 and we met at the YWCA hall every Wednesday evening. Guide meetings were fairly formal, with drills and inspections: dress, nails. We did badge work, Morse code, semaphore, knots; with team games along the way.
>
> On fine days there would be wool trails, tracking and stalking, flower gathering and nature recognition expeditions. Winter time was cosy around the open fire with tea and a snack. Camping was an important part of 1st Kendal guiding. We travelled to camp on at least one occasion in a sheep lorry, together with our tents, utensils and personal belongings.
>
> Another time we travelled on an open lorry; piled high with goods and Guides. We had wooden tent pegs and mallets – and no adult help. We had to dig a trench for the latrines which were then surrounded by hessian cubicles with a red flag to indicate if the cubicle was occupied. Each Guide in those early days slept on a groundsheet and a palliasse. The palliasse was a sheet or mattress cover folded in half and stitched down two sides. It was then filled with straw from the farm barn; great fun, but one of many lengthy tasks when making camp. The palliasse was not comfortable as it proved to be very prickly.

At 15 I transferred to Rangers. We became very involved when the evacuees from the 'doodlebugs' arrived in Kendal. My recollection is that it was quite late in the day when they arrived by train and we helped to distribute drinks and snacks and then bedded them down for the night. It was a very emotional experience for us and much more so for the evacuees.

In 1943 I became acting Captain and in 1946 I became Tawny Owl. This continued until 1948 when I married. (Taken from *Once a Guide, Always a Guide, A Book of Memories From When We Were Guides,* Trefoil Guild Members, Cumbria South)

Jean Jennings was eleven when the Second World War broke out and was already a Girl Guide. Here she tells her story of being evacuated:

'I was told to pack to be evacuated – so I packed my Guide uniform'

'I was 11 when war broke out in 1939. I wasn't taken in the first evacuation but in May 1940, they decided that they would do a second evacuation. I grabbed my Guide Uniform and put it in my suitcase. I don't know why.

I was evacuated with the school and we went to the train station. We had no idea where we were going.

We travelled from Croydon, in the outskirts of London and hours later arrived at Exeter St Davids in Devon.

The WRVS came along and handed out cartons of orange juice and then we ended up at Barnstaple in North Devon. We were taken to a school and we sat in a classroom. People came in and pointed at children, saying: 'I'll have that one, or that one!'

I didn't get chosen.

Finally I got taken to a public park by the river where the parkkeeper lived with his daughter. It was a two-bedroom little cottage with no bathroom and a kitchen with a range. I had to share a bed with the daughter who was about my age.

I was there nearly two years.

My father was in the RAF and my mother sent me parcels and letters every week. But I missed the Guides.

Before I was evacuated, I was a Guide and was patrol leader of the Robins. When I got to Barnstaple, I found there was a Guide troop there.

It would become my lifeline.

I unpacked my Guide uniform and joined the troop straight away. We went out into the country and went camping. I went to guide camp a lot and we met in the local school. But it wasn't just evacuees it was a troop.

Guides gave me a sense of normality because it was very lonely. I went to the grammar school and the daughter went to the local secondary school and we didn't really get on! And it was so lonely. Guides gave me a lifeline, because it was company, you got to know someone else. Especially as the house where I was stationed was so small there was nowhere to sit in the evenings in the parlour! I felt I didn't really belong but Guiding gave me a place to go.

We'd meet in the school hall which was lovely. It was war time of course so they'd dug up the garden at school and they'd got cabbages. We'd go into school with buckets of salt water and picking up the caterpillars from them!

It was companionship but we also learnt lots of things, like how to lay a table, and there was country craft where you had to recognise things like birds and insects.

I barely knew the war was on. The park keeper family had a little radio but you didn't get the news like now. You heard little bits about the bombing in London but you didn't know the full picture.

I didn't see my mother for two years. It was difficult when I got back home and with schooling as I'd missed whole chunks of my education. And I did my exams when the flying bombs, the doodlebugs, were going overhead. We took the exams in an air raid shelter!

I went back to Guides in my home town. Guiding taught you leadership and responsibility and it was also based on religion. Not being overzealous but you made your promise to God and the King.

It was hard to settle back into normal life. I think it changed me. I can't remember too much before the war.

It certainly made you grow up. I came home on the train on my own. I remember going through London and seeing all the devastation.

As you went through London there were all these derelict houses and it was like a bombsite. It is a different world. And it's a completely different world now and it's not a world I belong to in many ways.

It's good to remember how Guiding was as, in time, these things disappear...

The war was a difficult time for children, in many cases being evacuated and taken to strange new places. But for Mary Care, from Croydon, who is disabled, her war time experience was made even harder. Here she explains:

'Bombs went off around me...it was a difficult time'

Just before the end of the Second Word War, I was 14. It was 1944 and I was living in Croydon. I'm a disabled person and my mother used to take me in my chair for a ride round the parks in my wheelchair. We met a lady with her son who was in his wheelchair and the two mothers talked about disability. This lady told my mother about the Guide movement and my mother thought it was a good idea for me to belong.

So, my father agreed with Mummy's decision and I was enrolled as a guide in 1944. Everybody was very friendly and very helpful and I became a Ranger and then I became a Guider. So I stuck with it.

Croydon and London were not very safe places to be really during the war. We had a shelter in the garden and we had an indoor shelter too. It was frightening but my mother managed to keep things even and we got through it.

Guides helped take my mind off the war- it was a distraction.

We were prepared for things during the war such as First Aid, we had to be first aiders. Learn bandaging and all sorts of things.

Bombs went off around me. It was a difficult time.

I used to help my mother with cooking food and she would tell me all sorts of things that would go together.

I was a post Guide – that meant that we had letters by post. My Guide captain used to make a guide newsletter like a magazine with letters in it and drawings and all sorts.

I was invited to go to Coomb Farm which was a residential centre for young people and the scouts used to have a meeting and I went to help with the Rangers. When I was at Coomb Farm we went camping to Wood Larks, and this was a campsite for disabled people. And I went camping for 24 years there.

My first experience – I learnt to meet all kinds of people. When I went camping, it gave my parents time for themselves. And when I went camping, they would go and visit family members and have freedom for themselves. And take my brother with them.

We did outside cooking and I suppose I did enjoy it.

I stayed involved all my life. From 1944, right until today.

I represented England at the 13th royal conference of the Girl Guides and Girl Scouts in Oxford.

I was presented to the queen on the occasion of the NHS's 50th birthday. It was at Buckingham palace in the gardens. Her Majesty gave me an hour of her time. And my brother said to me no one will believe you!

Guiding has taught me to be adaptable. It's taught me to meet other people who are probably not quite like me. It's given me a tolerance.

It's changed a lot. Baden -Powell made it possible for young people to go camping and to have all sorts of adventures.

I even met Lady Baden-Powell at Hampton Court Palace. She was quite friendly and then she said quietly: 'The Guide movement will be quite safe in your hands.'

So that was a challenge to me personally.

I'm still a member of the movement. I want to be until I can't be any longer.

Chapter Five

The Making of Women

'War has always meant for women hardship and sorrow, and modern war brings to every one of us some measure of suffering or worry, but we bear these with fortitude because we can look forward with confidence to the triumph of our cause, and in that day when victory is ours and we have won, through to an enduring peace, it will be our common aim to work together for the happiness and well-being of mankind.'

Mrs Neville Chamberlain,
31 December 1939

The street was busy with skipping children, boys throwing marbles and younger ones playing hopscotch through puddles. One little girl ran to her friend and leaned in. The other girl cupped her hand over her ear as the first girl began whispering. The girl listened, nodded at the whispered message and ran off. A few metres away down the street, she met another girl. She leaned in and cupped her hand over the other girl's ear. This girl listened hard, nodded, then ran off. And so, she went to another girl and another, and so on and so on. To the untrained eye these young girls looked like ordinary little girls playing a game of Chinese Whispers in the street. But they were not. They were British Girl Guides in civilian dress learning a very serious art indeed. The art of wartime espionage.

As the war progressed and Hitler's forces invaded and took the Channel Islands in June 1940, the people of Britain began to feel nervous. At first, national pride, as well as a sense that war was happening far away in Europe had kept people's spirits up. Not anymore. Now, the enemy was no longer 'over there' on the continent. It was on our own our own British Channel Islands. . At any time, it seemed, Germany could invade England's south coast and war could come to Britain. And so, the Government began to plan for the worst – an invasion. And with it, they needed people on the ground ready-trained in message-carrying to form a resistance to this potential enemy invader. Government departments

began contacting youth groups – after all, the young were less likely to be suspected of espionage or resistance by the enemy. But it was a delicate balancing act; they needed young people who would appear beneath suspicion of enemy forces but were old and mature enough to able to remember a message, keep it secret and convey it exactly as it was told to the recipient. They needed young people with a sense of responsibility. And so, the government departments contacted the Girl Guides and Boy Scouts. In the first instance, Girl Guides helped government agencies with helping at First Aid posts and at Rest Centres and helping evacuees to their billets. But by December 1940, a year into the war, Girl Guides were given the great honour of wearing the Civil Defence Armband on their uniforms – a yellow rainbow badge with the crown above it. This year, 1940, also saw the most devastating attack on Britain – what would become known as The Blitz. From 7 September 1940, London was the target of a non-stop, systematic bombing campaign. It endured for 56 days and nights, causing immense destruction. The Blitz saw more than a million houses damaged or destroyed entirely. And of the 40,000 people killed by the Luftwaffe campaign, half of them were in London. Girl Guides were utilised in the capital helping people to shelters during air raids, helping the Home Guard by being fire watchers or helping other voluntary services. Advertisements began appearing in local newspapers for those who wanted to learn how to build emergency 'Blitz fireplaces' out of rubble from bombed houses or bricks found after a bombing raid. Blitz cooking classes were also given by Girl Guides who, surely, knew better than anyone how to build a fire and cook al fresco. The *Worthing Herald* reported:

> A practical demonstration of Blitz cooking given by the members of Worthing Division of Girl Guides at the request of Worthing branch of the Women's Voluntary Service was held in the Corporation car park on Wednesday. Miss I Fazan, WVS Regional Organiser, District Commissioner for Guides for Bexhill and former Sussex County Camp Adviser, lectured on the various ways and means of cooking out of doors and spoke briefly on its advantages. Introducing the speaker, Mrs F.C. Stern, chairman of the WVS, said: 'We should all know if our homes are blitzed how to manage somehow to cook in the open air.'

At the end of the lecture the Guides, superintended by Dr Marjorie Davis, District Commissioner for Guides in East Worthing, served a lunch of roast beef, steamed potatoes, cabbage and steamed pudding to about 501 guests.

Although the Girl Guides were courting favour with the public for their help on the ground during the war, 1941 brought a piece of news that would make headlines – even during times of war. In January 1941, news reached Britain that Lord Baden-Powell was dead. He had died in Kenya, aged 83.

The world's press announced his passing, in many cases with a heavy political slant during this time of war, as here in the *Western Mail*:

Lord Baden-Powell, whose death has occurred in far away Kenya, will be remembered as the creator the Boy Scout movement long after his fame the heroic defender of Mafeking has begun to fade in the memory his fellow countrymen. When he founded the movement in 1908, he could hardly have dreamed that it would spread throughout the world far beyond the confines the British Empire. His vision proved to be nothing less than an inspiration of genius. He succeeded in capturing the imagination of youth, their love of adventure and heroism, their adolescent idealism, and provided a means by which their latent capacity for the virtues of esprit de corps, personal fitness, discipline, loyalty, and the service of others found an outlet. Every boy has glimpses of life set in a halo of romance, and ardently desires in such moods to hitch his wagon to a star. But no one before Baden-Powell had seized the vast opportunities presented by this fundamental psychology or succeeded as he did in pointing the way to the star. He thus became the leader of hundreds of thousands who joined the Scout movement and have since testified to its wholesome and beneficent influence on their lives. The movement has developed into great moral asset of the nation. Powers and capacities which were being frittered away for lack of sound direction were given a focus. Youth gained access to a new field in which it soon learnt to excel. The Chief Scout

has since had many imitators, but none has excelled his achievement or remained so true first ideals. In Germany and Italy, the youth movements have been utterly perverted by the dictators. They are promoted for political or military ends to which the moral factors are wholly subordinated. And because the corruption of the best is always worse than any other corruption Nazi and Fascist youth are now amongst the strongest supporters of tyranny and national fanaticism. Baden-Powell always preferred that the Boy Scout movement should stand free of such malign influences. His aim was to make good, healthy, and patriotic citizens, not an army of servile robots, and to-day on his passing the judgment of his grateful fellow' countrymen is unanimous; he built better than he knew.

Although most reports of the loss of the Chief Scout pertained to how it might affect boys, the British government would realise that the Girl Guides were more than just helpers during air raids or wonderful at demonstrating how to cook. As the threat of invasion neared, Girl Guides' morale and responsibility could be useful – as messengers. At first, the patrols taught their girls through play; one girl was told a message, she was asked to run to another girl and whisper it to her, that girl to another girl, and so on until the final girl had to relay the message to the troop captain. Sometimes it worked perfectly, and a word-for-word message reached its destination perfectly. Other times, as in many games of Chinese Whispers, the content became distorted or was changed so much in transit it was no longer the same message.

Margaret Stanswood, a member of Ulverston Trefoil Guild, did war work as a Guide in the Second World War and remembers training for resistance message relaying, as this quotation from *Once a Guide, Always a Guide* reminds us:

> In the early days of the war, it was expected by the Government that young people such as Scouts and Guides would play an important back-up role should the Germans invade, and plans were made to use us as message carriers in wartime conditions. To this effect we spent many hours

learning the skills of message carrying. In the usual guiding manner, we learned by playing games. The game involved each patrol spacing itself at various intervals around the block of Hawcoat Lane, Wheatclose Road, Hill Road and Hartland Road so that at each 'station' there would be four or five girls. A message was given to the first girl who ran along the road and passed it on to No. 2 in her patrol who then ran on to the next girl until finally the message was conveyed to Captain by a breathless girl. Much was the hilarity at the outcome of these messages and heaven help Great Britain had it needed to rely on the memories of Girl Guides!

Like many other Guides of her age, Margaret remembered there was a distinct lack of pack leaders. All able-bodied young women had either been called up to serve on the home front in some way with the armed forces or were land girls working in the agricultural sector or making ammunitions in factories. This left many Guides without leaders or meant that some older girls stepped up to be leaders before their time. But even if packs did still manage to meet, just getting there could be a life-threatening, dangerous task in itself. As Margaret remembers:

Getting to and from Guides in the winter months was not easy as no street lighting was allowed and the full 'black-out' of all windows was compulsory. Only a torch with a tiny beam was permitted. The trees had bands of white painted round them which helped identify them and somehow we found our way home in the dark. I never remember being afraid and parents saw no need to accompany their daughters to and from Guides as the greatest danger they would encounter was tripping up on the pavement or finding the right gate in the dark.

She also recalled friends' houses being bombed and the windows being replaced with tarpaulin because no one could get hold of glass. Guiding was suspended in towns where bombing had taken place and it would not be until 1943 that it would start again.

Girls had to grow up quickly – as did all wartime children. But arguably, the Guides and Girl Scouts had to grow up even faster, such was the expectation that they would help out and do their bit for the war effort, using their training in camping, cooking, helping their communities and being more responsible than the average child. But being a Guide did not give them exemption from many of the effects of war. Like many ordinary children, Girl Guides were also evacuated from cities and towns to the countryside. This meant that many Girl Guides had to leave their troops and their homes and go to stay in areas where they couldn't be part of a troop anymore. But in other cases, some Guides were determined to keep guiding even if they were miles away from home without even a troop to go to. For other girls, Guiding wasn't just a pastime or a chance to form friendships, or even something forced on them during the war due to a sense of duty. Instead, it brought a long-awaited opportunity to get out of the house. War brought an expectation that young people would volunteer to help the home front efforts. This chance led to a liberation many young women would not have had otherwise.

Here Alice Wood, a Sea Ranger during the war, explains how joining the movement gave her the freedom she craved as a young woman:

'Although the war was on, it was lovely. The happiest of times'

When I was 17, the war was on but that made no difference: I was never allowed to leave the house anyway. Two of my cousins had been in the Girl Guides but my father had never let me leave the house in case I got into bad company.

But then war began. People of certain ages had to register to help the war effort and a lady there said: 'What would you go into if you were called up?'

So, I said: 'The WRENS.'

She told me I could apply to be in the WRENS but when I got there I found out it was a branch of the Girl Guide movement – the Sea Rangers.

I joined the Sea Rangers there and then.

I was so thrilled because this was an excuse to get out!

We didn't have to go – but I told my father a fib that it was mandatory so he'd let me!

When I found out it was a branch of the Girl Guides I was thrilled because I had a lot of friends and family who'd been in the Girl Guides.

We were given a uniform – a navy blue skirt and a Girl Guide top and an ordinary hat. We went and helped in a seaman's hospital nearby every night giving out rice pudding and soup and then we'd do the washing up and help the nurses.

When the tide was low, we used to go down and send semaphore to one another.

By then, Hitler was on our doorstep in France and we had to go around with the Home Guard. We went around to their meeting place and us girls would help them. Sometimes we'd be asked to put secret messages up drainpipes as training in case we were invaded. Hitler didn't get here in the end, but this was preparing us just in case.

Rangers was wonderful. We learnt semaphore and it was just an honour to get down by the river. The officers training at the naval college let us borrow their boats so we could go down the River Thames on a Sunday.

It was wonderful. Happy days. Although the war was on it was lovely.

In 1945, at the end of the war, I got married. The Sea Rangers came and did a Guard of Honour with oars at our wedding – the same oars we used to row with down at Surrey docks.

After Sea Rangers I joined the Trefoil Guild and made so many friends.

Then I had my children and became Guide Captain of the local church. Often we'd go down to one of the Guiding movement's Meccas – Foxlease.

Every year we stayed there three nights in the house – the same house Princess Mary gave to the Girl Guides. It is a lovely old house. So much history.

One year, every night we were there Lady Baden-Powell's daughter and her husband used to come and talk to us in the lounge. She'd reminisce and tell us different things – once, something about a terrific size pair of

knickers Lady Baden-Powell used to wear! Her daughter was a lovely lady and her husband. We were very lucky.

I actually met Lady Baden-Powell. We were supposed to have our names on our uniforms.

She asked me my name. I looked down. My badge was missing. 'If you had your name on there, I wouldn't have had to ask you,' she said.

So I got told off by Lady Baden-Powell for not having my name on this particular day!

Looking back, I thought my father was horrible not letting me be a Guide but now I realise it was because he loved me so much.

Over my many years in the movement, I've learned so much. A couple of bricks and an oven shelf and you can cook many a meal.

I've also made so many friends through it and that's made my life.

When I had my own children, I wanted them to experience Guiding too. Both my daughters went to Brownies from a young age.

One of my biggest thrills in life was seeing a glow worm. We were at camp in Kent and I saw this light and I said: 'What's that?'

The guider had sent all the kids down to sleep for the night but I said: 'I'm sorry but I'm not going to let these girls get to their 50s without seeing one.'

So I got my torch and I went around each tent and turned the torch on them to say: 'Look what I've got on my finger!' Then I turned the torch off and it glowed. And it was an absolute thrill that was, seeing a glow worm!

It was one of the biggest thrills of my life.

I think the Guiding movement has given women more freedom but I think back in my days it was more sincere. Still, it gives girls and women such opportunities. I've had a wonderful life in Guiding.

But although many of these women's memories are happy ones, being a Guide or Girl Scout during war time was not easy. Here Margaret

Stanswood explains how camping was even harder during times of war and rationing:

'Guide camping in wartime involved much ingenuity in finding food'

'Camping in the 1940s was more basic than it is now. One essential item on the kit list was a cotton outer cover for a palliasse or 'friendly donkey' as it was jokingly called. This was filled with straw from the barn as soon as we arrived at a farm and was our bed for the duration of our stay. It stopped the cold striking up from the ground but was cruelly hard, as it soon became lumpy.

In 1944 a gas mask was still an optional item on the Camp Kit List. Part of the forward arrangements for camping was getting the farmer to dig a latrine trench – no chemical toilets in those days! Sometimes he had not had time to finish the job, so we just had to get on with it ourselves.

Guide camping in wartime and, even up to 1954 involved much ingenuity in finding food. Ration books were required in order to get basic rations such as butter, sugar, bacon and meat. Even bread was rationed at one time, but as far as that was concerned we were lucky as one of our Leaders had connections with a local bakery and we always received ample supplies of 4lb square shaped loaves. There was a plot of land called 'the cabbage patch'. Cabbages and lettuce were planted and we had to take turns in hoeing and weeding. I cannot ever remember there being a product of all this work; probably rabbits and caterpillars were the beneficiaries. We older Guides (14 plus) sometimes went to serve cups of tea to Servicemen in what is now the Union Jack Club, but this was not very successful as our parents were not too keen on this activity.

Gradually, with the end of war, guiding began to once on take more its wider outlook as we began to meet Guides from other regions when we camped in the South Lakes. The uniform became less formal and we no longer wore long black woollen stockings, big hats or gauntlet gloves when carrying the flag.

Guiding has lots to offer the youth of today, if only they will make the effort to grasp the opportunities. For us fifty years ago, it was an opportunity to spread our wings and escape into the outdoors and have fun.

In this nothing has changed.

As war ended and people all over the world began to pick up their shattered lives, many parents enrolled their children in Brownies, Girl Scouts, or Girl Guides for something for children to do that was safe and cheap. Post-war life was not easy, with rationing in place, injured servicemen returning and a sense of unease that women were returning to their 'natural' pre-war roles. But for many young girls and young women, Girl Guiding or Scouting became a haven during uncertain times. Here Gillian Goldsmith, a Girl Guide in the post-war years, explains:

'The war had just ended but I was still very aware of bombed buildings...life disrupted'

I joined Brownies in 1945, aged seven, The war had just ended but I was still very aware of bombed buildings and life disrupted.

I just loved it. I loved the structure of it. I loved the fact it was offering me new skills. I ended up Seconder and Sixer. I embraced what it gave me, which was a life outside home.

On reflection, I gained acceptance. I was always naughty, always getting sent up to my room or slapped with a hairbrush. So, to find somewhere where they thought I was clever and nice to be with, and for them to think I had something to offer, was lovely. It was a strong structure that was always there.

I loved my Brownie uniform. I loved cleaning all the badges and everything – in those days had to clean the front and the back of the badges! We even had to tie our own ties, just like Baden Powell had taught us.

The uniform was the old brown uniform with two pockets, a proper belt and a proper brownie hat. I never got past second class. I was quite miffed! But I had badges up and down my arms.

There were badges in communications, first aid and hostessing. A lot of the badges that exist today really do go back to the early days.

We were still in an era of rationing, my parents were strict with me but I think that was because I was really rather naughty. But my parents had lost their youth to the war.

We were bombed and had to live in temporary housing.

It was bombed while my dad and grandparents were in it, under the stairs. We were very lucky that no one was lost.

As a result, my mother didn't have time to make things 'fun.' Life was limited.

But they let me go to Brownies, then Guides. The uniform was a blue all in one dress with a brown belt with a buckle. The hat was a beret. You had big pockets and had to have a handkerchief and a notebook and a pen, and 2 shillings and a bit of string.

I remember wanting to go to camp my first year and being shaken when my mum said she couldn't find the money. This was £5.

So, I went the second year, aged 10. It was primitive and a culture shock, because we had lats to cook everything on the fire and walk a long way for your water.

I remember having a midnight feast and eating a tin of condensed milk that was decidedly off!

My mother had no idea what camp was like.

There was more fun and freedom, more challenges, new experiences, midnight walks, adventures. And we had inadequate bedding. There were no sleeping bags. You made your bedding with whatever your mum could spare you and that would have been the grey utility blankets. You folded them up with your blanket pins and of course when you're at home you have no idea how cold you're going to be at night. We didn't have adequate anything because everything was still on coupons so you had your faithful old jumper to go over your pyjamas and I remember being extremely cold.

Then I found the secret – we used to have plastic macs in those days and they kept you dry. I found that I sewed it up so it made an oblong and still got the hood so you could

wear a woolly hat and I put this over my bed and because it was impermeable I don't remember being hot to the point of sweating but it kept me warm! After that it was fine and it was part of my equipment!

Food was stews, family food, an awful lot of mince and sausages, salad with cold meets, potatoes and root vegetables. Breakfast was eggs, and eggy bread – to make two eggs go round the whole unit!

We had quite an exceptional captain called May Wynn. She was one of the spinsters left behind from the First World War when all the young eligible men had died.

She had good associations as she took us on camp to a farm and another one on a camp to a stately home.

One thing that stays in my mind was an international camp where there was a contingent of very small girls from Chernobyl – the same year of the disaster. People had raided charity shops to find them clothes. We went pot-holing and the Chernobyl girls could easily fit through the apertures but my sturdy adult shoulders were a different matter. I felt just like Winnie the Pooh stuck in a hole!

Eventually I managed to twist free. Whenever my small friends saw me they would mime my predicament accompanied with enjoy gales of laughter, which I could not but help join in. We know the legacy of Chernobyl, and it comforts me to have experienced an opportunity to share something good with them.

The good thing about Guides is you learn how to problem solve. Another thing is tenacity. Even when it's bad.

And adventure! I've been to Norway, Denmark and later on when I was 60 I went trekking in Ethiopia and South Africa.

I'm quite sure that I would not have done that had not May Wynn whose early days actually taught me that you can do anything if you want to.

Many years later, I went on a course up in Windermere and we all lit a candle to somebody who'd had the most influence on us in our lives apart from our parents. And I lit a candle to May Wynn and I hoped her little star was twinkling up there.

Chapter Six

The Post-War Years

'In the atmosphere of the campfire, where traditional songs were sung, language difficulties were easily overcome and the proceedings did much to cement relationships with other countries.'

19 August 1952, *Portsmouth Evening News*

'They must go hand in hand, heart to heart, shoulder to shoulder and arm in arm, striving to stick to their job of striving to make the world a better place,'

Lady Baden-Powell

As children of Britain sat cross-legged on their living room floors, gathered (if they were lucky) around their small television set, they gaped in awe at the four-legged creature bobbing around on top of the piano. As Annette Mills sang away and Muffin the Mule danced, those children who were fortunate enough to have a television set in their home giggled with joy. It was a world away from recent years; of bombings and air raid shelters, of terrifying government announcements about possible German invasions, of deaths, of losses abroad. Now, all that seemed from another age. Only the hunger in the children's tummies as they laughed along to Muffin the Mule gave away the fact that one aspect of war had not gone away yet – rationing. The limit on goods per household did not end when the war did. As life got back to normal, as men returned from war and walked back into their jobs, as builders began the mammoth task of rebuilding Britain's cities and infrastructure, the rationing of food was still very much a part of everyday life. One food item that had not been rationed during the war was bread. But now, post war, bread was rationed. The 'national loaf' replaced ordinary white bread – a mushy, beige item that many people found distasteful and nothing like bread at all. But there was another hangover from war, too. The jobs women had done: jobs in ammunitions factories; in agriculture; in engineering; science; mechanics;

and all areas of employment that were traditionally 'male', were now welcoming back their male workers from war. For the women who had done these traditionally male roles during the war, it had given them a taste of emancipation from the home, of utilising skills they might not have known they had. Now, that was all over. Men returned to their jobs and women were told to vacate the jobs they had filled in their absence and quietly return home to family life and their roles as wives and mothers.

In our modern times, the 1950s is often portrayed as a halcyon age of the family unit: women keeping a perfect house; men in perpetual work; families leaving the cities and moving to the suburbs for a better life; more modern conveniences in the home; and the beginnings of rock'n'roll. But the 1950s was far from a paradise era. Post-war rationing in Britain meant families were still poor and hungry. Men had returned from war suffering from post-traumatic shock. Women had experienced a taste of freedom during wartime and now had to return to their traditional role of wife and mother. This seismic sense of change – or going backwards? – would have filtered down to the girls and young women in the Guiding movement, too. One moment these girls had been helping the war effort, the next that was all over.

What did they do now? Where did they go from here? Already, the greatest of their number and the very 'first' Girl Guide had left them. At the end of the war, in 1945, Agnes Baden-Powell died, aged 86. The national and local press – represented here by this piece in the *Somerset Guardian and Radstock Observer* – alike printed obituaries to this most formidable of women.

The death was announced on Monday of the founder of the Girl Guide movement, Miss Agnes Baden Powell, at a Kingston, Surrey, nursing home, at the age of 86. After her brother, the first Lord Baden-Powell, had founded the Boy Scout organization he carted on her to start the Girl Guides. It was a dramatic beginning. Girls were enrolling in the Scout movement, and it was when the girls attended a rally at Crystal Palace in 1909 that Miss Baden- Powell began her task. A skilled balloonist in her younger days, she claimed to be the oldest Girl Guide. She was the No. 1 member, first President of the Council and a national Vice-President. She retained her youthful interests, and it was her wish

to have a helicopter when the war ended. Throughout the German occupation of the Channel Islands the 11th Jersey Scout Troop carried on without a break, although meetings had to be held in secret without uniforms, and the Scout salute became a real secret sign.

Agnes Baden-Powell's funeral was held at Kensal Green Cemetery, London and she was then interred in the Baden-Powell family grave. And so ended the great, active life of a woman never too afraid to try new things or adventures, or show girls what they could achieve. But now, as a new decade dawned, what was the future of girls in the Guiding movement? What would Agnes Baden-Powell have wanted?

In the United States, the 1950s became an ever more conformist decade. Men and women were placed back in their traditional pre-war roles. Girl Scouts were no longer to be seen growing emergency vegetables and collecting wastepaper and scrap metal, but were back on the streets selling cookies. But the skills they had learnt in the war were still being passed down to the newer recruits. One example of this was the disappearance of one Girl Scout in the state of Washington in 1950. The little girl had been out in the woods looking to find the perfect Christmas tree when she got lost. A day passed, then two – finally 96 hours. Her parents and local people feared the worst. But the girl survived. Why? Because she was a Girl Scout, as the *Wilson Daily Times* reported:

> Employing her Girl Scout training, she found shelter and waited. Four days were required to find her but at the end of those four days she was in almost as good shape as when she got lost. That speaks well for the Girl Scouts of America. Like the Boy Scouts, it engages in a training program that not only saved this little girl's life, but many others in the course of time. Those who are older and who therefore missed their programs would have been hard pressed. In similar circumstances they might have died from exhaustion. This Girl Scout, however, didn't. She kept close to her shelter and showed faith.

When the Second World War ended, a baby boom meant that there were even more young people who needed entertainment, youth movements

and guidance. Even in a post-war time of rationing in the United States, girls would come to find comfort, joy and a sense of inclusion by joining the Girl Scouts. Here Ardi Butler of Seattle explains what Girl Scouting was like in the post-war years:

'I got a Girl Guide pen pal from England as part of an International Friendship badge. We've written to each other for 71 years'

I was a Brownie in 1947 when I was seven. Our uniform was a little brown dress with a brown beanie. We lived in a rural area with a lot of small family farms. Nearby Japanese families raised vegetables and flowers to sell at the market in Seattle.

This was post-WWII and there was still rationing. I remember that my mother was very nervous about not having milk. She talked my father into buying a goat and we were raised for a couple of years on goat's milk – which I still like!

One of my earliest memories from Brownies was a lesson on sewing. We made a blue and white checked apron and two of us sewed our aprons to our dresses.

When I was sixteen my mother, who was one of our leaders, signed us up for an Aid Program helping at a hospital run by nuns. Up until this time, I thought I wanted to be a nurse but my mother realized that when I had helped with patients whose situation or care troubled me, I was bothered. She noticed that and told me, "You're probably too soft-hearted to be a nurse."

My mother was very thrifty and believed in all the things the Girl Scouts taught: To be prepared – she went to end-of-the-month clearances, was very frugal and firm about a nutritious diet. We had a garden and she insisted that each meal had protein, starch and vegetables.

Our troop went troop camping and between that and going to summer camp at the permanent Girl Scout camps, I learned knot-tying, building fires, camp cooking – all very helpful when I had my own children and we camped as a family.

While I was a lifeguard and swim instructor at a River Ranch (a Girl Scout permanent camp), I learned about camperships. This is a scholarship given to a girl from an underprivileged background who might otherwise be unable to go to camp. These girls are not identified and are able to mix and mingle with every other Girl Scout.

Our troop did a lot of badges, but my favorite badge was the World Friendship Badge. Our next-door neighbor was an elderly English lady and she wrote to her friend in England who had a relative with children. That niece's child and I became pen pals and we've written for 71 years. I was nine when we started writing and she was in British Guides. At first it started with descriptions of ourselves and a picture. The first picture I got of her was in her Girl Guide uniform. As we got older, we shared recipes: she baked bread, I baked bread. She had a little garden, I had a little garden. We both enjoyed knitting, we both enjoyed cooking and during the years we shared recipes and patterns and we raised our kids and shared difficulties we may have had along the way. I've been to England four times now and I've visited Genifer each time. The last time I was there was bittersweet because I wasn't sure that that wouldn't be the last time. Genifer has been a dear friend and a really wonderfully bright spot in my life.

Now, years on, I can still participate in Girl Scouts. Each year one of the camping sessions at the end of the summer is for Partners. This allows younger girls to camp with an adult from their family. My granddaughter invited me to go to Partners Camp with her. She shared *her* Robbinswold, while I told her about mine. There is also a session annually that is held after camp season is over. It's called Women's Own where about 100 women come for a three-day stay at the permanent camp. There are activities, many of which we did as girls: canoeing, hiking, cooking, crafts, all kinds of different things. Some people come and sit on the porch in the sunshine and knit or relax! I love being in the lodge after meals and participating in the group singing the old camp songs.

Three years ago, when I went to camp with my granddaughter, Raelyn, I was walking through the Rotunda. I noticed a little plaque on the wall that said: 'Each campfire lights anew, the flame of friendship true.' The camp director said, 'I loved that saying, it's from an old camp song, but it's lost.' I assured her it wasn't lost, I knew the song. I taught it to the C.I.T.s (counsellors-in-training) and at the closing campfire down on the beach by the water, we sat together and sang the song we thought was lost. It was a lovely time.

Scouting has added immeasurably to my life. It is a wonderful experience for girls. It's difficult to pinpoint what it does for building the character of young girls, but I've seen its results in so many of them.

In the 1950s, even as women and girls took their place once again in their traditional societal roles, the lessons learnt in Girl Scouting were important – sometimes to the level of life and death in the case of getting lost in a wilderness. But, while many girls in 1950s America felt they were given lifetime survival skills and the chance to do physical activities usually only acceptable in the realm of boys, many women found that once they left the environs of Girl Scouting, they could no longer pursue those traditionally 'non-female' activities. Here Karen Chobot of Minnesota, a Girl Scout in the 1950s, explains:

'At Girl Scout meetings we felt we were running this thing ourselves. But when we got home we knew "we're going to have to give leadership back to the boys"'

I joined Brownies in 1952 and I was seven years old.

The 1950s was pretty carefree. We didn't have a lot. We didn't really have anything else to do, except maybe church activities. There were no sports - girls were not allowed to do sports. If you didn't do scouting there wasn't much else!

We weren't allowed to do overnight camping in Brownies but our leaders did lots of outdoor activities such as cook outs.

Outdoor was always my big thing. I loved Brownies because it was fun to not be at home. We didn't do much

outside of our families at all. We even went home for lunch everyday. My grandmother lived next door. We were just always home all the time.

We did charitable things, too. Christmastime all the troops during the baby boom and we'd go to tea in our white gloves and made baby bonnets to give to a child's hospital. The two leaders were very involved in Infant Welfare in Chicago to help children and that's where our bonnets went and we learnt to make button holes and sew on buttons. We also made receiving blankets and learnt to do blanket stitch.

In 5th grade I went on to Girl Scouts.

I really wanted to go because I really wanted to go on overnight camps. We'd go for two weeks.

I went on my first camp in Michigan. Even though the area we came from was very white middle class Chicago suburb we had black counsellors, we had counsellors with disabilities. So the Girl Scouts gave me those role models early on.

Being in Scouts was a good chance to meet people not like ourselves.

Girl Scout uniform was green dress, not gingham but a heavy cotton dress with long sleeves. We started out in that one with badges on the sleeves, a yellow tie and a beret and green socks.

First camp we did a lot of swimming and I learnt canoeing which I loved. We went on hikes and cooked out a lot. We actually cooked breakfast and the evening meal out every single day and only had lunch at the dining hall. We'd eat hotdogs and pancakes. Sometimes on buddy burners.

That took a lot of time!

I think Scouting gave me the expectation that I could do those things as a woman. So it was always a shock when I was outside of Girl Scouts, I was then told, no, you can't do those things.

As a freshman at high school we took a vocational test. They asked what sort of things you liked to do, then analyzed the whole thing and told you what kind of job you should do.

I had a load of outdoor things I clicked on. They I must have done it wrong. The recommendation came back that

I should perhaps be a forest ranger but at that period in history women could not be forest rangers.

I would come across that a lot in my life.

I couldn't understand why boys could do football and other things. So, it was depressing.

The older I got it continued. In careers, women got shunted into teaching, nursing, being a secretary. It was very limited.

I ended up as a librarian partially because I felt: 'what else could I do?'

I did end up as a Girl Scout executive later on. I even went to Roundup in 1962 and there were girls from all over the world.

We felt: here we are running this thing ourselves but when we get home we're going to have to give it to the boys.

And that was very discouraging that the boys got the best chances.

In my high school years I joined the Mariners, mostly because they had a blue uniform and most of us hated green uniforms from Scouts!

In the Mariners we earnt ranks and got chevrons for it for nautical things, Morse, knots and boating.

It was more military and modelled very much on the boys' Sea Scouts and we used a lot of information from the Sea Scout handbook.

What did Girl Scouting give me?

My first theatre experience was a brownie. We went to see Hansel and Gretel at the art museum in Chicago and that blew me away!

There's a lot of those 'firsts' that happened in Scouting and that's the important thing.

Well, I am basically quite a shy person and Girl Scouting is a very safe home. Even though I was shy as a kid, it didn't bother me to go to girl scouts because I was in a thing that I knew.

It was a safe place. There wasn't a lot of criticism. You didn't have to meet the mean girls. They didn't go to Brownies!

I would not have looked to put myself in a position of leadership if it were not for Scouting. I worked as an executive on a council in Georgia and my experience in Girl Scouts gave me the feeling that I *can* do those things.

I also made good friends at the camps over the years. I had a pillow case that everybody signed. We shared cabins, we shared meals. I often think: Where are those girls now?

Ms Chobot is not alone in her memories. Although many women remember fond and happy memories from 1950s Girl Guiding and Girl Scouting, the resounding feeling they also describe is one of 'having to give way to the boys' once they left. If the 1940s gave women the chance to fill jobs left by men who were fighting and the sense of emancipation that came with that, the end of the war also brought an end to women's freedoms. Many Guides and Girl Scouts reported that although they had seen their leaders, mothers and even older friends fill roles that they might not otherwise have had during the Second World War, these 1950s Brownies, Guides and Scouts lived through an era where women and girls were put very firmly back in their place. Guiding and Girl Scouting, therefore, became the only safe place where girls and young women could take part in the activities they wanted that, outside of Scouting and Guiding, were considered the boys' domain. Camping, cooking outdoors, rambling, hiking, getting dirty, exercising, were all things that many 1950s Girl Guides and Scouts recalled were not so fondly viewed in 'the real world' outside of camp. This made Girl Scouting and Guiding even more important for these young women who were living in a strange no-women's-land between the Second World War and the emancipation that no one yet knew would come in the 1960s.

One event Girl Scouts in America recall with fondness, or even a wistfulness at the near impossibility of getting a ticket, was Roundup. This was a national event to show off the best of the best of Girl Scouting. But getting a chance to go was hard and competition was tough. The 1950s was the decade of the very first Roundup. This was a huge gathering of immense importance, designed to show off the very best of American Girl Scouting. Other nationalities were also invited to attend. The first Roundup was held in 1956 in Milford, Michigan and brought about a huge sense of excitement among Girl Scouts. After badge upon badge, many experiences of camp and

charitable work, many Girl Scouts would come to view Roundup as the pinnacle of their Scouting experience. Initially eight girls were chosen from each Girl Scout council. These would form one patrol who would then join another three patrols to form one whole troop from their area. But that wasn't all. If you did get selected, girls then had to attend training camps to prepare for the enormity of Roundup. The first event, held in Michigan, had 5,000 attendees with representatives from every state in America. Three years later, another Roundup was held in Colorado Springs where popularity had increased so much there were 10,000 girls attending. The next Roundup was in 1962 in Vermont followed by another one in 1965 in Idaho, as well as being twinned with a European version to be held simultaneously in Verona, Italy, for European Girl Guides. When the next Roundup was cancelled in 1968, there was heated debate amongst Girl Scout leaders. Many asked why an event so popular and so well-loved by girls and young women had suddenly been cancelled. But there was no explanation. The only explanation that did come eventually was that it might be better to hold more regular, smaller events to reach more girls than the three-yearly enormous events that Roundup had become.

To many girls' dismay, the next Roundup would not be held until more than twenty years later in 1986. Here Judith MacLellan, from Florida, a Brownie in the 1950s in America, tells of her opportunity to go to Roundup:

'I went to Roundup in 1959. Girl Scouts took over a train from Florida all the way to Colorado!'

> I started as a Brownie aged eight in the state of Ohio where we lived. The uniform was a brown dress with a belt, with a hook on the belt and a little plastic pocket where you kept your belongings. There was also a beanie hat which we dearly loved to through around!
>
> You had to put your initials in the hat so you could find it afterwards!
>
> My meeting was in a Protestant church and I am Catholic and this was quite unusual! We used to go peek in the sanctuary which was really exciting.

The Second World War had recently ended and there was still rationing. My mum had help from neighbours, giving her shoe ration vouchers because I was one of four children.

In 1954 my family moved to Florida for business and I found a new Girl Scout troop.

The intermediate uniform was a green dress with a green leather belt and this little yellow tie that had 'Girl Scouts' on it in a trefoil shape.

I went a lot on summer camps as well as day camp. There were Quonset huts left over from the war and we camped in them.

Then, aged 16, I started working in summer camp as a counsellor, counselling the younger Girl Scouts, which I loved.

One of our leaders was a biology teacher and she knew a lot about the natural world. She'd give us lessons but in a casual way about nature and from her I learnt to fillet a fish!

Camping skills involved primitive things like digging your own latrines, lashing a toilet seat together. Yet some of the badges were more domestic – I remember being taught to make a bed.

In 1959 I was lucky enough to go to Roundup in Colorado. That was phenomenal. You had a long selection process and our council sent eight scouts, and we camped out in Colorado in beautiful mountains. The whole experience was again, being with like-minded people who are enjoying the out of doors and the philosophy.

We got on a train in West Palm Beach Florida with no grown-ups! We changed at Atlanta and just rode on. The entire train became filled with Girl Scouts and we just ran around talking to each other. We thought that was just wonderful.

After joining the Mariners, where I learnt canoeing and sailing and became a lifeguard, I went to college. Afterwards I became a teacher – something I think I'd learnt the skills for as a Girl Scout counsellor.

I then moved from Florida to New York City, because I fell in love! There, I knew I had to get a job and I knew two things: Girl Scouting and teaching.

So, I found a job at the Girl Scout Council for Greater New York City.

Afterwards I worked as a teacher in New York. I became assistant principal and one day the principal said: 'When I see resumes now and I see someone was a Girl Scout, I move them to the top of the pile since knowing you!'

Whatever she saw in me, she put down to my being a Girl Scout.

After I got married and had four children, all of them became involved in Scouting. I was a cup mother for my son's Scout troop and a leader for my daughter's Girl Scout troop.

The songs, I've handed down to my kids, singing them to them at bedtime, and they have done the same with their children. So now when my grandchildren sing the songs, I love it.

Things have changed so much in Girl Scouting because the world has changed so much. My daughter is now a leader and she's very conscious about the world and leadership. It is very girl-led now and I think that's so important: it's not about the badges or the uniform, it's about the ability to think you're able to make a difference.

If the end of the war brought a time of uncertainty for Brownies and Guides in Britain, there was, at least, something to look forward to in a time of rationing and job-insecurity for women – the 1952 International Camp. The camp was to be held at Beaconsfield in Buckinghamshire, England, and would host 1,000 Girl Guides and Scouts from 36 nations. The press seized on this positive news of international cooperation after six years of brutal warfare. The *Yorkshire Evening Post* said:

Seven THOUSAND British Girl Guides, many of them from Yorkshire, will joining with 1000 Guides from 36 overseas countries in an international camp to held Beaconsfield (Bucks), from August 11. In addition to English girls, members of the movement In France. Germany, Egypt, Tripoli and Turkey will also be there.

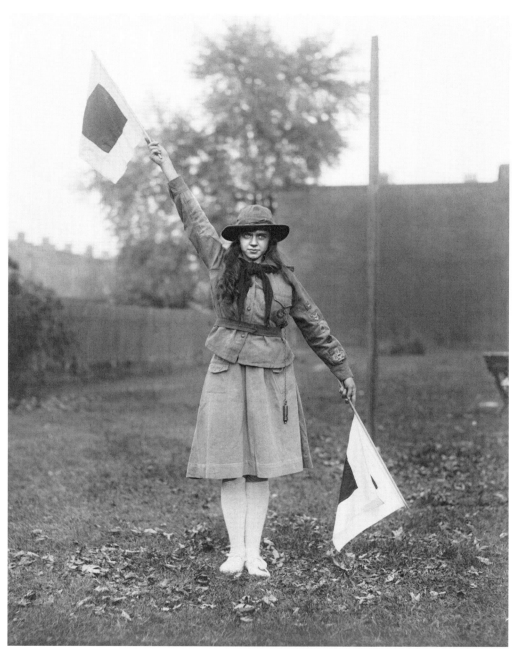

Girl Scout Waving Two Flags, Washington DC, USA, National Photo Company, 1920. (Glasshouse Images / Alamy Stock Photo)

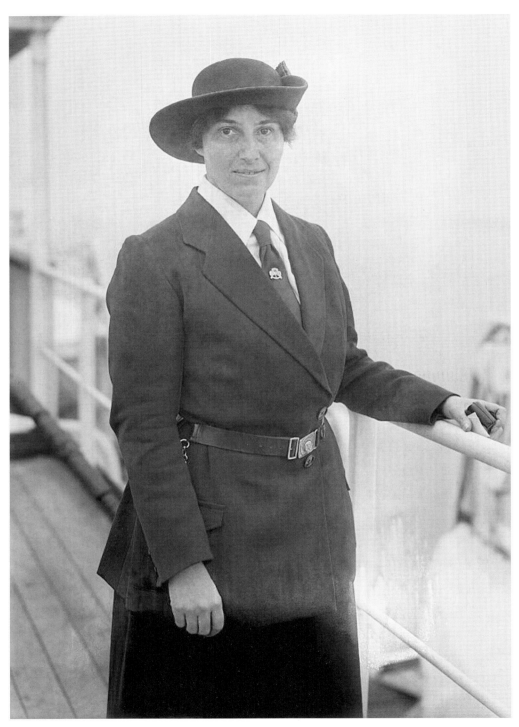

Olave Baden-Powell. (Archive PL / Alamy Stock Photo)

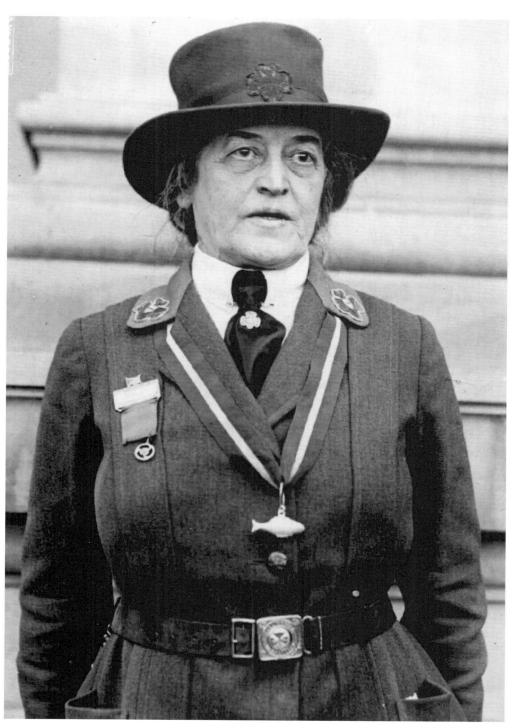

Juliette Gordon Low, 1923. (Archive PL / Alamy Stock Photo)

Baden-Powell's mother and sister, Agnes, c1900. (Granger Historical Picture Archive / Alamy Stock Photo)

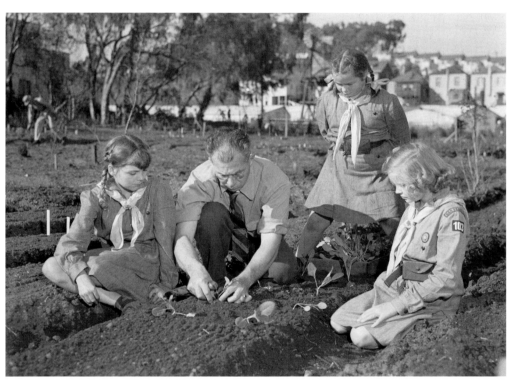

West coast Victory Gardens at San Francisco's Junior College during the Second World War. Professor Harry Nelson helps Girl Scouts. (Everett Collection Inc / Alamy Stock Photo)

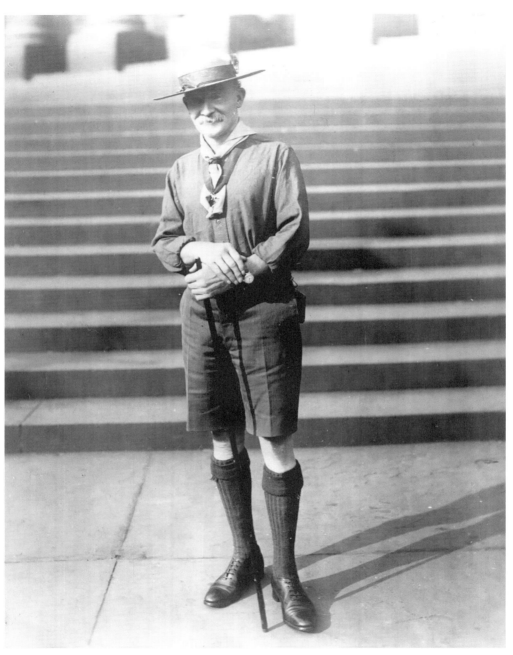

Robert Baden Powell. (Keystone Press / Alamy Stock Photo)

Princess Margaret with Brownies, c1990. Artist: Sidney Harris. (Heritage Image Partnership Ltd / Alamy Stock Photo)

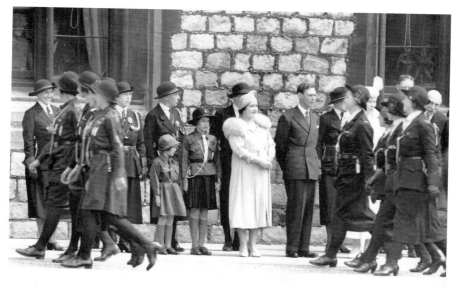

From left to right: Princess Margaret Rose (in uniform as Brownie), Princess Elizabeth (in uniform as Guide), Queen Elizabeth, King George VI and Queen Mother Mary (slightly covered) at a parade of girl scouts. (Sueddeutsche Zeitung Photo / Alamy Stock Photo)

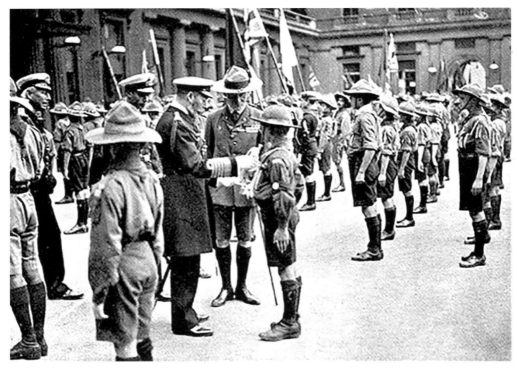

Scout Rally 1909.

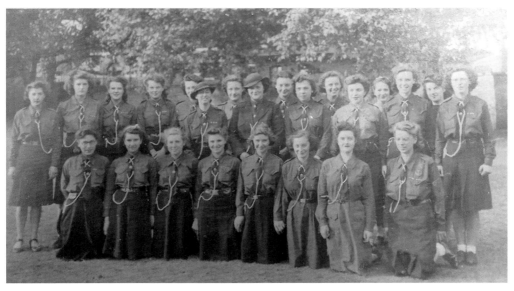

Alice Wood's Sea Rangers group, taken circa 1939.

Sea Ranger Alice Wood's wedding in 1945, with Sea Rangers guard of honour.

STITCH IN TIME - - -AT CAMP

THE GIRL SCOUTS in this picture are: left to right, Judy Carmichael, 17333 34th Avenue So...
Ardith Rader, 12816 34th Avenue South, Joyce Eggers, 14106 55th Avenue South and Marg...
Love, 13418 Military Road.
—(Photo courtesy Post Intelligen...

Left: Ardi Butler features in a local newspaper article, 1950.

Below: A map drawn by Ardi Butler of Robbinsworld Girl Scout Camp.

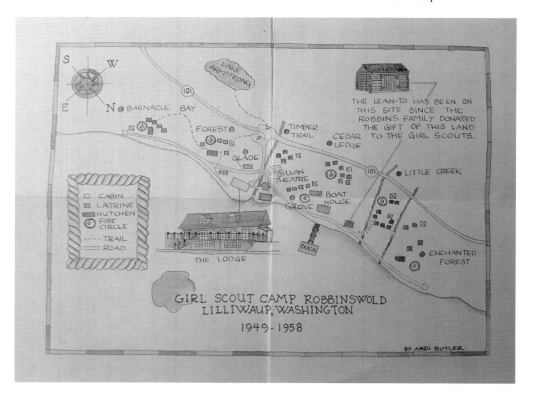

GIRL SCOUT CAMP ROBBINSWOLD
LILLIWAUP, WASHINGTON
1949-1958

BY ARDI BUTLER

Ardi Butler (middle) and friends at camp (1952).

Badge sash owned by Karen Chobot.

Left: Karen Chobot in uniform, 1953.

Below: Akiko Koda (left) in uniform.

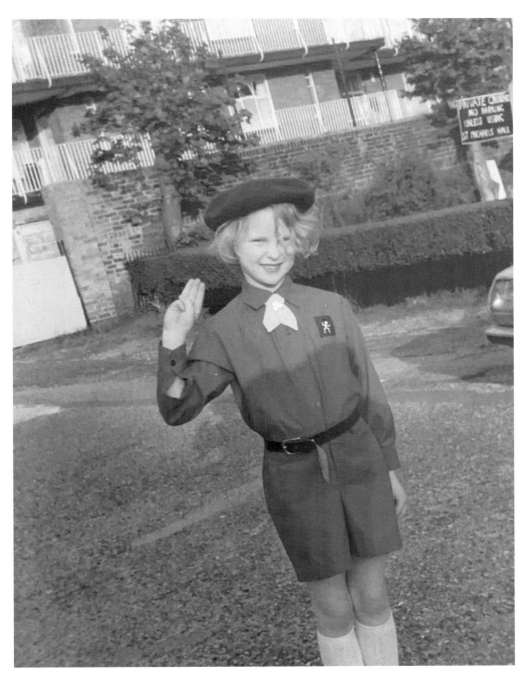

Lebby Eyres, in her Brownie uniform, 1978.

Above: Joanna Griffin at her enrollment ceremony.

Left: Judith MacLellan's badge sash.

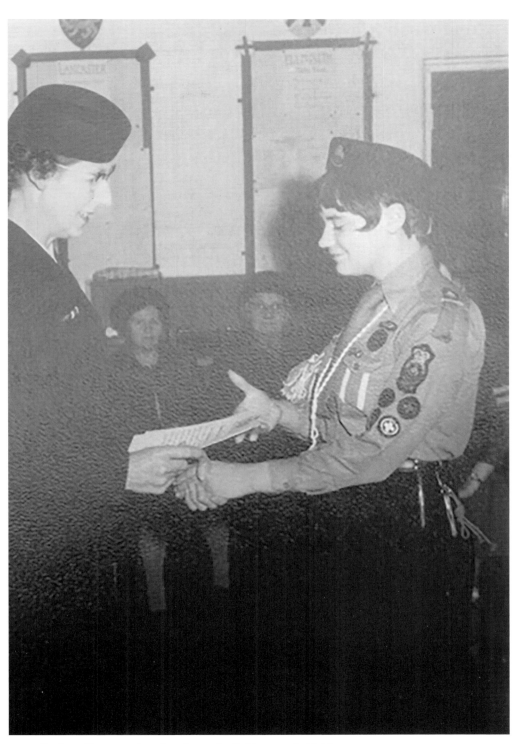

Barbara Dow receives her Queen's Guide award, 1966.

Above: Barbara Dow in a tiller girls performance on camp.

Left: Ally Capellino's design for Brownies' uniforms.

Some of the overseas visitors are already here and staying with Guides in various parts of Britain. On Thursday a party of from Finland went to visit homes in Yorkshire, where they will remain until the camp opens. Highlight of the itinerary will mammoth camp fire on August 13 and four days later Lady Baden- Powell, the World Chief Guide, is to fly specially from Norway to wish the Guides bon voyage on their home Journey the following day. Each country will demonstrate some particularly national aspect their guiding activities such national dances cooking and handicraft. British Guides will bake biscuits in their own hand-made moulds made in plaster and bearing the international camp emblem.

For Scottish Girl Guides, they chose to take native heather as their offering to their international counterparts, as reported in the *Aberdeen Evening Express*:

Nine excited Girl Guides from the North East were waved off at Aberdeen Joint Station today by parents, friends and envious little sisters.

The guides were on their way to the World Guide Camp at Hall Barn. Beaconsfield. Bucks, each carrying a little gold ball in her luggage. The gold ball is a mystery to the guides. They were asked to paint tennis ball gold and bring it to the World Camp tor pageant which will be part of the entertainment staged for the foreign guides who will attend. As the train moved out of the station Miss Helen Slater, former captain of the 2nd Huntly Company Girl Guides who had come from Huntly see them off, handed a piece of white heather to Guide Jean Robertson. That piece of heather will probably find its way to some foreign country after the Camp.

During the camp, girls from all nationalities shared tents together, made friends, ate together, cooked over campfires together and so much more. In a year that had seen the death of George VI and the young Princess Elizabeth ascend to the throne, the country seized the new hope and

sense of new beginnings that the International Camp brought. The *Portsmouth Evening News* put it like this:

> Back home today after attending the International Girl Guides camp at Beaconsfield are Rosemary Hicks of 5, Gladys Avenue and Julie Game of 10, Holmdale Road, Gosport. Rosemary, who is a member of the 11th Portsmouth Company, and Julie, a Guide in the 2nd Gosport Company, were specially chosen to represent the district at the camp. Swedish and Swiss Guides were their tent companions during the stay at Beaconsfield and they made friendship with guides of many nationalities, there being 40 countries represented among the 1000 girls at the camp. In the atmosphere of the campfire, where traditional songs were sung, language difficulties were easily overcome and the proceedings did much to cement relationships with other countries.

Ten months later, in June 1953, Queen Elizabeth II's coronation took place at Westminster Abbey. She was only 25 years old. As the Queen had been an avid Guide herself, the Guides of Britain did all they could to mark the coronation, starting months before the ceremony itself. Trees were planted, Coronation gardens were designed and divisions' names were put into hats across the country so that lucky winners might be picked to gain a spot along the coronation route to represent their troop as the Queen's carriage passed by. A month later, Lady Baden-Powell visited a troop of Girl Guides celebrating a Coronation Rally, saying that the girls should go away and remember this day and their Queen who, as she was proud to say, 'was one of them.' 'They must go hand in hand, heart to heart, shoulder to shoulder and arm in arm, striving to stick to their job of striving to make the world a better place,' Lady Baden-Powell said.

Lord Baden-Powell might not have been here in person anymore but he was never far from anyone's thoughts. According to the *Kingston Times* which reported the Guides' Coronation Rally held there, Lady Baden-Powell said that:

> ... Her husband's name would always be remembered. He had seen that something more was needed in the world

and instituted this wonderful movement – the Boy Scouts. Having started that the Girl Scouts were started who later became Girl Guides. In the world the women and girls had always been obliged to take second place, but he could not agree with that.

He remembered that he had got into some trouble so long ago because he had declared himself in favour of votes for women. He was in favour of equal pay for equal work and was definitely on the ladies' side.

Three years after the Queen's coronation, Brownie, Guide and later Guider, Mary Derby-Pitt (living at the time in Livingston Station, West Lothian) would see Her Majesty when she visited her area. Here she recalls her memories of Guiding in the 1950s and onwards:

'We saw the Queen. It was history in the making'

I was six when I started Brownies, in 1956. The uniform was with the toggle hat, the dress and the tie you had to knot yourself. We lived in a small village and everybody went to Brownies or Cubs. We met in a village community hall. There were 30 in the troop at that point. We had an awful lot of nature trips, walking, collecting. That's how I still know all the leaves of all the trees to this day, because we learnt all that. There were only six or seven badges, mostly cooking, nature, adventure. Nothing like Guides eventually got. By the time I was a Guider there were twenty odd badges! On camps, we cooked sausages and fried egg. We did potatoes but that wasn't easy to do. It was usually something you could put in a pan and cook, like sausage and egg. Brownies taught me life skills and to understand people and to understand nature. It was really good. That's why I stuck with it so long. I flew up to Guides aged eleven. The Guide uniform was the same kind of tie as the Brownies: you had to tie it. Then it was a navy skirt and the blue blouse and Guider's belt which I've still got. Guides wasn't as much fun as brownies had been.

Time passed and I was still guiding when I got married. We had a guard of Guides of honour at my wedding. I then

became a young leader. I took all my exams and certificates etc and went from assistant Guider up to Leader Guider. I got the offer of Commissioner but I declined. I had about maybe 30 girls in my troop. We held the meetings in a local church hall and regularly had four or five girls in my kitchen and we'd make cakes and scones and toffee apples. I was a newly married woman but my husband got involved and loved it! He'd be mixing up stuff, baking tablet a Scottish confection and everything. He'd help the girls with their cooking badge although he preferred helping them with the outdoor cooking on a campfire. Brownies and Guides helped me because, when you look back, you realise you learn how to clean brass, cook. That's what I liked - it was learning skills whether it be household skills, athletic skills, nature, trying to keep the kids learning all the time. My strongest memory was in 1964 when the Firth Forth bridge opened and we were a Guard of Honour for the Queen.

We got a certificate and saw the Queen in the car and she waved at us. It was history in the making.

Another woman who was a Brownie in the late 1950s was Tonia Crouch, from Croydon in Surrey. Here she recalls her memories of Guiding at that time:

'Brown Owl found out I hadn't been baptized so she sorted that out!'

I was seven when I started Brownies in 1958. The uniform was the brown dress with the brown pocket and the leather belt and the little purse on it and then a brown tie which was the triangular one that you had to fold in a reef knot to make it into a tie. You then had to tie the ends round the back of your neck so you had to learn to do that behind your back – I find it hard to do it in front of me as I'm so used to doing it behind now! We also had brown berets.

We met in the church hall where there was a little stage and a balcony. We loved it.

I had to armfuls of badges when I left Brownies, everything that I could do I did. The first badge I earnt was either collectors' or artists' badge. I had everything you could think of and not only the arts and crafts skills but First Aid and Child Nurse too.

I just loved Brownies.

I think we went camping once and Brown Owl was very nice and cuddly and motherly. Tawny was a bit severe! Little Owl was much younger.

I made a lot of friends there. We had four sixes: pixies, sprites, elves and kelpies. I was a pixie the whole way through.

I remember Brown Owl discovered when I was nearly nine that I hadn't been baptized and she sorted out getting me baptized with my mum! And all the unit came in their uniforms which was lovely. I remember standing at the front at the font in my brownie uniform and Brown Owl, Tawny and Little Owl and all the Brownies were there.

I was 11 when I went to Guides. We learnt a lot of skills such as sewing, washing things, cooking, cleaning - all the things girls did in those days. I learnt cooking and knitting and sewing and I don't think they do that sort of stuff now - how to run a home, how to cook properly.

Camps were wonderful. We'd go away every summer and all the gear was put on the back of a truck and we used to sit on top of it all, hanging over the tailgate! There was no health and safety then!

We learnt how to light a fire with just one match, how to cook using an old baked bean can with a little fire underneath and using the top of the can to cook on and using sticks to cook things on. We learnt how to cook with haypits with no fire at all, where you dig a hole in the ground and line it with hay and put porridge in there and in the morning the porridge would be cooked because the heat from the ground would cook it.

We had to be prepared. You had to have a clean hankie in your pocket and one to lend, a plaster, a penny for the phone, a piece of string and a safety pin!

I've still got my sheath knife. It was part of the uniform – I used to walk off to guides with my sheath knife on the back of my belt which was six inches long!

I went into being a Brownie Guider, then I got married. When I had children, my girls went into the Brownies.

I was a Fluffy Owl in their pack. They made up the name for me! I did all the art and craft stuff.

I became a leader of the Brownies and retired five years ago.

I think it's changed a lot. But kids still need to learn how to run a home, make a cup of tea, make the toast, lay the table. My daughter learnt to lay a table when she was a Brownie and ironing and washing - things they don't teach at school anymore.

I do like the fact that it is an all-girl organization because girls need their own space without boys distracting them. It started as a girls-only space and it should stay that way.

It was nice when my daughters became Brownies, they enjoyed Brownies and had to call me Fluffy Owl at Brownies they weren't allowed to call me mum!

Now I realise it's influenced my life in so many ways. I go to the greenhouse and I'm tying tomatoes and find myself doing a Clove hitch knot.

I can also still light a fire with one match! I learnt a lot about nature and I love nature still.

I still think it's a good thing for young people to do because it's a different environment to school.

The uniform is much more practical now. When I think we were in a little dress that had to be crisply ironed back then! I was fortunate that I went to school that had a brown uniform so I could double up my school cardigan. I think it's much more practical now with the shorts – I mean we could wear brown shorts when we were camping. But I think it's much more practical now with the outfits as ours weren't meant to be active in. Guide skirts were straight blue skirts, not practical. You couldn't run in them...although we did!

In America, the 1950s was the great era of the perfect American housewife. Polished, serene and rich in the knowledge of baking, child-rearing and home-making, this 'type' of woman was extolled in the American media. Sherley Penrose of Middlesex, New Jersey, was a Girl Scout in America during the 1950s. Although the skills taught then might be considered 'dated' or 'sexist' today, she believes the 1950s life skills she was taught helped her greatly in life. Here she explains:

'Career choices for girls now is great – but the fundamentals are still necessary'

I joined Brownies in second grade when I was seven years old and wore a little brown uniform with beanie cap. I was very shy at that age so socializing was important. Arts crafts, home making skills, service to others were strongly stressed.

My mom was a stay-at-home mother, Dad went to work after the Navy.

When I was nine, I joined Girl Scout juniors. The uniform was a green dress that lasted 20 years before it being changed. We continued to learn life skills (sewing, home finances, cooking, service to community - especially those in need)- valuable skills that were used in everyday life.

In 1976 I became a leader when my own daughter went into Juniors and they needed leaders. I loved Junior Scouts- the girls at that age eight to ten years old were so eager to learn anything. At that level our program was divided into five worlds: outdoors, art, people, today and tomorrow, wellbeing. The badges increased from 76 to 108 so there were so many choices. Girls did not shy away from wearing their uniform at public events or to the meetings.

I had all three grades, so some were just moving up a level, some had been in a year, and some were on their last year. This helped the girls learn and help each other. I also had five schools' worth of girls coming (all in town and one being a religious school). I found this great as the next level they would all be in the middle school and by then have a bunch of friends

they already knew from their troop. We had a few adventures. We toured a car manufacturing company as a father/daughter field trip, we helped at a naturalization ceremony at the county seat for new citizens by playing the National Anthem and then serving everyone GS cookies. Another time we stayed on an army base for a weekend to tour and learn.

Planning their own activities was a major part of my troop's agenda. I did not plan their activities – the troop members did. My job was to advise, make sure the activity was safe, money spent wisely and stayed within the rules of Girl Scouts.

I certainly got to experience opportunities I would never have if not for Scouting. I have also made a lot of lady friends who we still socialize today – many years after being leaders.

Girl Scouting has changed. I think back then it taught life skills, encouraged more service to their communities and a sense of Girl Scouts being an important part of life. Now it all seems centered on their profession, science, and improving yourself and very little continuance on service and doing for others.

This may sound 'old thinking' but if a girl cannot sew on a button, balance her finance, or understand the world, I do not think we have done our job. I also think we are losing our heritage – Juliette Low's ideas for example.

Ask a GS in Daisies or Brownies and they have no idea who she was, what she did because the leader does not know or find it necessary to make them aware of the tradition.

So, I am helping to establish the first GS Museum in NJ and when a troop comes in the first presentation is all about the beginnings in the USA and its founder. Most of the troops have no idea and some of the leaders do not know the beginnings.

However, girls in general have better job advantages, travel opportunities. Lifestyles for women have changed drastically.

Girl Scouting is helping girls today gain as many advantages as possible in exposure to career choices and opportunities outside of their 'box'. This is great, but fundamentals are also still necessary.

Chapter Seven

Emancipation?

'Over 100 people were injured or fainted, cars were overturned and windows smashed by a mob of screaming teenagers after the Beatles' last performance in Dublin last night...When it was all over the street was littered with umbrellas, high-heel shoes and ladies' headwear...'

On the Beatles' performance, *Belfast Telegraph,*
8 November 1963

'The fact that more Guiders are needed was stressed. Many girls leave the movement before they reach the senior stage.'

Lady Baden-Powell's speech reported by the
Aberdeen Evening Express, 12 October 1962

If in the 1950s young people did not have enough to do, it could be argued that by the time the 1960s were in full swing, they had *too much* to choose from. Gone were the days of only having church or school to keep girls and young women occupied. Now, a new breed of child-adult had been born: the teenager. As young people who had previously dressed as mini-versions of their parents and followed in their footsteps realised this did not have to be their destiny, a whole new world opened up for them. Cinemas became the place for teenagers now, not adults. Cafes and coffee shops opened up with teens as their clientele. Bands that would have been considered unthinkable began to appear on national television – the Beatles, the Rolling Stones and of course, Elvis Presley. The 'tweenie' age between child and young woman had previously segued seamlessly. But now it had a name and, with it, a sense of identity for young people. Conforming was no longer the only option. Girls suddenly had choices.

Since the advent of the National Health Service in Britain in 1948, children had become progressively healthier, fitter and stronger. As a result, many girls began puberty earlier than their mothers had. This, plus the new 'teenage' revolution, created a perfect storm for girls and young

women – what did they want? Where did they want to meet? What were their goals? Youth clubs sprang up more and more all over the country. Suddenly boys and girls wanted to 'hang out' together as groups, not separately based on gender. Many chose to meet at youth clubs to drink coffee, talk, play games and listen to music, rather than to join a single sex youth organization and enjoy fresh air. The contraceptive pill also came onto the health market in the UK in 1961. At first, this was for married women only or to assist unmarried women with 'menstrual regulation'. But of course, many young women who wanted to experience a sexual life without the burden of getting pregnant and having to marry might have claimed menstrual irregularity to get access to the Pill early. In 1964, the Brooke Advisory Service started in Britain to provide young people with access to sexual health advice and contraception.

With all these seismic changes, was it any wonder that Lady Baden-Powell felt the need to boost the recruiting powers of the Girl Guides? The *Aberdeen Evening Express* reported her new drive:

> Lady Baden-Powell, world Chief Guide, gave a boost to the recruiting campaign of the Girl Guide movement in the North East when she visited Aberdeen today. After arriving at Aberdeen Joint Station, where she was met by County Commissioner Mrs Isobel Leckie, the Chief Guide went to the Commissioner's home for a private lunch. She then attended a reception at the Town House. Youth leaders and headmistresses were asked by Lady Baden-Powell to watch out for potential Guiding material they come across in their jobs. The fact that more Guiders are needed was stressed. Many girls leave the movement before they reach the senior stage.

But in other areas, the Guiding community insisted the movement was as strong as ever and was 'not dying' as the *Belfast Telegraph* was keen to report:

> MORE JOINING GIRL GUIDES: The Girl Guide movement is not dying. The census for last year showed the membership for Great Britain and Northern Ireland at a record level. Mrs. Mary Bartholomew, Commonwealth headquarters information officer, told an audience at a

special annual meeting in the City Hall last night that nearly 1 million belonged to the movement. Outlining the new programme to be introduced later this month, Mrs. Bartholomew said: 'The new approach aims to encourage the Guiders to use the initiative and imagination of the girls, as well as their own, to help evolve more exciting and adventurous programmes which are in tune with their needs and interests.'

It aimed to show more clearly the relevance of Guide training to everyday life...

Mrs J. W. Haughton, vice-president of the Girl Guides Association of Ulster, presiding, said that she wanted to assure the public that although the outward appearance and methods were being modernised, the basic principles and ideals of the movement remained unchanged.

The 1960s could arguably be described as the decade full of the most temptation for teenagers and young people. The pop music scene exploded, the advent of the contraceptive pill gave young women choices for the first time, pre-marital sex – although still sneered at and regarded as immoral on the whole – was something young people were experimenting with on a growing scale. With this in mind, the Guiding movement could not stay stuck in its ways. It had to adapt to keep up. Many parents and teachers, however, considered the Brownies and Guides a wholesome activity far preferable to going to youth clubs or dances. Barbara Dow was a Brownie and then a Guide in the London of the 1960s. Here she explains why she felt it was a positive thing for young women to do in the sixties:

'Brownies and Guides was a very good influence during the 1960s'

I was involved in Brownies before I even *was* a Brownie. My mother, Alice Wood, (whose story is in an earlier chapter of this book) did a lot of Brownie badge testing. One of the ones Mum did was 'child nurse' where the Brownies and Guides needed a real child to give them their tea, sit them on the potty and give them their bath. That child was me!

We had so many girls come to the house and I remember Mum asking them the same questions and I'd try and say the answers and she'd say: 'Not you!'

They were questions about how to take a child's temperature and so on. I used to pipe up the answers!

Mum was in the Trefoil Guild and they had wonderful children's parties and the other children were the same age as me and we had wonderful times.

Then, when I was old enough I joined Brownies. I had very happy memories of getting dropped off really early, running to the vicarage – where we held our meetings – and getting the key to open up. I was only seven!

They had a cupboard full of posters and I'd run around the room decorating it getting it ready, getting the toadstool out, I was always the first one there.

Brown Owl's father was a vicar and he had a huge mansion of a vicarage in rural Nottinghamshire and we used to take over for the whole week!

She'd meet us at the station where we'd say goodbye to our parents and – at seven years old – and we'd go off up to London, across on the tube, to Kings Cross station! It seems unbelievable now.

We had a wonderful time up at this vicarage – they still had the servants quarters in the attic and they still had the old bell-pulls to ring for help, a basement and huge gardens. I went three years running when I was seven, eight and nine.

The uniform was the brown dress and a triangular tie. You could also use the tie for bandages and slings.

I learnt a lot: leadership skills, being a Sixer and welcoming younger children. I was a Sprite. Due to Mum's influence, I got as far as I could get with badges and I got the Golden Hand so I got wings to fly up to Guides.

I started Guides aged 11 or 12 in 1962. The uniform was a very heavy navy skirt with a cotton long sleeve buttoned at the cuff, again a triangular tie. Hats, to be begin with were berets but we did change to the stiff air hostess type hats half way through.

During the sixties, I believe Guides was a good influence. I have very happy memories of the shows every Easter. We'd start rehearsing the summer before the following Easter, I was a tiller girl, kicking my legs in the air! We had quite a big stage at Greenwich town hall. They're fond memories.

Our Guide camping was in Dorset. We'd go by train and were collected by the farmer in a big cattle truck which hadn't been particularly cleaned! And he drove us to this farm and we were going: 'Moo!' to people going by. That was near Corfe Castle.

I used to help out at Brownies, then I helped out at guides. Then at 15 I joined the Sea Rangers. I worked my way up to the number one, just below the skipper, right up until I was expecting my daughter Joanna and I couldn't get my skirt done up anymore!

Because Mum was a Sea Ranger during the war, I really couldn't go anywhere else. We had a room by a college and we were in Surrey Commercial Docks.

Although there were still limitations on women in the sixties, we had huge opportunities. Every weekend we'd be off doing something. A friend became so jealous she became a cub and Scout leader just to get out!

The Sea Rangers had a lovely cottage called Rose Cottage at Cookham, Surrey, in the grounds of Cliveden House. It was not long after the Profumo scandal. There was no electricity in the cottage and only gas cylinders for cooking. It was like something from Goldilocks and the Three Bears with lattice windows and on the edge of the River Thames. It was beautiful.

Being in Brownies, Guides and the Sea Rangers taught me so much. I've always been told I'm cool, calm and collected. I never seem to worry which may come from being in Sea Rangers, taking authority and being in charge of a group.

I can still ride in a boat or a canoe. I can change a plug. I'm good in a boat! I can remember my semaphore.

In fact, my joining the Sea Rangers even led to me meeting my husband as we both used to go boating at

Surrey Docks. He was in the Sea Cadets and we met there. They'd offer us canoes they didn't want anymore. I went to collect one and met my husband David! I carried on as far as I could go and got my Duke of Edinburgh Gold award.

Once I had my own children, I encouraged them to join the movement and they did extremely well, getting their Baden-Powell awards.

You could say it's in our family blood!

In America, Brownies and Girl Scouts was still a popular thing for girls to do in the late 1950s and early 1960s. Mary Hornsby, from Western Washington, recalls her time in the movement at that time – and a very special meeting:

'I took my mother to meet Lady Baden-Powell – with her hair in pin curls!'

I joined in 1957 when I was seven. After Brownies, in the early sixties, I joined the Girl Scouts. I earned the Curved Bar award which was the highest you could get back then. I also earned a sash-full of badges.

Camping was really big. We did things like lashing – where you take a heavy twine and put together things, you can use three sticks to make a tripod to build a fire on it, you can even lash a toilet! It was incredible just knowing you could make things in a different way.

We did reflector oven baking. You'd put aluminium next to a fire and you could cook things like biscuits that you couldn't bake directly on a fire.

My mom was my leader and we were taught to cook a little dish for breakfast: you took an orange, cut the top third off, scooped out the orange – because that was part of your breakfast - then you had partially cooked bacon before that and wrapped that inside the orange peel and then cracked an egg into it. You then put that into the coals and the egg would cook. So it was a way of trying and learning different things.

Emancipation?

I went to camp several years and camping as Girl Scout was a big part of Scouting in the United States.

We moved around a lot my dad was in the services. Fifth through eighth grade my mum was my leader in Little Rock in Arkansas.

We went camping, we had camp Olympics, there were swimming events, knot-tying events. I believe it was the equivalent of a finishing school! You learn how to cook, how to knot, skits, singing. I loved the songs. The songs have really changed over time. A lot of the songs nowadays are a lot sillier but it's whatever brings Girl Scouts together.

The sixties was a time of youth culture but I went to Catholic school so we were much more conservative. I don't think we had any black girls in our troop. At that time, that was when my dad taught at Little Rock high school which had just been integrated a few years before, so we were aware of things like that. But we used Girl Scouts as a way of being with other people and learning skills.

Over the years, Girl Scouting has become much more girl-directed.

Back then that was not the case. My mum would come up with all sorts of ideas and that was what we did.

We did a lot of badge work and camping. My mom took us camping and we did little skits, and canoeing at camp, I still remember how to do knots.

I didn't have a problem with my mum leading the troop. She was also our cookie person.

In the sixties, the auditorium in Little Rock announced Lady Baden Powell was coming to visit and do a talk. My sister and I went. I'm the oldest of six kids so my mom couldn't go and hear Lady Baden-Powell speak because she had other children to take care of at home.

I remember sitting in this auditorium watching this older lady speak. She was wearing clothes an older lady would wear, but not a uniform. I remember sitting there thinking: this is the lady who helped start it all.

Afterwards my mother came to pick us up in her little Volkswagen Beetle. Her hair was in pin curls. I saw Lady

Baden Powell going out of the back of the auditorium and I said: 'Mom, you've got to meet her!'

So I dragged my mother over to meet Lady Baden-Powell, my mother with her hair in pin curls!

I think my mum shook her hand then we went.

But it was important for me to tie it together. It makes me tear up remembering it. It shows what a big thing Girl Scouting was.

By the end of the Sixties, things were changing for women but because of my mother and Girl Scouting, I've always been a very independent person. I got a PhD and I worked for Boeing for 35 years as a user interface designer. It was funny, Boeing had very few women engineers when I started but I never considered myself a woman, just one of the team. And I know that people remembered me and my name because I was a woman doing engineering work.

But it didn't occur to me that my work wasn't equal to what the men were doing.

I'm sure girl scouts had a part of that. Learning new skills, even if it's tying knots, or how to kayak or canoe, it tells you 'I'm capable.'

And it's important, getting away at camp and doing that thing in the company of women where you are not pretending not to be smart because you're around men.

Even though I was this person who was accomplished. I remember being afraid to tell my boyfriend that I got straight As! That's a difference in society. A big difference.

Women need the strength building that comes along with girls scouts but it's also very culturally dependent. It's like anything else, it adapts to where you're living and the people you're with.

I finished college, went to graduate school and only got back into the movement when my daughter was seven. Just as my mother had done, I became her troop leader from second through to 12th grade.

And after that I didn't want to quit. There was so much camaraderie among the women as co-leaders.

Girl Scouting has been an important part of my life. My daughter's an only child and I'm convinced that her life was completely affected by girl scouts.

It's more girl-led now. For a while they hardly had badges, but a coordinated set of activities and you have a certain number of activities you do per badge, but it's just organized differently and I think a lot of people missed that so they brought that back. There's something about getting that little patch!

You can get patches for various things, cookie sales, family-oriented patches, it's become very tech, and that's one of the things I like about the evolving cookie selling and now they'[re teaching girls how to set up their own website and how to have contact with customers, again, it's getting them ready for life afterwards.

Camp helped with that too. There was a much wider variety of people. You were exposed to a larger world outside yourself and you slept in a tent with them or cabin and you learnt how to get along with them.

And if you have a problem, how do you deal with it?

And that's what this job as the counsellor was to help with that.

It's the ability to get together with other people. I love seeing the other women, and encouraging them. That's my job now. Every time I see them I tell them I need to tell you how much I appreciate you. You will have made a difference in your life and you will appreciate what you've done, just as I appreciate what my mother did for me.

That's a priceless gift.

If 1960 didn't already mark the beginning of a new and exciting youthfully-explosive decade the likes of which might never repeat again, it also marked the 50th anniversary of the Girl Guiding movement. Fifty years had passed since a handful of girls had 'gate-crashed' the Boy Scouts' Jamboree at Crystal Palace. Since then, Girl Guides had lived through a Suffragette movement, votes for women, the First World War, the depression after the war, followed by the Second World War. Girl Guides had come so far. A huge event was held in Wembley to celebrate

a half century of Guiding. Rehearsals started in earnest. The dramatic element attracted the attention of *The Stage*:

> SHOW FOR GUIDES' JUBILEE. To celebrate their Golden Jubilee, the Girl Guide movement have engaged a number of stage personalities to produce a massive arena show at the Empire Pool, Wembley, on July 21, 22 and 23. The principal item ... is a masque for youth, written for the occasion. It is aimed at expressing a contemporary theme in drama, dance and music, and it will be performed by a cast of nearly 1,000.

In the build-up to the event in Wembley, many other events were held to mark the Jubilee year. Camps commemorating the 50th anniversary were held. And in Walsall, in the West Midlands – the event itself is reported below in the local *Observer* – a Jubilee Rally was held at which 4,000 Girl Guides and their leaders paraded. There were so many of them the parade was over a mile long. At the event itself in Wembley in July 1960, plays were performed, entertainers sang and danced. And, as ever, there was a royal endorsement from a very famous ex-Brownie:

> Princess Margaret at Empire Pool Guide Show: Harrow and Wembley Guides – and a very few scouts – were among the 700 performers in a play seen by Princess Margaret and Mr. Antony Armstrong-Jones at the Empire Pool, Wembley, last week. Other performances were seen by Princess Alice. Countess of Athlone, by the Princess Royal, by Olave, Lady Baden-Powell, and by Michael Dennison and Dulcie Grey. The play was ... written to commemorate the golden jubilee of Guiding...
>
> Many of the performers had travelled thousands of miles to take part. The longest journey was made by two girls from Hong Kong and Wembley joined them in Chinese dances.
>
> ... Princess Margaret was wearing a lilac-coloured dress with a fur stole and a five-string string pearl necklace.
>
> The whole festival was a triumph of organization. Altogether there were a thousand performers from all parts of the British Isles and from parts of the Commonwealth

and America. They had been rehearsing for months all over the world, but Thursday was the first time they had all come together.

But despite the excitement of ushering in another fifty years of Guiding to come, was there a sense that numbers were dwindling? A decade or two earlier, girls had jumped at the chance to join an organization that got them out of the home and active outdoors. Now, more and more newspapers – such as the *Marylebone Mercury,* 1 December 1967, below – were printing pleas for more Girl Guides and leaders to come forward:

> SOS For more girl Guides. An SOS for more Girl Guides was made at the annual meeting of the Marylebone Guides Local Association. Mrs N Regan, the Secretary, said they also wanted more members to join the local association. Our job at the association is to support the Guides with a little money if necessary. We try to help them out - we're a sort of cushion behind them,' she said. 'We would like more people to take an interest in the Guides and this they could do through the local association.' She said they encountered difficulties in Marylebone because of the 'shifting population'. She added: 'There is a very pressing need for more guiders.'
>
> Miss D Warwick, the district commissioner, whose father was one of Baden-Powell's original helpers, said: 'We will, obviously, lose some girls to other activities, but some will stay on if the foundation work has been done properly in the Brownies.'

Elsewhere in other London and regional papers, the same refrain was being heard – we need more Guiders, we need more Guides. What was taking these girls and young women away from the movement? What had changed? Some argued that television was the new enemy, luring girls away from the great outdoors.

Others argued that popular music and culture had turned young women's heads from the wholesome activity of camping in a field – and that they would more likely be found camping out overnight on a wet

pavement queuing for Beatles concert tickets. Whatever the reason, Guides were seeking more helpers and more Guides themselves. But another, more pertinent explanation, was women's roles. Although the Newsom Report in 1963 said that schools should provide the skills of running a home and that female education should 'follow broad themes of homemaking', many more women were going into work in Britain, though many women left school at the minimum age and married. Yet, more and more women were employed in the UK in the 1960s. Before the Second World War only ten per cent of married women had jobs. By 1951, 22 per cent of married women had jobs and by 1961, it was over 30 per cent.

But this wasn't just because of a shifting attitude to women – it benefited businesses too. There was already full employment for men and businesses often preferred to employ a woman because in the Sixties they did not have to pay them as much. This would have a knock-on effect on Guides in the UK. Whereas their mothers' generation would have stayed at home, many more women in the 1960s had full-time jobs and a family, and therefore had no time to give to the voluntary pastime of being a Guide or Brownie leader. It is no coincidence that many of the Guiding leaders from the previous decades had either been single childless women or stay-at-home mothers. The tide was turning for women. But was this newfound position in society, in the family and at work, coming at the price of losing their sisterhood within the Guiding movement?

In the United States, women's roles were changing fast too. When President Kennedy started the Commission on the Status of Women in 1961, he told the nation, 'We want to be sure that women are used as effectively as they can to provide a better life for our people, in addition to meeting their primary responsibility which is in the home.'

But was this not a paradox in itself? How could women be 'used effectively' in the workplace to ensure a productive workforce and still meet their families' needs at home? Women who believed they could 'have it all' once the Pill disencumbered them from unwanted pregnancies, soon realised that this was still not the case. Not only did they have to excel to be better than a man in the workplace, they still had the lions' share of the responsibility in the home. And, despite the furthering of women's rights in the workforce, American women still needed their husbands to co-sign if they applied for a credit card. A study

done in America in 1963, found that for every dollar a man earned, his female counterpart only earned 59 cents. With this struggle still very much ongoing, was it any wonder there were not as many young women with the free time to give to organizing a Girl Scout troop? Was it now time to introduce a more feminist thread into the Girl Scouting ethos that reflected the times girls and young women were living through?

The attitude to Girl Scouts during these changing times was not helped by a rather infamous lawsuit between the Girl Scouts of the USA and a poster company called Personality Posters Manufacturing Co. A poster was at the heart of the litigation. The poster in question featured an attractive, blonde, heavily pregnant teenage Girl Scout in a short blue uniform, the skirt barely covering her burgeoning bump. Her hair was tied in childlike bunches and she smiled naively (suggestively?) at the camera. The text across the poster said, 'Be prepared.' This was the most scathing and derogatory slur the Girl Scouts had ever endured. They sued the poster company to the tune of $1m for false representation saying that the poster was 'false, scandalous and defamatory libel'. The *Troy Times Record* wrote:

> The Girl Scouts filed a $1 million libel suit in federal court Monday against a firm that published a color poster showing a pregnant Girl Scout with the motto 'Be Prepared' across her chest. The suit, against Personality Posters Mfg. Co, Inc, of Manhattan said that the use of the Girl Scout trademark was 'false representation – a deliberate and intentional design to destroy the association's purpose and program.' The poster was 'false, scandalous and defamatory libel,' the suit said. It asked $500,000 in damages and plus another $500,000 in punitive damages. The court was also asked for an injunction against continued sale of the posters and for an order that all the posters in existence be destroyed.

News of the poster reverberated around the world, particularly in Britain where the movement had begun. The *Daily Mirror* reported on it with a page lead:

> The full-colour poster was meant as a joke – and it caused a lot of laughs among New Yorkers. It showed a smiling beauty

in a Junior Girl Scout's uniform…and in an advanced state of pregnancy. Below the picture was the motto of the Scout movement 'Be prepared'. But when the leaders of the Girl Scouts of America saw the poster they were not amused. In fact, they were horrified. And now they are suing the poster's manufacturers for $1 million - £416,666 – claiming that the joke poster was a 'wanton and malicious defamation of the Scouts.' They also allege that it was 'intended to impute unchastity and moral turpitude among its members.' The girl on the poster was wearing a full Junior Scout uniform including a green beret with the insignia 'GS' and a New York troop shoulder patch. It is a long way from the image that the Girl Scouts, a fifty-seven-year-old organization with 3,750,000 members ranging from age seven to seventeen, try to project. Their suit filed in New York Federal Court, claims that the poster was designed to destroy their aims of 'truth, loyalty, helpfulness, friendliness, obedience, cheerfulness, thriftiness and kindred virtues among girls'.

Two months later, it was reported that the Girl Scouts lost their case. The *Raleigh Register* shared with their readers:

A federal court judge has turned down a petition by the Girl Scouts of America to halt the sale of a pop art poster of a smiling pregnant Girl Scout with the motto 'be prepared.' The Girl Scouts filed a $1 million suit and sought an injunction to prevent Personality Posters Manufacturing Co, Inc, of New York from distributing the poster. The suit called the poster a malicious defamation of the Girl Scouts. Judge Morris E. Lasker turned down the application for the injunction and said he doubted anyone could defame the Girl Scouts. 'Those who may be amused at the poster presumably never have viewed the reputation of the plaintiff as being inviolable,' Lasker said. 'Those who are indignant obviously continue to respect it. Perhaps it is because the reputation of the plaintiff is so secure against the wry assault of the defendant that no such damage has been demonstrated.'

Although Judge Lasker's words were well-meant and a hearty defence on the 'inviolable' reputation of the Girl Scouts, there was still indignation and shock that a model representing Girl Scouts had been used in this derogatory and sexualising way. True, the reputation of the movement was impeccable – how could it not be? But a growing sense of mockery and derision by society towards a group of girls and young women was tangible. Why was the girl in question in a Scout uniform? Why was her dress so short? Why was she smiling in a vacant and suggestive manner?

Despite Judge Lasker's words, the Girl Scouts believed the damage had been done. Whereas, two decades prior to the sixties, Girl Scouts might have been viewed has hearty members of an organization which added to society with charitable acts, growing vegetables during times of war, selling cookies and generally being a backbone of American wholesome society, now that had all changed. This image would be long remembered as a motif of how society had become more cynical and sneering. Using the image of a Girl Scout, with all the sense of female emancipation, support and kindness she represented was a shock. Now, instead of representing a safe space for women and girls, she was a figure of ridicule as well as of the sexualization of teenagers. This marked a watershed in how society would view both Girl Scouts in the US and Girl Guides in the UK.

Was the Scouting and Guiding movement now outdated? It had always been an organization that had done so much for young women and girls.

But now, had society lost respect for the movement for good?

Chapter Eight

Let's Talk Equality

'The movements will go on. As long as a child is a child, the Scouts and Guides will exist to give adventure, companionship and friendship.'
Lady Baden-Powell, *Liverpool Echo*, 28 April 1970

'If we bring in boys, they'll dominate us when we go camping or other trips. They'll try to tell us how to build fires and stuff.'
Piqua Daily Call, Ohio, 28 October 1975

At first it had been touted as a conference discussing women's history. But, as the weeks had passed during 1970, more and more feminists had heard about the first ever National Women's Liberation Movement conference. And now its tone began to change. The conference was held from the 27 February to 1 March 1970, at Ruskin College, Oxford. What the organisers had imagined as a conference for a handful of women interested in history had now exploded into something far greater and suddenly 600 activists from all over the world had announced that they wanted to attend. Photographs from the event show how important it was. Row after row of women – some mothers, some activists, some career women, some historians, some factory workers – are seen sitting, rapt, legs crossed, notebooks in hand, listening to speakers. Subjects discussed included the history of feminism, equal pay, the right to education, free contraception and abortion, financial independence and so much more. This was a year of change for women. It was the year the Women's Liberation Movement gathered momentum. It was also the Diamond Jubilee for Girl Guides and Girl Scouts. Newspapers at the time were packed with women's rallies, feminist sit-outs, demands for contraception on demand, equal opportunities – as well as scathing comment, as here in the *Leicester Chronicle* of 13 March:

> Predictably, in these days of perpetual protest, women have
> again taken up the banner of equality in yet another attempt

to 'liberate the female from a life of drudgery in the home and inferiority in the factory.' Emily Pankhurst may have started off the emancipation cry but have nothing on the modern, militant man-haters.

If our male readers are already chuckling quietly to themselves, they'd better wipe off those self-satisfied grins because this time the lassies really mean it. Two weeks ago, 600 advocates of 'petticoat power' gathered together at Oxford to coordinate 'direct action' between the numerous women's liberation movements which have spung up all over the country.

Ironically, the very same scathing newspapers who mocked the Women's Liberation Movement were also full of comment and celebration about the 60th anniversary of the Girl Guide movement, a movement formed around the rights of girls and chances for young women to reach their full potential. As Olave, Lady Baden-Powell had said herself, her husband had 'declared himself in favour of votes for women. He was in favour of equal pay for equal work and was definitely on the ladies' side.'

If girls who had been encouraged to do anything and be anyone then left into a world within Guiding, what happened when they entered 'the real world' where women's desires and demands for equal rights were mocked openly. What would become of them? Were girls' rights and their desire for equality only acceptable within the realms of Brownies, Guides and Girl Scouts? What would these girls face once they left the environs of their troops and campsites?

Still, the celebrations for 60 years of Guiding went ahead. A performance was planned for September 1970 at Wembley and all over the country rallies, march-pasts and events were held. Local papers as well as the nationals widely reported the anniversary, as here in the *Burton Observer and Chronicle* of 1 January 1970:

Sixty years ago, the Crystal Palace stadium was the venue of a rally for the London members of the newly-formed Boy Scout movement. The lush green of the turf was hardly visible between the tightly packed, orderly ranks of khaki shirts were only relieved by the various coloured neckerchiefs ... As 'The Chief' neared the end of the

rearmost rank, he stopped and started in amazement and disbelief. There, standing smartly to attention, attired in white blouses and dark skirts, with the traditional scout hat topping newly waved hair was a line of GIRLS. In answer to BP's question 'Who are you?' the girls' leader answered: 'We're Girl Scouts.' That answer was to set off a chain of activity which was to culminate in the formation of the largest and best-known organization for girls throughout the world – The Girl Guides.

While there had been some concern over possible dwindling numbers at Brownie and Guide troops, by 1970, there were around 750,000 Girl Guides in Britain and it was a popular pastime for girls. Despite the tremendous upheaval happening for UK women in the workplace, seeking equal pay and employment rights, girls still had a relative amount of freedom outside the home. Many women interviewed for this book recounted the seventies as a time when their parents allowed them to cycle or walk to Brownies or Guides alone; to be out playing until dinner time and leading a generally outdoorsy life. By 1970, 183,000 women went to university – which made up 40 per cent of the university student intake.

Newspapers in the seventies reported regularly on the government's pledge to promise equal pay to women by 1975. It caused a furore of heated discussion between traditional men (and women) who believed women should not receive equal pay and those on the opposing side who claimed it was at least 90 years overdue, as the British Trade Union had first voiced the reasons for equal pay in the 1880s. The *Aberdeen Press and Journal* was vocal in January 1970:

'In Britain traditional patterns remain. Even in the professions where equal pay for women is already accepted. For example, only 16 percent of British doctors are women ... Even when housewives do a full-time job their husband expects them to keep house, cook meals and look after the children. (More than half of Britain's women workers are married.) Employers value women less than men because they are more prone to take time off to tend sick members of the family, especially husbands. Most

women workers treat their earnings as supplementary to men's and are content with a routine occupation. Many regard the pay as less important than the opportunity to do interesting work and meet people.

This notion that a woman's earnings were 'supplementary' to the family income, rather than the main income, and the idea that any job must of course be dropped the moment a family member was ill, was indeed holding women back in the workplace. For young Brownies and Guides in Britain, this would have been a time of great confusion – some Brownies would have had stay-at-home mothers against the idea of working, others might have had mothers in full-time work but seen them juggling the lion's share of the domestic workload. Other older girls might have seen their parents reading the newspapers' comments on women's equality and the burgeoning Women's Liberation Movement and wondered – what will become of us?

But many, of course, in 1970s Britain, were content merely to enjoy the excitement of the diamond jubilee. The royals also championed the Jubilee, with Princess Margaret and Princess Ann attending events around the country. Lady Baden-Powell was also seen at many events, including one in Liverpool at which she was given a guard of honour by Brownies and Guides with disabilities. The *Liverpool Echo* proudly reported:

> A guard of honour made up on handicapped Guides and Brownies from all over Merseyside cheered and waved as her train from Carlisle rolled into the station. Lady Baden-Powell, the world's Chief Guide, is in Liverpool to attend tonight's meeting of the South West Lancashire Girl Guide's Association at St George's Hal l...
>
> She told the youngsters about the jubilee year of the Guides and of their many sister Guides and Brownies scattered all over the world ...
>
> 'It is very, very nice of you all to have come here with your smiling faces back to Liverpool again...'

Lady Baden-Powell, who was 81 in 1970, had just returned from a tour of South Africa where she had visited twelve towns with Guiding

movements. Even as an octogenarian widow, she was carrying out her role as Chief Guide around the globe. If girls and young women were concerned about the changing role of women as reported by the worried newspaper columnists when referring to the debate on equal pay, they had only to look to this feisty woman to see how strong a female could still be in her latter years.

But while prodigious events were being planned all over the world for the diamond jubilee, Brownie, Guide and Girl Scout troops still carried on as normal – meeting in their troops weekly, earning badges and planning camps. One leader was Jenny Beacham who ran Kingham Guides, a rural Brownie Troop in Oxfordshire:

'Guiding gave girls the opportunity to find out what they can do - and the opportunity to try things and not worry whether they're going to get it wrong'

In 1969, I was twenty-one and I became a Guiding leader. It was a very rural company in Oxfordshire. Camping was the main thing, then of course there weren't so many school trips so a lot of those girls in the village, the camp was the only summer holiday they got and it was the highlight of the year.

It was quite primitive in those days. Even in my latter years, it had to be a camp site with flushed toilets and showers but back then we had chemical toilets. We had to dig a pit to empty them in when we got to the camp site and fill it all in and make it good before we left!

And then put a stick in the ground so the next lot knew where not to dig.

In 1970 we had the first county camp for 60 years of Guiding and Lady Baden Powell came to that so that was a big event.

Every five years after that there was another camp and the girls got to go to a big camp with hundreds of girls and internationals as well.

But we used to go to camp on alternate years, seaside and countryside so in the 1970s we used to go to Hayling Island

then the following year, Bedfordshire, Dorset, and we used to travel quite a distance. We also did local weekend camps, absolutely mad really! I couldn't do that later on as teaching became more difficult and I had to work at weekend and didn't have time to camp at the weekends. But we used to go locally and then the summer camp for a week or ten days.

We would go off in an old-fashioned bus with our tents, the flagpole and our kit bags and the girls were sitting on tents in the back of the bus!

Girls were being treated a bit more equally by then. It's a girls-only space and they could do what on earth they liked and gallop around in the mud like a load of boys would, which they wouldn't dream of doing if the boys were there. Even in later years we'd take them to a site in the middle of the woods but you took your life in your hands driving to it through great bit muddy puddles but the girls used to love getting absolutely covered in mud so I think even in the noughties they just enjoyed being themselves and doing stuff together.

We used to do fire-lighting and tracking. We'd send two of the older girls off to lay a trail and then twenty minutes later we'd send the rest off to follow them!

In the winter we'd do a pantomime in the village hall. We had wonderful memories.

I stuck with it until I was 65. I became District Commissioner and Division Commissioner and Camp Advisor but I always kept the unit going because I wanted to keep contact with the girls.

When I was finishing in Guiding, we'd take the girls canoeing and climbing and abseiling which we didn't have the opportunity to do in the seventies. It wasn't known about so much then. In those days, girls were quite happy to rampage around the woods!

A camping camp was more the old fashioned thing where everyone had their duties and in the morning after breakfast we'd collect wood for the fire, empty the loos, collect the rubbish, tidy the camp, tidy their tents, then you

had inspection, then you put the flag up, then gather around the flag with a reading or song, then elevenses and then if they were cooks they'd go off and prepare lunch while the others did something for a badge, then after lunch was rest hour, which doesn't happen anymore! They used to be happy to go off and sit and read in their tents and lie down and read! I remember myself going to sleep during rest hour cos you knew the girls were all right in their tents!

But Guiding has moved with the times. When I look back at the old handbook, I think it's amazing how it's moved on.

The patrol system was stronger then, though, and the patrol leaders. They stayed on until they were 16 then whereas now it's only 14. So you had a huge age range between 11 and 16, when you think of the development of a girl between 11 and 16. The 16-year-olds who were patrol leaders were seen as good role models.

Guiding gives them the opportunity to find out what they can do and the opportunity to try things and not worry about whether they're going to get it wrong.

It gives them confidence for their future and because they've been in an atmosphere where they can voice their opinions so it helps them form their views. They do listen to each other and obviously argue because girls do!

But it builds them up for the future.

But building up women for the future was exactly what the women fighting for equality were doing. In the United States, the Women's Liberation Movement was making even more headway in the Seventies. It was even reported in British newspapers how things were changing for women across the Atlantic, for example in this *Daily Mirror* piece in January 1970:

In America, where women - once stirred into action – work very hard to achieve their aims, The Women's Liberation Movement is going very big right now. And getting bigger every day. Their members are forcing men to do an equal share of babysitting. The women, sick of husbands who dodge off to meetings, airily leaving wives to mind the

offspring, are now doing their own dodging off to meetings, leaving their mates holding the babies.

Indeed, in 1970, talk in the national press in the United States often reverted back to the big question; what did equality mean for women? The US Senatorial Candidate Dianne Feeley said that women must break out of the role as the 'happy slave', stop accepting the notion that she is there to 'serve, to take care of her children, to be a consumer and maybe learn to bake a cake'.

The movement in America was gaining huge impetus and women now began to strike for their rights. The *Middletown Times Herald Record* in New York State, reported on 29 March 1970:

> Two hundred and fifty women, ranging from mini-skirted career girls to grandmothers in slacks, came here from all parts of the country to attend the annual conference of the National Organization for Women (NOW). The Women's Liberation Movement is aimed at not only changing discriminatory laws but the whole concept of man as the bread-winning, decision-making head of the household and woman as his subordinate helpmate. It envisions a society where men and women would share equal opportunities for supporting their families and taking care of their children.

But not everyone was for women's rights – even highly educated Americans, like those at Barnard College, a private liberal arts college in New York City, could report this in their *Bulletin* in October 1970:

> Of the seventy seniors interviewed, only five said they were members of women's liberation chapters, three said they had never heard of the movement, and 26 gave negative opinions of the women involved. A senior who planned to marry and occupy herself with children and hobbies called the women's liberation members 'creatures ... Women's liberation advocates were described as a 'somewhat ridiculous', 'decidedly unfeminine', 'very militant', 'aggressive, unattractive',

'small band of extremists' ... Many students expressed concern over losing the 'fringe benefits of femininity', such as 'being treated differently.'

If educated women from a progressive and liberal arts college thought like this about the women's liberation movement, then it is not difficult to imagine the reaction of people from small towns in America. The movement may well have been gaining momentum in the United States, but it was also being met with aggression, disgust and ridicule. What could the Girl Scouts do to aid their girls when they entered this seismic new world? There were cases of some Girl Scout troops inviting feminist speakers to talk to their girls, such as one in New Brunswick, NJ, in 1972, reported in the *Cedar Rapids Gazette*:

> Feminists and Girl Scouts joined together for an all day awareness conference earlier this month in New Brunswick, NJ. The Delaware-Raritan Girl Scout Conference billed the day as 'a labor of love for people under 21 by people over 21.' The over 21-ers, all feminists, advised the Girl Scouts to urge their high schools to offer girls physical education programs equal to boys and intelligent vocational guidance towards careers formerly reserved for men. Women's Political Caucus also gave the scouts hints on how to get girls elected into top high school government offices.

To add to this hotbed of discussion and changing times, in 1975, the 40th National Girl Scout Convention was held in Washington and the main topic of discussion was whether to admit boys to its ranks. By now there were around 4 million Girl Scouts in the United States and now at this conference 1,800 delegates debated whether admitting boys might aid the cause – or crush it. Arguments for admitting boys included the notion that more boys might actually attract more girls, and another argument pro boys in the movement was that it would teach boys and girls to work alongside each other, putting biological differences aside. But others at the conference argued that boys mature faster than boys and so any ideas of age grouping would be counterproductive. One 17-year-old Girl Scout questioned said, 'If we bring in boys, they'll dominate us

when we go camping or other trips. They'll try to tell us how to build fires and stuff.'

A hand count was finally taken at the end of the debate and in the end, it was decided that the Girl Scouts should remain just that – a girls-only space. The truth was that the Girl Scouts had been teaching feminist principles to its girls for decades. The definition of feminism, according to the Oxford English Dictionary, is 'the belief and aim that women should have the same rights and opportunities as men; the struggle to achieve this aim.'

The Girl Scouts of America had been instilling this belief in its girls since the movement had started under Juliette Gordon Low. In fact, Low herself had said herself in her book *How Girls Can Help Their Country*:

> Girls need not wait for war to break out to show what heroines they can be. We have many every-day heroines whose example might be followed with advantage, and we daily hear of brave girls whose pluck we admire.

It may not have been militant, or angry, or bra-burning – but the Girl Scouts had been telling girls they *could* climb that tree or *could* light that fire with just a piece of flint and *could* build that shelter as the rain poured down, long before the nation's press was demonising the modern woman who wanted female equality. Indeed, Juliette Gordon Low's book of course talked about not aping boys, about the fact that one day the skills these girls learnt might be used in their own home-making and motherhood, but it also taught them shooting, fishing, semaphore, drill, campfire-lighting, self-defence, archery and woodcraft, to name but a few skills. Feminism, by its definition in the Oxford Dictionary, therefore, might well have been taking the world by storm. But it was really nothing new to a Girl Scout or Girl Guide.

In 1977, though, news came that sent the Girl Guides into mourning. Olave, Lady Baden-Powell, died in June of that year aged 88, in a nursing home. The *Liverpool Echo* shared the sad news:

> Lady Baden-Powell, World Chief Guide, and widow of Robert Baden-Powell, founder of the Scout and Guide

movements, has died in a Surrey nursing home. She was 88. Her death is today being mourned by 20 million Scouts and Girl Guides in over 100 countries.

Obituaries and articles praising her achievements and dedication to the Girl Guiding and Scouting movement appeared all over the world, here represented by a piece in the *Birmingham Daily Post*:

> Over the years of visiting her 'family' of Guides and Brownies throughout the world, she was decorated by numerous governments and sovereigns. Guiding was the focal point of her life, in which she strove to weld girls of different nations into a sisterhood based on friendship and service to the community. After a private cremation, Lady Baden-Powell's ashes will be flown to Kenya to be buried in her husband's grave at Nyeri.

American newspapers reported on the loss of the Chief Girl Guide, too. The Californian paper the *Corona Daily Independent* said:

> She spent more than 60 years of her life working for and furthering the cause of Girl Guiding. She was one of those courageous women who led other young women and girls to walk unchartered paths and to participate in endeavors previously closed to girls…
>
> [She] travelled extensively all over the world bringing together young members bound by ideals of service to God, country and mankind. She gave special encouragement and assistance to the movement in developing countries. In each place her warm greetings included every girl of whatever race, creed, colour or background.

One woman who felt welcomed into the Girl Scouts was Akiko Koda who was born in America and raised by Japanese parents in San Francisco. She spoke Japanese at home and knew no English until she started at the Brownies in kindergarten. Here she explains how Girl Scouts supported her without even knowing it during a time of great upheaval during her childhood:

'My mom left when I was 14. I raised my brother alone but Girl Scouts helped me'

I joined as a Brownie in kindergarten so I was five. I went through brownies, juniors, cadettes and finally to senior scouting which was a special program called the Mariner program. We didn't do traditional Girl Scout things. We had a boat and did a lot of maritime training. We also learnt knots and paramilitary things. So much so that a lot of our people went into the Navy or the Coastguard afterwards.

I started Brownies in 1966. I did a lot of reading and a lot of day camp. But I also learnt English as a second language. I was born in the States but my Mom didn't speak English so we spoke Japanese growing up. It took about two years cos they didn't have English as a second language class. So I learnt English at school and at Brownies.

I remember learning about flowers and plants and trees.

I also did community service, selling cookies. My dad worked at an electronics plant and he was a manager, so I'd stand out front when everyone was getting off work, with my little cookie order sheet. I picked them all my dad's employees of the crowd and I sold a lot of cookies!

The uniform was a green dress, with a sash. We had a Girl Scout camp 20 miles south of us at Hidden Falls. We did a lot of swimming and you had to bring old shoes as we went creek walking. The funny part was that Hidden Falls used to be a nudist colony so sometimes there were people who hadn't got the message that it was now a Girl Scout camp!

It was a shock for both of us!

They actually had waterfalls and you'd wear old baggy shorts and slide down the rocks to the water which was a lot of fun. We did crafts and a lot of singing. I learnt to polka at Girl Scout camp to a song called Witch Doctor. A lot of fun.

I learnt to light and build a fire. In fact, I'd say I was a closet pyromaniac. I was good at it! The next year, they took

away my matches and gave me a flint and a stick and I still
won!

So, I got my Fire Starter badge. I also got Sewing and all
the ones that were available.

When I was in Junior High, my dad died. Then when
I started high school my mom left. My older sister had
also left. I was left with a seven-year-old brother and my
14-year-old self.

It was a very difficult time, I didn't want any adults to
know my mother had left, because I worried they'd take my
brother away from me. He was all I had left.

So, Mariners gave me something to do, obviously, but
they also helped. I was working from the time I was 15.
They would babysit for me, they would let me bring my
brother with me.

Strength of character is one of the things Girl Scouts
told me. And doing the right thing. You have that inherently
somewhere in your DNA, but it really drives that point
home.

I wasn't much of a cook but I got the badge. I worked
in a Japanese restaurant and they'd give me a full dinner –
vegetables, rice, meat, soup. I'd take all that home and that's
what my brother ate for dinner the next day. If I worked often
enough I could keep him fed and then handle breakfast and
lunch.

The Girl Scouts helped. They were there. They were
always there. Our skipper did not know what was going on
in our house, but my brother was always welcome when
I brought him along.

I finished scouting in 1979 and in high school we had a
counsellor who helps with moving forward into college.

Mine literally said that as a woman, I had three options:
to be a nurse, a teacher or a secretary. He told me: 'Your best
bet is to get married and have children.'

But my Cadette leader was a big inspiration.
She encouraged me to do whatever you want, don't let
anyone tell you what you can't do, what you can do, just go,
try it, do it, keep going.

She's the one I remember the best except my Senior Scouting Skipper. She was a very strong woman – very smart and she worked. Both made me believed I could achieve what I wanted in life.

After Mariners, I moved over to the Boy Scouts. I worked with them and taught knots and a lot of the same skill sets I used in Mariners. I also taught them to sail.

I soon realized there were differences between Girl Scouts and Boy Sea Scouts. It was more physical with them. They had three giant poles and had to put them up in a tripod and lift a barrel full of water. We didn't do that at Mariners. They did obstacle courses, like the military does.

I worked with the boy Sea Scouts for 20 years.

Now Girl Scouts seem to be more physically active and more adventurous. Physical activity when you're younger is important, and having the courage to try things.

Those are the things you learn in Girl Scouts - to try things in a safe environment. You're unlikely to get hurt. You can try things you wouldn't have thought about or known about. To have that kind of courage…that's the other thing I see in people who *haven't* been Girl Scouts. I realise how much we were encouraged.

As a woman you're always going to run into 'you can't do that.' Or 'because you're a woman' so you need to get past that in your own head.

As a Girl Scout you have an environment where you learn those skills and I think they get ingrained in your system without even knowing it.

I've worked in male dominated industries as a project manager. The leadership abilities, I got from Girl Scouts.

And so those kinds of skills you learn in Scouts, you don't learn anywhere else.

It is true that so many useful skills were learnt by women all through the eras of Brownies, Girl Scouts and Girl Guides. But in a post-1950s, perfect housewife era such as the 1970s, some girls found the skills they were being taught to be obsolete. Lebby Eyres, a writer from London,

was a Brownie during the late 1970s and early 1980s. Here she explains how she felt she was part of an end of an era:

'Our Brownie pack was incredibly domestic – we felt we were a sort of dying breed'

I was a Brownie from 1978 to 1981. I grew up in Highgate, London which had quite a village atmosphere. There is a big church called St Michael's Church and the Brownies was attached to that.

Our uniform was the brown dress with a yellow cross-over tie. I was a gnome and I remember my uniform was quite short!

Brown Owl was an old lady and a real community figure in the village. We met in a hall that was rather bleak with strip lighting. The first thing we did each week was stand in a circle and recite the Brownie Guide motto:

'I promise that I will do my best, to do my duty to God. To serve the Queen and help other people and keep the Brownie Guide Law.'

Then Brown Owl would judge who was the best turned-out Brownie. If we were smartly-dressed with our hair nicely brushed, then there was a little soft toy (a brown owl) and you'd get to take it home and bring it back the following week.

Some of the Highgate mums would come in and do various activities with us or give talks. We did sewing together.

There was one class about how to brush your hair and keep your hair clean.

Brown owl asked: 'What do you do after you've washed your hair and you're going to dry it? What mustn't you to?'

I was completely stumped!

Obviously the answer was to wash your hair brush each time so you didn't transfer whatever hideousness was in your hair brush to your clean sparkling hair!

She was quite a traditionalist!

I was absolutely obsessed with the Brownie Guide Handbook. I probably inherited that from my sister who was

a Brownie and Guide. I had an early 1970s version of the handbook. It was very domestic task based.

I do remember this particular section which told you the order you had to do the washing up in. You had to do the glasses first, then the plates, then the saucepans which is perfectly sensible advice which has stayed with me!

The rest of the book took you through all the different badges and what you had to do for each badge which always sounded onerous to me.

It was very traditional, My parents were nearly 40 when I was born, I was the youngest and they were quite traditional and my dad was the church warden and they were mixed up in that world – the primary school, the church, Brownies all mixed. I do remember being very jealous that my friends who had slightly younger parents who went to – there was a 1970s Woodland Folk, a bit hippy. Our friends went to Woodland Folk and they did a lot more fun activities.

I think definitely Brownies wasn't cool then. The Woodland Folk were!

There was this atmosphere at the primary school that we were a slightly sort of dying breed and it was all sort of old fashioned.

The whole focus of our particular pack of Brownies was incredibly domestic. I remember the badges were things like baking and domestic chores. And one badge has an image of the gnome is dancing around with a sweeping brush.

But after all that's what Brownies were originally – they clean up!

That is the lesson that I remember from the handbook. It was very traditional and very rigid. There was areal disparity between the girls and the boys. I had friends whose brothers were Sea Scouts and they were tying ropes and climbing trees while we were doing these domestic things.

The washing up and the hair-brush stuck with me.

But on a positive level, I think it did sort of reinforce thinking about other people. There is a huge self-improvement element to it, and the fact you're taking these badges. The slight problem with the badges then was that

they were quite focused on domesticity. And depending on who your Brown Owl was. Some might have had more forward-thinking Brown Owls. Ours gave her life to the Brownies. It was the 1980s and she must have been elderly. But she will have grown up in 1910 and all of those values of wartime values were very much uppermost in her mind. There was a real emphasis on duty and tradition and helping other people. You're getting the prize for being the best turned out Brownie. On a micro level you're getting rewarded for having strong leadership skills (to be a sixer).

And it was very nice. I can't remember there ever being any bitchiness or nastiness which there was at school – girls being mean to each other.

Brownies did feel like a safe space.

I sadly fell out of love with it in the end.

Chapter Nine

Social Change

There were tents pitched as far as the eye could see, laundry hanging out to dry on makeshift washing lines and women cooking on open campfires. But this was not a Brownie, Guide or Girl Scout camp. This was a demonstration; a political moment for women that was beamed into news stations around the world. It would become known as the Greenham Common protest and, as more women joined the movement, the Greenham Common Women's Peace Camp.

It started in 1981, when a party of women from Wales called Women for Life on Earth travelled to Greenham in Berkshire to protest against the British government agreeing to store Cruise missiles. Just as their suffragette forebears had done seventy years previously for the right to vote, these 36 women now chained themselves to fences to demand that the UK not store weapons of mass destruction. News of the women's movement and demands spread around the globe and a year later, 30,000 women came to protest, followed by 50,000 a year later. The women set up a camp of tents with cooking facilities and agreed to a peaceful protest of singing, dance, story-telling and hand-holding in the face of police aggression. The women dressed as witches, created spider-web imagery to represent their strength and fragility and even dressed as teddy bears to demonstrate their power as mothers who were against the dangers of nuclear war to their children. At first, there were also male protesters present. But the women soon decided they did not want men in their midst. The *Reading Evening Post* reported that:

> Men have been banned from the women's peace camp at Greenham Common. The strict 'women only' rule came into force yesterday as the protestors prepared to fight an eviction order. The women decided that when the time came for them to face bailiffs they will present an all-female front. One of the protestors, Marion Hirsh said: 'Our protest is

strictly peaceful and we feel that by having only women here it will help keep it non-violent. Another protestor, Helen John, said the camp was started as a women's initiative and should be seen by everyone to be exactly that.

Just as in Girl Guide, Brownie and Girl Scout camps, these women felt that their space should be a female-only place. Men would change the dynamic, take over, perhaps bring unwanted violence, change the ethos. The parallels are all too apparent; a group of women who wanted to change the world, who wanted to do that in an all-female space, and who sang songs around campfires and supported each other. Many of the Greenham women might have been mothers of Girl Guides or Brownies. Some were mothers of babies or toddlers. Some women were even pregnant. The general consensus was that these women were bringing attention to their cause as women – and mothers – who wanted to protect the family and future children. They used their femininity, motherhood and 'place' in the home setting to oppose the patriarchy of all that was aggressive and male – the Cruise missiles, the wire fencing, the armed soldiers, the police. Photographs of women dressed as teddy bears being dragged away by police filled the papers. Other images of women lying in the road in front of police cars and army vehicles, holding hands, were seen around the world. The women were peaceful but there was one death, when a woman was dragged under the wheels of a horse box. Another woman gave birth to her baby in a tent.

But the camaraderie between the women was a force that the police, soldiers and media could not seem to break. A camp that everyone believed might last a few days, lasted weeks, then months, then years. Each time a camp was dismantled, the women would create a new one. One woman even said, speaking to the *Guardian* many years later in 2017:

> The smell of Greenham was wood fires, food cooking – it was like being on a Girl Guides' camp. The feelings were so high and intense that the number of people didn't matter. You were just aware of the commitment, that this was a historic moment.

It is fascinating that this woman compared the feeling at the protest camps at Greenham Common to the camaraderie of a Girl Guide camp. Perhaps

'this woman had been a Guide herself? Or perhaps she referred to the famed sense of unity and inclusion Girl Guiding was known for. Either way, the comparison showed just how much Girl Guiding was still at the forefront of people's minds, even in a decade of tumultuous extremes such as the 1980s. On one hand, Britain saw the rise of Thatcherism, of individualism, of the 'yuppie', fast money-making, fast food. But on the other hand there were the women of Greenham Common, women peacefully protesting in unity – and even referring to that sense of unity as being akin to that of a Girl Guide camp.

As well as political upheaval, the 1980s brought about a sense of wanting everything fast – and now. Microwaves became more common in the home, as did 'ready meals' that came frozen and could be cooked in minutes. Fast food restaurants popped up on more and more streets in Britain and the phrase 'couch potato' was used more and more often to show how sedentary people were becoming. Children still played in the street, but more time was beginning to be spent indoors, playing the rudimentary 1980s computer games.

Brownies and Guides gave children of the 1980s a chance to leave the video games behind and run about outdoors. But as children and teenagers gained more freedom and as popular culture was more accessible through television programs aimed at teens, a flurry of teenage girls' magazines which covered everything from make-up tips to first kissing, Brownies and Guides arguably became decidedly 'un-cool'. Many women from the time interviewed for this book explained that the cool girls didn't go to Brownies or Guides and that the movement had a distinctly white, middle-class flavour in the 1980s. Annuals from the time still talk of outdoor activities such as bush craft, fire-lighting and den-building. But the crafts included were still rather archaic and domestic – sewing, making a doll's bed from a matchbox or creating table dressing sets. Perhaps Brownies and Guides, although very safe and very happy in their warm bubble in church halls, were avoiding the harsh realities of life for young people in the 1980s on the outside. In November 1983, the *Belfast Telegraph* reported:

> Attack on Girl Guides: Nine arrested. Nine people are to appear in court later this week following an attack on a group of Girl Guides and their friends after a disco in Castlederg on Saturday night. About BO young people, more than half

of them girls, and all aged between 10 and 15 were in a car park after the disco when they were attacked by a group of about 15 youths. Stones and other missiles were thrown but there were no reports of any injuries. According to the police nine arrests were made for disorderly behaviour and those arrested are expected to appear in court on Thursday.

Of course, attacks such as this were thankfully uncommon. But one cannot imagine a group of youths attacking a group of Girl Guides in the early part of the twentieth century in the same way. The original sense of respect for the movement was perhaps, among some sub-groups of the young, replaced with a sneering disdain for how these girls were out of touch with the harsh realities of life in Thatcher's Britain. Still, the Guiding movement continued to be popular and the 1980s saw younger girls admitted to the movement – both in the UK and the United States. In 1984, in America, the Daisies were born. They were named after the childhood nickname given to the American Girl Scout founder Juliette Gordon Low. This sub-group of the scouting movement in the United States was trialled in 1976 as 'pixies' and had evolved into Daisies which officially now launched. For achievements, Daisies would receive flower-shaped badges and kept scrapbooks. The uniform was blue and the age range was from kindergarten to first grade (ages four-six/seven.)

Three years later in the UK, the Rainbows were born with the same age range as their American counterparts. They may have been young, but they too were encouraged to vow: 'I promise that I will do my best, to think about my beliefs and to be kind and helpful.'

Encouraging girls to join the movement at a young age meant that more would be likely to carry on and join Brownies.

In 1985 the Girl Guides Association turned seventy-five. A week of celebrations began, reported on here by the *Buckinghamshire Examiner*:

National Guide Week starts on Monday to celebrate the 75th anniversary of the Girl Guides Association. Princess Margaret launches Guide Week on Monday at a candle-lighting ceremony at Buckingham Palace where lighted candle lamps will be received by delegations from all over the world to take back to their headquarters.

Souvenir mugs, stamps and badges were issued to mark the occasion. But at the same time, there was great economic uncertainty in Britain. The same year Guiding celebrated three-quarters of a century saw the biggest ever miners' strike in the UK, with 142,000 miners on strike. It was also the same year that saw Britain's biggest ever mass arrest, with 537 travellers taken into custody during the Battle of the Beanfield, in which travellers were subjected to police brutality and would later win a legal battle for damages for wrongful arrest and criminal damage. The 1980s might have been a time of new technology and accumulation of wealth for some. But, in Britain, it also saw a growing number of people unemployed, social unrest and public demonstrations. Brownies and Guides, therefore, was a place of solace, comfort and security for many young girls who might have experienced unemployment in the family or seen social and civil unrest. It was also a place to be hopeful, to think further afield than your own country and to try and so some good in the world. Here Alison King, now of Rotarua, New Zealand, a Brownie in the 1980s, tells of her experience:

'We built a home for a family in Mexico'

I was eight when I started Brownies when I lived in the UK. My parents had both been in the army and we'd moved from London to civilian life in the country. It was 1984.

My troop was 1st Mickleton and I joined the Imps.

It was a small village and all the girls went to Brownies. We'd meet in the village hall which had a wooden dusty floor and bar heaters to keep warm.

I don't remember any badges except hostess badge.

After Brownies, when I was ten, I joined Guides in 1986.

Guides was a lot more regimented and we needed to remember our pencil, paper, piece of string for inspection. Every night had a purpose to it, whether it was preparing for a badge or being tested.

Our Guide troop had other Guides from outside our village as other villages didn't have enough to make a troop.

Although things were changing a lot for women in the eighties. I wasn't really aware that women didn't have the

same opportunities as men. Our leaders pushed us to do more of the active badges such as fire prevention, crime prevention – if we expressed an interest.

In Guides we went camping a lot with other Guides in our district and we did a lot of outdoor activities, although not as many as the Scouts. We had a joint Scout and Guide camp one year which was fun and that included expedition, wood craft, leatherwork.

A high point for me was joining a Guide trip to Mexico to Our Cabana --. There we went as part of Operacion Lamina where we built a home for a family. There were Guides from across the south of England as well as Girl Scouts from Canada and the United States.

Then, as part of my Commonwealth Badge, I made a pen friend called Janine in New Zealand in 1992. We are still in contact today, we met up a few times while I was in the UK and she was visiting from New Zealand and I stayed at her family home when I travelled to New Zealand my first time.

It taught me to try new things as an adult but it also gave me the opportunity to try new things as an adolescent. I am confident to try new things and accept that I don't have to like it or keep on doing it.

The 1980s was a time of change for women. On one hand, Brownies, Guides and Girl Scouts were being taught how to hostess but on the other, the world was telling them they had to fight for more rights. In America, Jenny Jones was a Brownie and Girl Scout in the 1970s and 1980s in Mississippi. Here she explains how things changed during her time:

'We went through the whole feminist movement. Our programs ranged from how to set a table and serve tea to how to be an entrepreneur and be a leader'

I started Brownies in the 2nd grade in 1978. Our summer camp was at Camp Tik-A-Witha and we always had the most wonderful times in the pool or in the lake.

When I was in the 11th grade, there was a big international event in Canada called Echo Valley '88. They chose ten of us to go from our council and we didn't really know each other. We were from different cities in the council. But we worked as a patrol before we went, we'd have meetings to talk about the trip and what to plan, what to expect. And then Echo Valley asked us to bring or do or perform something that was reflective of where we came from.

I taught my patrol how to clog, which is an Appalachian history dance like the Irish river dance.

We put metal taps on the bottom of our shoes and we had red and white checked outfits that came up like overalls and white T-shirts and I taught them a clogging routine to James Brown's 'Living in America!'

It was such a hit, they asked to us to an encore performance at the closing ceremony!

Going on camp gave me the chance to try new things, to go on adventures, to do things I wouldn't do and break out of my norm. It always gave me confidence that I could do these things and I didn't have to be afraid to try.

Our troop had an annual service project – every year Jerry Lewis did a telethon which raised funds for muscular dystrophy. And it would go on over a weekend and people watching television would watch comedians and performers, singers, perform and Jerry Lewis would interview them and there was always the number at the bottom of your screen for your local town and you could call to make a donation.

So every year my troop would volunteer and spend the night answering phone calls.

I'm still amazed at what Girl Scouts do in service whether it's community gardens, or helping with the local animal shelter, or doing Christmas boxes for the local nursing home - it's still such an important part of what they do today.

I really stayed in the movement. In fact, I've worked for them ever since. I've been membership recruiter. I was a camp director for seven years.

Now I do special event fundraising and marketing and PR. Girl Scouts still does an amazing job. The movement can appeal to every girl. Whether she's an outdoor girl or whether she's into technology, engineering and math or if she's into the basic badges like First Aid or baking badges, there is something in Girl Scouts that appeals to every girl.

But it has changed.

We went through the whole feminist movement, which was huge when I was growing up. That was really coming in in the 1980s and picking up speed. So it went from how to set a table and how to serve tea to how to be an entrepreneur, how to be a leader, how to take part in high adventure. So it's definitely changed from those earlier days of home care to adventure and science and things like that.

I think it's been an organization serving in a leadership position for the development of girls and how girls have changed over the years.

It's a safe space for girls to try new things and if you fail, it's OK, there's nothing and no embarrassment or feelings of defeat.

It's try, try again in a safe place with your friends and other girls and share your feelings and adventures.

Kat Nash was a Brownie in the late 1980s in Bromley, South London. She explains that she felt it was her 'destiny' to join because of her family connection:

'My whole family was in Guiding – it was my destiny to join'

'My grandmother Alice Wood [featured in an earlier chapter of this book] and my mother Barbara were both in the Guide movement, so it was my destiny to join!

I started in 1987.

The Brownies was run at my primary school so it all went on at the school and it was natural to go home have dinner and go back to the school.

Brown Owl's big house was a memory. And Mum used to test the cooks' badge at that house as well. And I remember

it was really weird that Mum was testing me how to make a cup of tea and I had to be really well behaved around her while I was getting tested!

During one pack holiday, Nan came too. We had these tiny camp beds and I remember feeling really homesick, so while everyone was asleep I went to Nan and climbed in bed with her. Then, very early in the morning, she took my back to my camp bed so none of the other brownies would know!

But, with a mum and a nan in the movement, I felt I had to behave myself with the other kids. Nan wouldn't let me step out of line in any aspect of my life! You do the right thing at the right time which Guiding instils in you as well. If Nan was there, I had to toe the line!

In time I joined Guides. I loved it so much that one year Mum said I could go on holiday with the family, or go on Guide camp and I chose camp!

I think Guiding kept me on the straight and narrow during teen years. Certain friends didn't make the right decisions and there were definitely teenage temptations around me but thanks to Guiding, you always come back to doing the right thing. I never stopped going to Guides but I didn't tell everyone because it wasn't cool then to be a Guide!

I achieved my Baden Powell award then went to Venture Scouts. I then left and became a teacher and had my family.

My daughter goes to Brownies and my son goes to Beavers.

I think Guiding has taught me to be self-sufficient and responsible. If you couldn't put your tent up or do your washing up, it didn't happen: no one did it for you. We became really independent. And you had to get through things and if you couldn't do it, you had to try harder. You weren't allowed to give up on anything. It taught me so much and so I wanted my own children to go and learn the same kinds of skills.

Skills for life are things that come up again and again in women who have been Girl Guides or Girl Scouts. Sam Eccles, a Guide in the 1970s

and 1980s, believes her experience in the movement gave her career opportunities she would not have had otherwise. Here she explains:

'I got my first job because of Guiding. In those days, people saw a Guide as someone who was reliable, mature, responsible and organized'

'I joined Brownies in 1974, 8th Kendal (Methodist) in Kendal, Cumbria. My mum had been a Brownie and a Guide and encouraged me to go. There was only one other girl from my street who went to my Brownies. I think you were considered 'posh' if you were a Brownie or Guide.

We moved away from Kendal in July 1976, when I was 9, to just outside Manchester to be closer to my Grandparents. I couldn't get into a Brownie pack as they were all full, so mum put my name down for Guides and on my 10th Birthday the following March, I started at 3rd Radcliffe Guides with some other girls from my street. It was about that time that my mum got talked into helping at Brownies too.

From Brownies in Kendal, I have memories of fun and games at meetings and of going to Brownies Revels, which is a gathering of all Brownies from a District or Division for a fun day of games and activities. Sadly, it doesn't really happen now. I also remember going to the commissioner's house to be tested for my House Orderly badge. I had to do her washing up, polish her shoes and make her bed! She was impressed that I knew how to do hospital corners with the sheets.

As a Guide, my fondest memories are of camping and campfires - a love I still have today! We learned to cook on open fires, sang campfire songs and got wet and muddy most camps. I remember one camp at Bowley in Cheshire, that got so muddy my friend and I took off our sock and shoes and just walked around in bare feet, letting the mud squidge between our toes (much to Captain's horror!) I can remember looking enviously at older Guides and leaders with camp blankets full of badges when I had so few on mine, at a camp recently I heard a Guide say 'Wow,

look at her blanket' as I walked past and it made me smile. Some people buy badges willy-nilly off the internet and have 3 or 4 full blankets, I still have the same old army blanket that I started when I was 10 years old and every badge on there has meaning to me. I also loved working with my friends on interest badges and with my patrol on the patrol pennants and patrol purpose patches when they were introduced.

Guiding was popular at that time, there were many more units in Radcliffe then than there are now. I was always proud to wear my uniform to school on Thinking Day and to go on St. Georges Day and Remembrance Day parades in town. I have always been proud to be a member of Guiding and I still wear my uniform to work on Thinking Day - other people's reactions still amaze me!

I think that being in Guiding has taught me independence, not to worry what other people think and to just be me and be happy with that. I got my first job because of Guiding. In those days, people saw a Guide or a Scout for that matter, as someone who was reliable, mature, responsible and organized. I am not sure people still see it that way today, in fact I have encountered many people who are surprised to learn that Guides still exist.

Guiding also gave me some of the skills I needed to run my own home. I know that women are not considered 'the home makers' anymore but everyone still needs to know how to cook, read laundry labels, sew on a button or give basic first aid. These are all things I learned in Guiding - along with how to light a fire, identify trees and plants, pack a rucksack and build a shelter. I know that the world has moved on, but I believe that there is still a place for these things alongside mixology and vlogging badges.

Mum and I started running Brownies together in 1989 and I got my warrant in 1990. We did Brownies together for 10 years. When my old Guide Captain stood down I took on the Guides to save it from closing. Then we handed it over to another mother and daughter team.

Another woman who began Brownies in the 1980s is Joanna Griffin. Like many others, she believes the skills and confidence Guiding instilled in her helps her every day today in her job:

'I'm a paramedic – I'm convinced Guiding gave me my leadership skills'

I wasn't very academic at school but I loved being in Brownies and Guides because I excelled there. I remember vividly my uniform, being tested for badges and lovely memories of Brown Owl carving a pumpkin at Halloween and us sitting watching it glow with a candle.

I got on with lots of badges, became a Patrol Leader and then got my Baden Powell Award. This was always a very big celebration with a party and a cake – even the local paper printed it!

I was 14 and in charge of five girls for a whole week of camp and some of them had never even been away from home before. They'd get homesick or wet the bed and I had to help them. Camp was a wonderful experience with your own Patrol kitchen shelter, wash tent, toilet tent, a bucket and a toilet seat with chemicals!

We even had to incinerate sanitary towels!

But I learnt such good life skills.

Now I'm a mum and my own daughter was a Rainbow and is now a Brownie.

I became a leader and help to run a Rainbow group.

These tiny girls start at five, we had a sleepover, some of them had never been away from home before overnight, but they all loved it. Really shy ones came out of their shells and it's such a warm, fuzzy feeling.

Badges have changed over the years. When I was Guide we did Hostess, Home Maker and Needlework. Now it's Mixology and Aviation! It's evolved a lot.

Now I work as a paramedic and I'm convinced my Guiding experience gave me confidence and leadership skills. I also learnt a lot of first aid at Brownies and Guides– I learnt how

to do mouth to mouth on a resuscitation manikin, which might have led me to the work I do now!

What I love about Guiding is it is still a safe all girls space. There are not many places like that anymore. It takes young girls away from a whole load of aggravation and angst.

In America, Lori Mobley began her Brownie experience in the 1980s. Although she recognizes the skills learnt back then were more domestic, she believes Girl Scouting has made her who she is today. Here Lori, of Illinois, explains:

'I thank my mom for putting me in Brownies. It's given me so many opportunities'

I was or seven when I started Brownies. At that time we didn't have anything called Daisies so Brownies was the first thing I could join.

I would say we had a reasonable size troop. Around 10 girls.

We had books that we worked through – badge works and opportunities for us to work as a group or on our own. I recall a lot of crafts. Especially if it went with the book itself.

I loved Scouts so much.

I remember field trips. Camping was big. One of my favourites was a part that had train cars that they converted so there were bunk beds and that was one of my favourite Girl Scouts memories but also having my mom as a leader. That was another big highlight and became one of my friends because of Girl Scouts, her mom was also our leader. Our moms worked well together which made our troop worked well together.

We still domestic badges – when I look at the badges today there's definitely a different focus today.

The 80s was still quite domestic.

I remember on camp things like horseback riding. I can't recall anything more like the boy activities.

My mom was our leader and I was a good kid so it wasn't an issue! It's different for my own kids now who sometimes say 'Mom, we need a break from you! You're our girl scout leader, you're involved in cheer leading with us...' so I think it's a bit different for my kids. I enjoyed having my mom as my leader and that's why I am a leader today. Because I know it made such a difference in my life today and I wanted to give back.

The day my daughter entered kindergarten and there was an opportunity to sign up for Scouts, I went to a meeting and I was raising my hand saying I'll be the leader!

And I found out that a woman right down the street from me said the same thing and we ended up co-leading together for most of the years.

I remember I thought it was Brownies and then Juniors but my troop ended up stopping in 6th grade. I didn't even know that Girl Scouts continued and there were more levels. I never knew anything about awards, bronze, silver, gold at that time.

We unfortunately ended and we did 1st through 6th grade. I would have been about 12 or 13.

I ended Scouts in 1988 and so then I became a leader in 2007. That was when my own daughter joined. My daughter is now 17.

She started as a Daisy. I have another daughter, two years younger who also started as a Daisy then her troop disbanded so I absorbed her and another girl into my troop. So now I have ages 14 through 17, so a mixed level troop.

I am a teacher.

When my kids were in middle school, I felt the badges were getting more complex and girls focus wasn't on girl scouts anymore. My oldest who is 17 she is almost embarrassed now to be a Girl Scout and she finds it hard to sell cookies! It's heart breaking to me but I never experienced it when I was in middle school and high school. It is hard.

I think there is so much of a focus on girl leaders and women now. Our meeting this weekend what we have

planned is an activity focusing on world thinking day. So what I've put together is focusing on the idea of respecting others regardless of your race and there's going to be some difficult discussions.

Then we will talk about women leaders and what they have done to benefit us. That's a really good focus on women's rights.

Another activity is I took a bunch of advertisements off the internet and we're going to have a discussion about what's wrong with this picture? Why is it not acceptable? You know, a picture of a woman holding a baby, vacuuming the carpet while her husband is sitting on the couch on his cellphone. You know having these conversations about stereotypes and girl empowerment and women empowerment. So I don't recall anything like that as a kid.

Girls have a lot more choice now.

I think back to some of the songs, even the Girl Scout promise. The promise hasn't changed. On my honour I will try to serve God. Now, I think that's a bit of a different area too. As a child you even talk a bit more freely about God but now would I hate it if Girl Scouts ever changed their promise and omitted the word God. On my honour I will try to serve God and my country to help others at all times and to lead by the Girl Scout Law. So I think about that phrase to help others – again, me being a leader and giving back, that's my way to help others. I also plan events for older girls.

There are skills that maybe our children don't get anymore. Like cooking – and that's such an important skill regardless of whether you're a girl or a boy.

If it weren't for Girl Scouts I don't think I would have this drive to be the leader I am today. I am a teacher but also I'm the president of a teacher's union.

I just think that I have been empowered myself and I continue to learn and be empowered. And I am proud of that. I am proud of the person I have become. I can thank my mom for putting me in Girl Scouts and giving me those opportunities.

Heather Burbridge was a Brownie in the 1980s in Edinburgh. She believes the 1980s was a strange time because life for women was changing and at a crossroads. Here she explains:

'The 1980s in Britain was a strange time. We were stuck between two eras and Brownies reflected that'

I started Brownies aged seven in 1980. We had a Brown Owl a Tawny Owl and when we ran out owls, someone's mum had to be a Snowy Owl, then we got a Little Owl!

The 1980s was a strange time for women. Both my parents worked but my gran was very anti women working. She felt women who were taking jobs were taking it from men.

I knew about things like Greenham Common in the news. There was a clash and lots of societal upheaval. I remember being at school and saw a program about nuclear war and if there was a nuclear attack stay away from windows and there was a government leaflet for us! We watched a video at school of a pumpkin on a stick being shredded because that's what would happen if the windows went during a nuclear explosion! There were weird global tensions.

Brownies was cosy. I remember very wonky papier-mâché mushroom that we had to drag out of the cupboard and a wonky 'lake' to look in the reflection made of corrugated card! I remember not being very dexterous with my fingers for the salute.

We met in a 60's village hall so it was quite nice. We were in Folkestone, a small coastal town. The floor was parquet and there were velvet curtains and a stage.

The uniform was the brown dress and the crossover yellow tie and you had to put your silver badge in the middle. It had pockets which was good – I still like dresses with pockets to this day! You had it for your ten pence piece, your pencil and your bit of string. We wore white socks and school shoes and a brown bobble hat.

I was a seconder and I was a bit grumpy about that because I wanted the power! I was quite envious that I wanted to be the sixer.

I was a sprite. We had a green badge with someone leaping around. I went to a grammar school and we still did embroidery and needlework not metalwork. It was similar at Brownies. It was all about being a very good housewife. I remember ironing, I think that was part of the home maker badge, and a lot of washing up.

I remember at camp one of the main things was making a stand for a washing up bowl out of wood and twigs.

I remember camp and singing the songs, Ging-gang-gooly, Thunderation and that was nice. We cooked bananas in chocolate. I remember collecting twigs for the fire but I don't remember climbing trees, it was more foraging and treasure hunts, not too much dynamic stuff.

I went to Guides for about three or four months but it all felt a bit serious and I was rebelling at that point and it was a bit too straight and I thought: This isn't cool.

It felt a bit matronly.

At that point I had more friends at high school I was hanging out with and Guiding wasn't very cool. I think it's a bit cooler now!

I think it's definitely changed a lot – there's much less about Queen, country, home maker 1950s vibe now and it's more gender neutral.

My daughter goes now and they are quite proactive at doing things with other groups. There is a more international flavour and concepts about the role of women and ecological awareness. There is a more global outlook rather than domesticated things we did. They also do more sports, games and more camps and the badges are a bit more technology-related not just home-related. So, it's cooking but not just domesticated cooking. It seems a lot more relevant to today.

In the 80s I think Brownies hadn't really updated its curriculum, just like school hadn't really. At 6th form we were really pushing because the boys were doing metalwork and electronics and we had to fight at the time to do those classes. It was still very segregated. But we grew up with 60s mums and dads and there was a hangover from that time.

143

I enjoyed Brownies, though, and although it was very domestic, I certainly know how to iron!

Brownies was a group thing: teamwork, having fun, singing songs. I think it was also quite a cheap thing to do for parents - relatively speaking it's still actually an affordable thing for children to do today. In that way, Brownies and Guides is classless which is good, and not very expensive.

My son is a Scout and it's a really good way for him to do adventurous stuff. The Guides have done quite a bit but not quite as much as the Scouts. But it's pushing that way.

I think it was much more dynamic when it began in 1910 and then after the 1950s women were put firmly back into their place. And that was still very much there in the 1980s when I was growing up. I believe we were still stuck between two eras.

One thing Brownies did teach me was how to tie a decent knot, how to start a fire from kindling and to have 10p for the phone! And that's always useful.

The general, resounding consensus from women interviewed for this book who were in the Guiding movement in the 1980s is that they were very much stuck 'between eras'. On one hand, women's liberation was well and truly mainstream. In the 1980s, Britain had a female prime minister, there were laws for equality between the sexes in the workplace. On the other hand, school lessons were still segregated in the UK: boys did metalwork, girls did needlework. Boys did woodwork, girls did home economics. Brownies, too, was still very much focussed on domestic abilities such as home-making, washing and setting tables. What had started in 1910 as a movement where girls had wanted to do the same as boys with all the outdoor activity, camping and fire-lighting that came with it, now seemed to have dipped back into a hangover from the 1950s where women were put very much back in the home.

But change was just around the corner.

Chapter Ten

A La Mode

'I don't want the girls to look like policemen.'

Princess Margaret, 1990

'OUT, go the severe, drab, school-like uniforms of yesteryear. IN come casual mix-n-match tops and bottoms that can be worn in 100 different combinations.'

Daily Mirror, 1990

It had all started in 1910 with girls grabbing whatever clothes they could find to fashion into a uniform and turning up to see Robert Baden-Powell at Crystal Palace. Colour, style of hat, general uniformity didn't matter. What mattered was that they were there and they just wanted to join. They had guts, determination and the will to do exactly as their counterparts the boy Scouts were doing. Uniform came a firm second.

In fact, until 1917, a generalized uniform for Girl Guides and Brownies was not in use. Then, as uniforms came about, they started as blue rather than brown until finally the Brownie 'brown' uniform was born. By 1938, the Brownie tie changed from brown to yellow and they wore brown berets. Then, in the 1970s, the beret was discarded in favour of a knitted brown bobble hat. But although hats and ties had changed, the basic code of a knee-length dress had always remained. Maybe, after 80 years of the same uniform it was time for change?

That change came in 1990. Jeff Banks, a British fashion designer who had launched his own fashion label in 1969 and had been hugely successful and had created a BBC fashion program called *The Clothes Show,* was approached by the Girl Guides Association to talk about redesigning a uniform that had not changed since its origins 80 years earlier. The brown knee-length dress and brown bobble hat was as synonymous with the Brownies as was their three finger salute. So why change it now?

The press debated the uniform change as well, such as this from the *Sandwell Evening Mail*:

> Top fashion designer Jeff Banks has introduced style to the traditional Brownie uniform. The new uniforms, the first major change since Guiding began in 1910, are made up of sweatshirts, hooded and plain, sweatpants, trendy chambray skirts, mini-skirts, culottes, US football-style knits and peaked baseball caps. Colours remain almost true with sunshine yellow/ forest brown for Brownies, blue-navy for Guides, aquamarine/ navy for Rangers and young leaders and white/ pale navy for Guiders and Commissioners. The Jeff Banks garments are supplemented by a range of three colourful scarves designed by Cressida Bell, English Eccentrics and Timney Fowler houses of London.

The *Daily Mirror* also extolled the new uniforms, saying:

> 'OUT, go the severe, drab, school-like uniforms of yesteryear. IN come casual mix-n-match tops and bottoms that can be worn in 100 different combinations.

But it was reported that there was Royal Intervention when Jeff Banks wanted to change the Guides' uniform to a darker blue. Princess Margaret, President of the Girl Guides, disapproved of a change in colour and allegedly told him, 'I don't want the girls to look like policemen.'

Banks got to work in earnest. But, as he explains, the final stage was the most nerve-racking. Here he explains:

'The final stage of the redesign? Getting Princess Margaret's approval!'

> I was approached by the head PR for the Brownie Guide movement and Dr June Patterson-Browne, the then Chief Guide, to see if I would redesign the Brownie and Guide uniforms. The reason was really twofold: one was that the uniform was becoming inappropriate – girls sitting cross legged in a brown dress in a church was not a good sight! - and

also more importantly there were lots of different people manufacturing the uniform and the Girl Guides weren't getting any benefit from it.

I agreed to undertake it. At the time I presented a show called The Clothes Show in Britain and I used the show to do a running project so we could actually reach out, not just to the Girl Guide movement but to everybody to come and cooperate in this venture.

So that's how it started.

Next, I did a whole market research programme. I got Land Rover offer a prize to a Brownie troop for the best market research contribution.

We got a lot of research back in from all areas across the country as to what they thought; how they thought the uniform should be, how the existing one was inappropriate. We had about 100,000 responses.

The resounding message back was that they wanted something that had longevity that would actually stretch across from Rainbows, Brownies, Guides and Senior Guides. They wanted something that had a coordinated look across all the divisions that was the principal requirement. Next, it was taking into account all of the different activities that the Guide movement had moved into – a lot of outward bound and athletic courses where it needed outer wear that was protective clothing and would enable them to do those activities.

Fundamental to all of it was a polo shirt. So for the Brownies it was a yellow polo shirt for Guides it was a white polo shirt, for senior guide members it was a navy polo shirt. For the bottoms it was a culotte so it was a dividing skirt which meant they could be much more athletic and move much more easily in the uniform.

Then I concentrated on different visual elements: the polo shirt, adding the colour of culottes. When it got into the seniors, we designed tailored culottes and jackets and across the board I designed nylon jackets and padded jackets and a range of T-shirts that matched all of those different divisions.

There were 1.2 million members at that stage so I had to do something that would embrace 1.2 million women – quite an undertaking!

Despite redesigning a uniform that hadn't changed in 80 years, I didn't meet any resistance. Right from the top down they were really looking for change.

I had to do lots of visits around the country to local Brownie movements and Guide movements for them to criticize the design and for me to amend it – all part of a normal design process. It took quite a long time doing the research on the design before we made any samples.

Fabrics were completely different to the original ones used. All the polo shirts were 100 percent cotton. The culottes were polyester cotton so they were easily washable with a minimum of ironing and after care. I was recognising that they came from busy families or maybe they were away at camp so again the clothing had to be very durable and to be maintained well.

But, as a designer, I did come under criticism – mostly from my own daughters! Was I ruining my image as a designer, making a uniform for the Girl Guides?

My response to that was that I found the Guides to be the most amazing movement. The women that were involved were professional women: lawyers, bankers, accountants - a great bunch of phenomenal women.

I had no personal association with the movement yet I had a real appreciation of what they were doing for young women and what the guide movement represented globally.

So, I looked at it as a badge of honour.

The final stage was getting Princess Margaret's approval, as head of the Girl Guides. So June Patterson Brown and I had to go to Kensington Palace with all of my designs to present to Princess Margaret so she could actually sign them off.

We arrived at Kensington palace and got shown into this very elaborate sitting room with two couches opposite one another. Then Princess Margaret came in, saw us there, immediately turned tail and walked out again!

Apparently they'd got it wrong - she was supposed to be seated before we were escorted in.

So, we had to go back out again, Princess Margaret got herself seated, then we could actually start the presentation.

I showed her design boards and illustrations. It was a very hot day and I could see her beginning to nod off. So June gave me a nudge and said: 'Show her her uniform!'

So I said: 'By the way, Ma'am, as president of the Girl Guiding movement I've designed a special uniform just for you.'

She perked up! I showed her hers: long culottes and a very petite jacket.

She said: 'What colour will it be?'

I said: 'There will be a whole navy blue for the Guide movement that you can actually choose. I've brought a whole bunch of colours for you to choose from.'

We went over to the window and I started leafing through the navy colours.

Suddenly, she stabbed her finger on one and said: 'What is that?'

Making it up as I went along, I said: 'Oh that's French Navy, Ma'am.'

She said: 'What do the French know about the Navy?'

I laughed and couldn't respond to that. So she approved the colour, and 'French Navy' became the navy blue of the Guide movement!

The next stage was to get the whole collection sampled, manufactured and tested. I had to do road tests in different brownie and guide movement across the country so people could approve it.

Then they wanted it approved by the General Council of the Guide movement by Princess Margaret and her lady in waiting various other very senior members.

So, we mounted a fashion show at the banqueting hall near the Houses of Parliament for her Royal Highness and all the leaders of the Guide movement.

We had about 25 representatives from Rainbows, Brownies, Guides, Senior Guides, and they all marched

forward together in front of the panel so her Royal Highness could approve each division.

After a whole afternoon, we got it signed off and went into manufacture.

The first order, amazingly, was 400,000 pieces!

The whole process took about two years. It was a long process but I got amazing feedback. One day I was in my car driving past Buckingham palace. There were about 200 Brownies outside the palace on Queen Victoria's statue and they all had baseball caps and their yellow polo. One recognised me and they all started shouting: 'Jeff! Jeff!' and waving their baseball caps.

I was constantly invited to Girl Guide jamborees so I became an honorary guide, the only man!

I decided to donate the copyright of my design to the Guides so they could control the manufacture of where it was made, who it was made by, how it was sold. All the royalties from that went to the Guide movement.

As a thank you they presented me with an amazing porcelain statuette with historical guides in their uniforms.

I still have it to this day.

One other thing is one of my proudest pictures is of a young Kate Middleton, now The Duchess of Cambridge, wearing her Brownie uniform. I can truly say I dressed a future Queen of England.

Girls all over the UK welcomed the new, fashionable, easy-to-wear uniform. Mums were relieved that suddenly they had easy to look after, long-wearing, easy-to-wash items that could be mixed and matched. After eighty years of girls wearing stiff brown dresses, often that restricted their movement, surely now was the time for change. But some leaders who were interviewed at the time said they would have preferred 'more uniformity' and complained that the mix and match outfits might not look as smart when on occasions such as church parade.

But the change in uniform marked more than simply a nod to comfort and practicality. A uniform that was softer, easier to wear, trendier, more child-friendly and 'cool' meant that girls could feel perhaps even prouder to be part of the movement. Culottes replaced skirts, a huge leap

after eighty years, and were surely a step in the right direction towards equality for Brownies and Scouts. After all, it was far easier for a girl to run about, climb and generally get mucky in a pair of shorts than it was in a knee-length ironed dress which often rode up the leg the more the girl grew. The mix and match element of the new uniform also was a step in the direction of a more girl-led feel to Guiding. If you could choose what you wore to meetings, what else could you decide on? It gave the girls the individual choice to choose 'their' uniform and what Guiding meant to them as well as how they would be perceived and represented.

Hannah Lilley, who is now a Brown Owl, started as a Rainbow and then as a Brownie in 1993 – just two years after the new uniform was designed.

'The best bit about camp? The 'midnight' feasts!'

I started Rainbows aged five. Then aged seven in 1993 I started Brownies.

We were a Guiding family: my mum, her three sisters and my grandmother and she had been since a little girl and my grandmother was a Brown Owl. Then my Granny became District Commissioner in Kent so it was a given I'd join!

The Brownie uniform was the Jeff Banks design: a pale yellow T-shirt with the Brownie emblem on the chest and a Brownie sweatshirt over the top. We had brown culottes and a sash that went across our right shoulder.

Brown Owl got us to start with the Hostess badge so all of us did that one. I don't know if she thought it was something relatively easy for us to attain or she felt it was an important skill for us to learn but once we did that, we had free rein.

There was also an emphasis on sewing because, as she said: 'Sewing is important, then you can sew your badges on!'

I went on pack holidays. It was the first time I'd stayed away somewhere that wasn't Granny's. But because my granny was District Commissioner for Kent she volunteered and came along too.

In the weeks leading up to camp you'd be making things, so you'd make and decorate your name badge and decorate

a table mat which had graces to stick in the middle to use at camp. It all added to the anticipation.

The best memory on camp was the 'midnight snack,' with the small treats we were allowed to bring. The older girls would organise it and make something to cover the clock so the adult leaders wouldn't know what the time was if they caught us. We'd then get up and turn our torches on as we made a circle and ate our snacks, told stories and giggled, thinking the leaders had no idea. It was only later as a young leader myself when I was organising it that I realised the adult leaders had known along!

Master actors!

I went up to Guides for two years but I didn't like it and I found it very strict. So after two years I decided Guides was not for me.

I didn't want to leave Guiding so I approached my Brown Owl and went back to help at the age of 12 to be a young leader and that's how I'm still there!

I became Brown Owl of my pack in February 2019.

I think now it's more girl-led now but a lot of active badges have disappeared.

The hostess badge might have seemed dated but as a teacher there are so many children I see now who hold their knife and fork in the wrong hands or don't know how to set the table for Christmas lunch.

It's a simple thing laying a table but it's a life skill which has stuck with me!

But mostly Guiding has most taught me an attitude. I walk around with the mentality of 'I am a Guide,' If I see rubbish, I pick it up. If I see someone who needs help, I offer it. That kind of ethos is ingrained in my head.

The motto was 'lend a hand' and that's something I still do as an adult.

And something I teach my Brownies.

Christine Daniels had joined Brownies in the late 1950s, but it was in the 1990s that she felt her most wonderful Guiding opportunity came along. Here she explains:

'I travelled to Russia and Uganda and was humbled'

I joined Brownies at seven years old in 1957, then I went on to Guides and then I joined the Land Rangers and Cadets. In time became a leader. I ran 4th Barnet Brownies before moving to Leighton Buzzard where I continued to run a Brownie Pack and later a Guide unit.

We did so much over the years but the one thing that stands out is when, in 1995, one of my best opportunities came along. I attended an adults International Selection weekend in Derbyshire where, along with seven other lovely leaders, I was lucky enough to be chosen for The Girlguiding Bridges Project. This entailed going to Russia to introduce Girlguiding to the community of Yoshka-Ola in the Mari El District in central Russia. We started out by having a few weekends together in the UK to get to know each other and learn to understand the purpose and expectations of our visit. Our journey to Yoshka-Ola took a day and a half, first by plane to Moscow and then a 22-hour rail journey in wooden bunks on a sleeper train where all the lights went off each time you arrived at a station. It was a humbling experience as there were many shortages of food and resources. We stayed with families during our visit so got to learn a lot about their lives. We were looked after during the day by some wonderful young students who were learning English, and we visited town and village schools and schools for the blind, and the gifted and the talented. We also visited orphanages, hospitals and experienced some of their hardships. However, the people were always happy and smiling and very welcoming. It was October and very cold when we were there so we always dressed warmly. Our young hosts would sometimes say when we arrived anywhere on visits: 'Ladies please take off your clothes' but we understood!

My last unique opportunity was to be part of an International leader team in 2011, taking a group of 14-18-year-olds on a community service project in Uganda. This was another of the best experiences in my Guiding

life. We stayed in a small hotel, which had an intermittent electricity and water supply, but we were provided with gas lamps and buckets of water so which were at the ready when needed, which was quite often. We walked each day to Busembatia village to work with and get to know their community. We decorated their school walls with pictures, the Alphabet and times tables, created resources under the guidance of the teachers from the school and played with the children. We helped in the brick building for outside toilets in the village and took special pushchairs to the outlying villages to families of children with disabilities.

Between us we carried beds for around three miles across the land to two elderly ladies and a blind man who needed them, and my experience of gadget making came back into play when we made washing up stands using rocks as mallets, we also taught simple healthy hygiene routines.

We were asked to run a Guide meeting for some of the local children, boys and girls and were told to expect around 20 or 30. We had songs, games, crafts and a large parachute all ready, however news must have spread very quickly and we ended up with over a hundred children.

We had to quickly rethink our strategy but being experienced in Guiding it wasn't too difficult a task. In pairs we were allocated to a family for a couple of days so that we could learn more about their way of life, and the highlight of this was spending a day preparing and cooking the main meal on open fires, once again all my camping skills were useful. It was just one of the fantastic, magical and very rewarding experience that Guiding has given me. I would encourage everyone who can to try and do at least one International experience in her Guiding life.

I retired in 2018 after 50 years and recall my childhood in Guiding as the most magical and fascinating time of my life, it was nothing like school and nothing like home. At meetings and at camps I always felt transported to another world. As a Brownie it possibly felt like a world of 'make believe' but as a Guide I found who I was and what I could be

and I felt so safe. This has followed me into my Leadership role and with all the girls who have passed through my units I have made it important to give them a choice in all things, so that they can join in, can grow and change at their own pace and hopefully then be more confident with themselves. I am proud of my leadership in Guiding as I have seen that it has had an impact on girls becoming positive and confident young women.

(Taken from Personal Life Memoirs 2020: Chris Daniels Girlguiding Member of Linleighbridge District, South Bedfordshire Division, Bedfordshire)

After ten years of the Jeff Banks Brownie and Guide uniforms in the UK, it was decided some new items would be needed. The new uniform items were designed by fashion designer Alison Lloyd of Ally Capellino. Alison Lloyd had launched her first womenswear collection in 1980. Now she took on the job of doing a redesign of the Brownies and Guides uniforms. Like the previous uniform, it would be mix and match. The new Rainbow uniform now would have a red hooded jacket, jogging bottoms, cycle shorts instead of a skirt and a red and blue polo shirt. Here, she explains what the project meant to her:

'Working on the uniforms was a lovely project'

The project to design the uniform for the Brownies came to me from somebody else who was a friend of a friend of someone in the Guiding movement and wasn't able to do it. They asked me if I wanted to do it and I said: 'Yes, absolutely!'

I was a Brownie and a Guide myself. I think I was more successful as a Brownie than a Guide. I was thrown out of Guides in the end but I did enjoy that as well! One of the very useful things we learnt was making a tripod stand for a washing up bowl out of three sticks. I loved that and the camping.

The uniform I wore was the brown canvas all-in-one with the front pockets which I thought was gorgeous.

I took over from the Jeff Banks design in 1999.

The first uniform they wanted was the Brownies. I went into some schools and did some research about what girls wanted. They seemed to want zingier colours.

My daughter was 11 at the time so I looked at her and what she was into. Jersey and Lycra had moved on a lot by then and I wanted to make the uniform a little more light-hearted.

They wanted a skort – a mix of skirt and shorts – so they could move more easily. I did a lot of trousers and didn't really see the need for a skort but it was more of an adult choice really.

After that I worked on the Guides' new uniform. We designed this uniform with the same principles we'd applied to the Brownies. We put a bit more red in it and designed polo tops and we also put a stripe on it to make it more sporty. After that I did the leaders' uniforms and the Rangers and Rainbows.

I'd been a fashion designer for years and there is really no difference in designing uniforms – you just listen to a brief that people want.

Personally, I am a rule breaker so I am on the fence with uniforms myself. But I like uniforms because they have a code. I think people can have pride in a uniform and I think the idea of uniforms – certainly in schools – is to provide some sense of equality, although it rarely ever does.

For little girls in the Brownies, though, I think the idea of being in a little gang and having a uniform is a lovely idea.

After I designed the uniforms I got a lot of feedbacks from the mums who said they liked them because they were a lot more modern.

In the end we finalised things with a track suit, two short sleeved T-shirts, combat trousers, short jersey cycle shorts and a hoodie.

The only thing is uniforms can look a bit swampy because it's the sort of thing you always buy about five sizes too big!

Chapter Eleven

The Future

On first impression, the thousands and thousands of girls for as far as the eye could see appeared to be part of a festival or attending an enormous concert or outdoor dance party. As a voice rang out from the stage asking if they were ready, an enormous 'Yes!' rang out from the 20,000 strong crowd. A Mexican wave of pink scarves, T shirts and jumpers cascaded in one fluid movement across the throng. This was Fusion – a one-day-only festival to celebrate 100 years of Guiding. It was held at Harewood House, an enormous stately home in Yorkshire. Surrounded by 100 acres of gardens and land, this was the perfect venue to welcome the 20,000 girls – from aged five to 90 – to celebrate the centenary of the Guiding movement. The Mexican wave of pink had been the end to the day-long celebration that had included live music, performance, dance, food and drink and incredible displays including an acrobat descending from a hot-air balloon. Were you to cast your mind back to that handful of girls who had attended the first jamboree Lord Baden-Powell had held at Crystal Palace in 1909, there were similarities – as well as huge differences. Just as in 1909 girls had come together to be recognized as part of the Scouting movement, so had these women and girls in 2010. But, while the group in 1909 had been a handful of girls without uniform, without common bonds or organization, now, 100 years on, just look at how Girl Guiding had grown.

The year-long celebration had begun with 4,500 girls meeting at Wetherby Racecourse with a 2k fun run. Celebrations took place in Britain for the rest of the year, with parties, centenary camps, new coins minted to commemorate the 100 years and even a meeting of 5,000 girls in Leeds who joined with 500,000 girls across the country by video. Here, the girls reflected on the past 100 years of Guiding and discussed their plans for the future.

But what were their plans for the future? In 2009, the Girl Guides Association began commissioning an annual Girls' Attitudes Survey.

This was led by the Guides' youth panel, called Advocate, which would lead the survey each year and look at the results. In the 2013 survey – in an era when girls and young women seemingly had more opportunities than ever before – the results were shocking. Three in five girls interviewed felt that sexism affected most areas of their lives, 87 per cent of girls aged 11-21 felt that women were judged more on their appearance than their ability and more than a third of girls between ages seven to 21 had felt patronised because of their gender. More worryingly, girls between the ages of 11 and 21 said they had suffered sexual harassment, with 60 per cent being harassed at school and 62 per cent having been shouted or whistled at in the street.

The study makes for fascinating – and disturbing – reading. Older women might have felt that girls now had more opportunity and equality than ever before, yet there these girls were, still reporting harassment, being patronised and even touched against their will. The report also found that girls felt that the school's sex education programme did not focus on relationships enough, along with reporting weight pressures, body shape shaming and the pressure to diet. The Guiding movement might have evolved in the 100 years since the forerunners started the organization to gain women equality, yet these girls still felt that the 'challenges faced by previous generations, such as overcoming stereotypes and constrains in work and family life, will soon be issues that affect them too'.

But it was not all doom and gloom. The study also found that getting a good job was top of their list of things to achieve in life and that 88 per cent of the girls interviewed believed their future family lives ought to be equal, with both parents raising any child equally. This study is fascinating because it delves into the minds of modern Brownies and Guides and the concerns they believed might hold them back. Being female, body shape, pressure on women to look and behave a certain way were just as pertinent now, it seemed, as it might have been decades earlier. The difference was, though, that now girls could voice these opinions and help each other. Girl Guiding was a place where girls and women could discuss the issues of the day within a safe sisterhood where all voices would be heard.

This would lead to modern Guides in Britain joining and leading campaigns that affected not just them, but women all over the world. In 2013, the Girl Guides joined the campaign against Page Three Girls.

The *Sun* newspaper – Britain's biggest-selling tabloid – had started the Page Three Girl in 1970, devoting its third page to an image of a nude woman. There had been outrage at the time, but the *Sun* argued the page was popular as it doubled its circulation in just one year following the appearance of the first Page Three girl. For years, women and girls had experienced the page three phenomenon as 'normal' in a family newspaper. But in 2012, a writer, Lucy-Anne Holmes, began a campaign to ban Page Three, citing that it had no place in a family-read newspaper and was demeaning to women.

In 2013, the Girl Guides of Britain got behind the campaign. They even ran their own poll which found that 88 per cent of Guides wanted the *Sun* to remove the page.

The then chief executive of Girl Guiding, Julie Bentley, said, 'Giving girls a voice on issues that they care about is one of Girlguiding's most important values. We are very proud that young women in Guiding are choosing to speak out and play a part in building the society they want to live in.'

Girl Guides' decision to back the campaign made headlines in all the national newspapers. The gulf between the image of a naked woman and the wholesome image of Girl Guides fuelled debate even further and furthered the cause. As the *Daily Mail* reported:

> The decision to hold a vote on the campaign was taken by Girlguiding's Advocates - our panel of young women aged between 14 and 25 who are the driving force behind Girlguiding's advocacy work. Explaining their decision to support the campaign, the Girlguiding Advocates said: 'The Sun is a family newspaper. Anyone can pick it up, turn to Page 3, and think that it is normal for young women to be treated as objects. This is just wrong. It is impossible to nurture your ambitions if you are constantly told that you aren't the same as your male equivalent. It is disrespectful and embarrassing. We need to get used to the idea that women are not for sale.'

The campaign worked. It took time, but three years after the petition began, in 2015 the final Page Three girl appeared in the *Sun* newspaper. After 44 years, it was over.

But the real work was just beginning. Nude women may have been banned from the third page of a national newspaper, but there was still a long way to go before girls felt equal to boys in terms of confidence, self-esteem and being judged on their appearance. This concern was so deeply embedded in women and girls that the Guiding Association launched a new badge in 2014 called Free Being Me. The badge was available to Brownies and Guides and was in partnership with the soap manufacturer Dove, who were then running their Dove Self Esteem Project. To achieve the badge, Guides and Brownies had to analyse narrow definitions of beauty, to learn that ideals of beauty varies around the world, and to write lists of things they liked about their own bodies, not in the narrow definition of 'beauty' but in terms of strength, for example, 'I like my legs because they are strong enough to ride a bike' and so on. The fact that such a badge was created could only be seen as a good thing, a talking point for girls and young women. But its existence in itself also indicated that there was still so much work to be done. By 2018 – the tenth anniversary of the Girls' Attitudes Survey – although some things had improved, girls still had similar worries. Fifty-four per cent of girls believed more attention was paid to women's clothing than what they could do, and 77 per cent believed female politicians were judged more on what they wore than what they said. The survey found that younger girls felt happier with their appearance but that as the girl grew up, her general happiness with her appearance steadily diminished. More worryingly, the survey found that only 25 per cent of girls and women aged 7 to 21 felt very happy, compared to 41 per cent in 2009. So, what was causing this? Social media surely played a role, with the survey finding that 52 per cent felt ashamed of how they looked compared to bloggers and influencers on social media. How was this happening to young women? It showed a worrying trend.

Still, it was a time for celebration. In 2012, America celebrated its centenary of Girl Scouting. National and local newspapers – such as the *Arlington Heights Daily Herald* in Chicago – marked the anniversary of Juliette Gordon Low starting the movement.

> Today more than 50 million women in the US are Girl Scouts alumnae. There are 3.2 million girls and adults in more than 100 local Girl Scout councils across the United States and others in more than 92 countries...

> Belonging to a Girl Scout troop provides a familiarity to girls if their family moves across the country or around the globe...
>
> Everywhere Girl Scouting is found it continues to inspire, challenge and empower girls. To celebrate its centenary, Girl Scouts USA will launch its year long 100th anniversary celebration...

All over the United States, as in the UK two years earlier, events and celebrations were held. There were en masse camps, cook-outs, concerts, and some troops marking the 100 years with '100 days of service' – planting trees, helping their communities and cleaning up rubbish. A Girl Scouts Centenary coin was minted – a centennial silver dollar – which featured three girls' heads in relief that depicted three ages of Girl Scouting over the years. The inscriptions included courage, confidence and character, attributes the US founder Juliette Gordon Low had inspired in her first Girl Scouts 100 years earlier. Life had changed so much for Girl Scouts in the past 100 years. But how much change was too much?

In 2017, the Boy Scouts of America announced their plans to admit girls to Cub Scouts as well as planning to begin a new older girls' programme for girls to follow which were the same as for Boy Scouts.

The new plans meant that Cub Scout dens would be all boys or all girls and larger packs could admit both sexes. The Boy Scouts voted unanimously to admit girls to the movement, saying it was 'critical to evolve how our programs meet the needs of families interested in positive and lifelong experiences for children', the *Guardian* reported.

But the Girl Scouts of the USA, on the whole, disapproved, arguing that girls needed a girls-only space and even suggested that the Boy Scouts were only inviting girls to join because they needed the revenue. 'I formally request that your organization stay focused on serving the 90% of American boys not currently participating in Boy Scouts ... and not consider expanding to recruit girls,' wrote the GSUSA president, Kathy Hopinkah Hannan, in a letter to the BSA's president, the AT&T chairman, Randall Stephenson.'

Discussion – and arguments – ensued. Some families argued that same-gender troops would be beneficial for families purely on a practical level. After all, it would be easier dropping both children at a

troop meeting one day a week rather than splitting between two different troops in different locations. But others argued that girls needed their own space away from 'toxic masculinity' and the change in behaviour that girls might experience alongside boys.

At this time, both Scouting and Girl Scouting in the USA had seen a steady decline due to children preferring to take part in sports activities instead, or simply to not partake in extracurricular activities at all. In March 2017, the Girl Scouts of the USA reported a decline in its membership from just over 2 million girl members in 2014 to 1,566,671 in 2017. Was mixing genders the way forward to encourage more young people to join?

By now there were 500,000 members in the UK and over 110,000 volunteers. In a stark contrast to its origins in homemaking, First Aid and outdoor camping skills, Girl Guiding was now well and truly at the forefront of current affairs and topical debate – including what many called the 'third wave' of feminism. The 'first wave' – fought by the early suffragettes – had pushed for voting rights for women and the second wave, in the 1970s, had focused on seeking equal pay for women and an end to workplace discrimination. The 'third wave' began in the 1990s and focused on all the earlier feminist concerns but also now included women's reproductive rights, as well as the rights of ethnic minority women or women who might not have felt included in earlier waves of feminism. Girl Guides and Girl Scouts discussed third wave feminism. In 2018, the Girl Guides Association published a blog post about three of their members who had attended the Women of the World Festival and who had given speeches on what feminism meant to them, women's rights and even on topics such as food waste. Girls were now no longer content to work for badges in sewing or cooking, but were being encouraged to learn about politics, about globalisation and climate change as well as reproductive rights and what they wanted for their futures.

Yet, despite all this, girls were still feeling held back in certain areas of their lives, as was reflected in the Girl Guides' annual Girls' Attitudes Survey. One of these surveys from 2016 found that a third of 7 to 10-year-olds believed they were judged on their appearance. Sixty-one per cent of those asked felt happy with how they looked, which was down from 73 per cent five years earlier. Worryingly, more than a third of these young girls believed women were rated more

on appearance than ability and 38 per cent of them felt they were not pretty enough. One resounding answer was that the girls mostly believed life would improve for girls if society would stop judging them on their looks.

How had girls and women come so far and yet were still held back by how society judged their appearances? A century earlier, girls' only preoccupation might be that their uniform was smart. How had this evolved into such widespread worries about their body shapes?

In so many ways Girl Guiding had projected women and women's rights forward. Yet, this one snag remained – women being judged on their bodies.

But the surveys also showed many positive changes in girls and young women's attitudes. In a 2016 survey, 84 per cent of girls and young women interviewed expected equal opportunities with men in their future workplace. And 76 per cent of girls asked felt confident in digital skills.

These girls were also able to vocalize that they felt disappointed by many advertisers showing women in 'traditional' roles and were able to identify when images had been air-brushed in the media. There was still a lot to do to make girls feel equal to boys. But at least, within Guiding, they could discuss these issues in a safe place where their voices could be heard.

Evie Mussett, from London, started Brownies in 2011, when she was seven. Here she explains why she still feels Brownies and Guiding has a place in society for young girls:

'Girl Guides is a good thing for girls to do'

> I started as a Brownie aged seven. The uniform was yellow flared trousers or brown and a yellow T shirt which could be short sleeved or long sleeved. We didn't have any necktie. There were hats available and skirts but most people wore a zip up hoodie and trousers.
>
> We got badges but we never really had any accessories other than a hat.
>
> We met at the local church hall. There were two or three people from my year and lots from the local schools, it was really popular.

We did a lot of cooking – we would be put into groups and did competitions. We'd have young leaders come in and we'd chat with them in a circle.

We went into the church yard and we did lots of games and sang songs.

I went to Guides aged 10. It was more popular than Brownies.

We went on a lot more trips regularly and we were a lot more independent. We had opportunities to arrange international trips where we'd go to different cities in Europe and we had to raise our own money and there was a lot of independence.

In Guides at about 13 or 14 I became a young leader and it was a lot more independent and doing things that were a lot more useful.

To raise money for our trip I was asking for grants, and I helped out at elderly lunches. I raised money through that.

We had a lot of discussion about different career choices and we were taught a lot of practical skills, like the traditional scout stuff. So, knots. But we also did domestic and cooking and hygiene.

We definitely did more outdoor things – they were teaching us how to control barbeques in the church yard and on camps we were making fires and shelters and putting up tents.

I then went on to Rangers from aged 14. That was more sitting with others and talking! We played games and we did a lot of cooking but most of the time we were sitting talking.

There wasn't a uniform we just wore what we liked.

I think Brownies and Guides has been really useful. Other than making friends, they taught us things that you don't really learn in school – social skills, how to cook properly. It's far-fetched but if I was in a forest, I'd know how to survive because of Brownies and Guides!

They taught us the things you complain they don't teach you in school.

I think it's good being in an all-girl space. I remember in primary school – which was a co-ed school – I was definitely

more outgoing when I went to Brownies. I think everyone was really confident there in comparison to when there were boys around.

I think Guides is a good thing for girls to do – definitely. I'd send my own kids to Girl Guides.

Since Girl Scouts' first beginnings in America when Juliette Low started the movement, attitudes had changed so much. But girls of today still feel Girl Scouting has played an important part in forming their character. Here, Katelyn Mobley, aged 17, from Illinois, explains what Girl Scouting has meant for her:

'We celebrated the centenary – 100 years of Girl Scouting'

I started Daisies at six years old and then went on to Brownies. My mom was our leader. We learnt camp skills and did a lot of crafts.

At nine I went on to Juniors and we had a lot more independence. We started archery and even did a low ropes course. We also were able to start staying away overnight.

I saw that the badges were changing to be more equal. There were still the baking or creative ones but also other badges about our world or how governments work.

Scouting has also opened doors to new hobbies. So you can try things out and discover you like it. You also have service badges and learning how to volunteer and work with the community.

I'm now an ambassador in Girl Scouts and what I've noticed is I don't do as much badge work but there are some much more adventurous opportunities such as five-day hiking trips. You have a Gold Award project you can work on which is the top award.

During my time in Girl Scouts I learnt about Juliette Gordon Low and how she started it and how she was inspired by the Boy Scouts and the Girl Guides in the UK. She wanted to do something specific for girls and help girls grow.

I was lucky enough to be a Brownie during the 100 years of Scouting in 2012. For the centenary we had a lot of

events. We learnt the history of Girl Scouts. We did lots to celebrate – a waterpark, bowling and a baseball event. It was nice to be there for the centenary.

I think Girl Scouting is a good thing for girls to do. It's good for them to find other girls in their school who they can become friends with.

I've found it's good being a role model to younger girls. Cadettes Seniors and Ambassadors help younger girls and there is leadership at a younger age.

Katelyn's younger sister Emily feels her experience in Girl Scouts has not only shaped her character, but given her ideas of what she'd like to do as a career:

'Girl Scouting has given me ideas for my future'

I started as a Daisy in a large troop. We did a lot of mini activities to earn petals and I enjoyed it. I then moved up to Brownies and the uniform was a brown long jacket and I made friends with girls I might not have usually interacted with. I now know people who don't go to my school. I know people not even in my grade.

Girl Scouting has come a long way. Badges are now about science and more learning-based.

My mom was and still is my troop leader.

Girl Scouting has taught me practical life skills. If I was lost in the middle of nowhere I'd survive but without Girl Scouts I'd be completely lost! I've also made friends from different schools and year groups. There are girls that outside of Girl Scouts I'd never have talked to but in Girl Scouts.

I'm now at senior level. Recently for World Thinking Day we got together.

On a normal week we'd be working on badges or hosting badge workshops with the Daisies, Brownies and Juniors.

My very first camp I could sleep outside at was amazing. Before that we slept inside but on one recently we slept outside in yurts and I was having a lot of fun!

I've learnt talking skills – when you're younger you don't know how to approach people but as you get older it gets harder. With Girl Scouts you can casually walk up to people. I've gained communication skills.

We have a free library we run and we check up on it and refill it with books.

I plan to stay in the movement as long as I can.

It's been nice having my mom as a troop leader. She encourages me a lot to get the work done and do extra work!

I feel we have equal opportunities now. My mom had way different badges and now we can almost do everything that the scouts can do but more in a safer way in a female only space.

I feel it's important GS stays as a girls-only space. Girl Scouts is for girls to get the life skills that they need.

Badges has given me tasters of career options for my future. Even as a Daisy we went to an animal shelter and toured around and I had so much fun and it was the only field trip I vividly remember. To this day that was one of my favourite things I've ever done and has given me ideas for my future.

Now, as Guiding and Girl Scouting moves into further into the twenty-first century, their future is brighter than ever. It is the world's largest youth movement, enabling girls from all walks of life, creeds, countries, cultures and backgrounds to reach their full potential. It has survived through two world wars, two global pandemics, the suffrage movement and women's liberation. It helps girls not only learn skills for their own future but gives them opportunities to travel, to forge lifetime friendships and to learn about the world and global issues.

The WAGGGS – the World Association of Girl Guides and Girl Scouts – continues to advocate for girls and young women all over the world, including helping them with digital skills, learning about climate change and the environment and female empowerment. One important badge is the United Nations Challenge Badge for Climate Change which has been developed with UN agencies to motivate girls to educate those around them about climate change and to make

change in their communities. Girl Guides have come so far since their early days.

The coronavirus pandemic meant that Girl Guides and Girl Scouts could not meet in person but that did not stop them in their cause. Troops adapted and met weekly via Zoom. They still studied for badges and achieved them. Guides and Girl Scouts also did a lot of good during the coronavirus crisis, just as their forebears had done during two world wars and the last global pandemic over 100 years ago.

One British Guide leader, Pat Mayle, from Salford, Greater Manchester, came up with an idea called the 'Comfort Bags Scheme'. The bag contained toiletries for visitors who have to stay overnight in hospital without warning. She told the *Manchester Evening News* in October 2020:

> It just took off, it's been incredible. Within 12 months we'd given out 1,000. Girl Guides of all ages can help with it as well. The young ones can bring things in they've collected and the eldest can make the bags for us.

Months on, over 18,000 comfort bags had been made and given out by the Girl Guides in the area. Pat Mayle had also delivered 2,600 bags to hospital staff and volunteers which contained hand cream, sachets of coffee, sweets and hand sanitizer. The pandemic which gripped the world only served to bring out the best in Girl Guides and Girl Scouts, as previous international tragedies and events had always done. So much had changed but at its core, the movement had not changed at all. *Lend a hand* ... The basics were still as true as they had been over 100 years earlier.

When those first girls dared to attend the Boy Scouts' Jamboree at Crystal Palace in 1909 and 16-year-old Nesta Maude had said, 'We're the Girl Scouts!' did she have any notion of the momentum she was starting?

It is important that these early beginnings, the names, experiences and attitudes of these early Girl Guides and Girl Scouts, are not forgotten even as Girl Guiding moves forward.

Just as Jean Jennings, interviewed earlier in this book regarding her experiences of a Guide as an evacuee in the Second World War, so poignantly said, 'Guides gave me a lifeline, because it was company, you got to know someone else.'

This was true for so many girls and young women – during war and during peacetime. Girl Guiding and Girl Scouting has given thousands upon thousands of girls a different safe space to be themselves. Not like home, not like school, the place that they call Guiding or Scouting is a different realm – a place to make friends they might not normally meet, a place to be the girl they might not feel they could be in a school or home setting.

At the end of my conversation with Jean, she also rightly added how important it is that we preserve Guiding and Girl Scouting and the voices of these women from the past. Theirs are not dusty old memories of a lost time, but rather anecdotes and lessons we should treasure today. Not only to see how Brownies, Guiding and Girl Scouting was, but to marvel at just how far it has come. As Jean Jennings said – and her voice still echoes in my ears –

It's good to remember how Guiding was as, in time, these things disappear.

Select Bibliography

Baden-Powell, Robert, *Scouting for Boys*, Oxford University Press, originally published 1908

Baden-Powell, Robert and Baden-Powell, Agnes: *The Handbook for Girl Guides o How Girls Can Build up the Empire,* originally published 1912

Brambleby, Ailsa, *The Brownie Guide Handbook,* Girl Guides Association, 1968

Gardner, Rev. Helen D. *The First Girl Guide: The Story of Agnes Baden-Powell*, Amberley, 2010

Kerr, Rose, *The Story of the Girl Guides*, Girl Guides Association, 1932

Low, Juliette, *How Girls Can Help Their Country*, Applewood Books, originally published 1913

Maloney, Alison, *Something for the Girls – The Official Guide to the First 100 Years of Guiding*, Constable, 2009

Synge, Violet, *Royal Guides: A Story of the 1st Buckingham Palace Company,* Girl Guides Association, 1948

Trefoil Guild Members, Cumbria South, *Once a Guide, Always a Guide, A Book of Memories From When We Were Guides,*

Websites

https://www.wagggs.org/en/
https://www.girlscouts.org/
https://www.girlguiding.org.uk/

Newspapers and Periodicals

The Daily Mirror
The Guardian
Headquarter's Gazette
The Spectator
The Stage